shocking
beauty

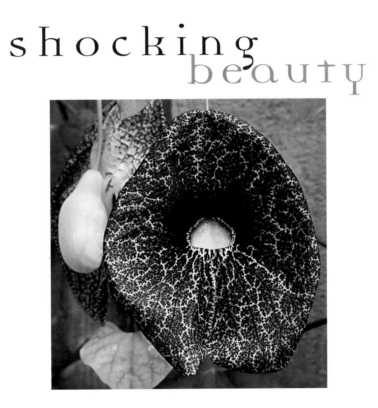

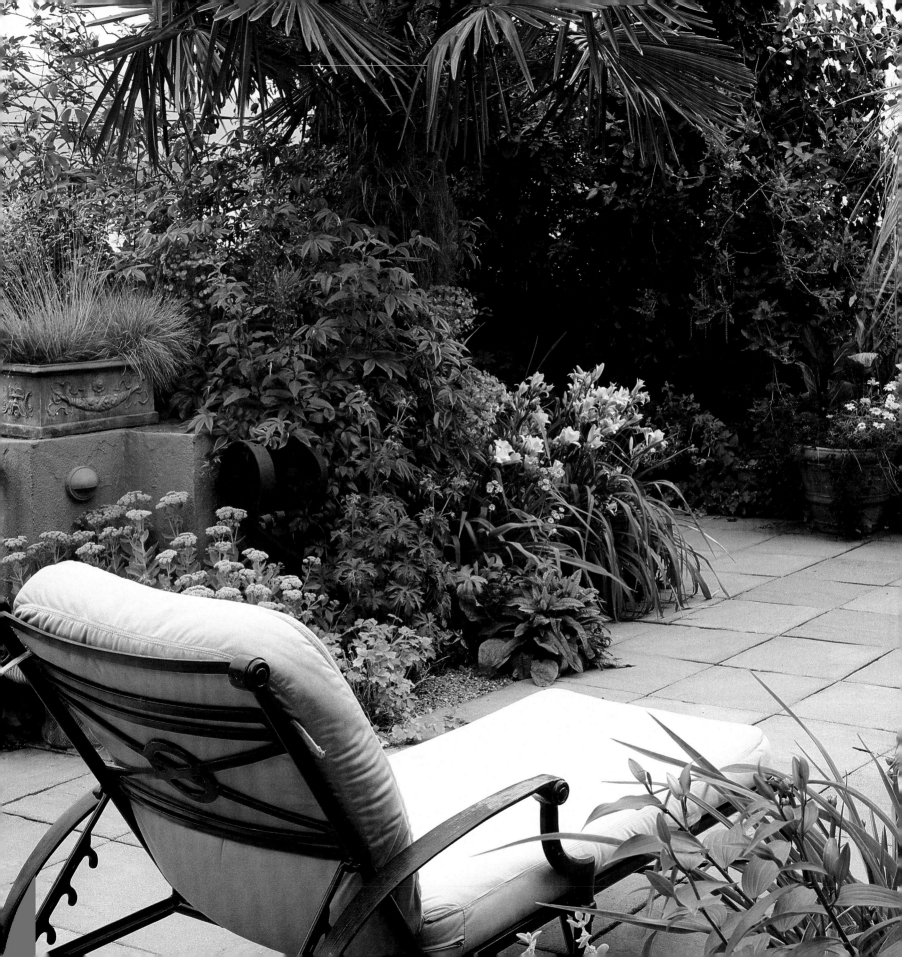

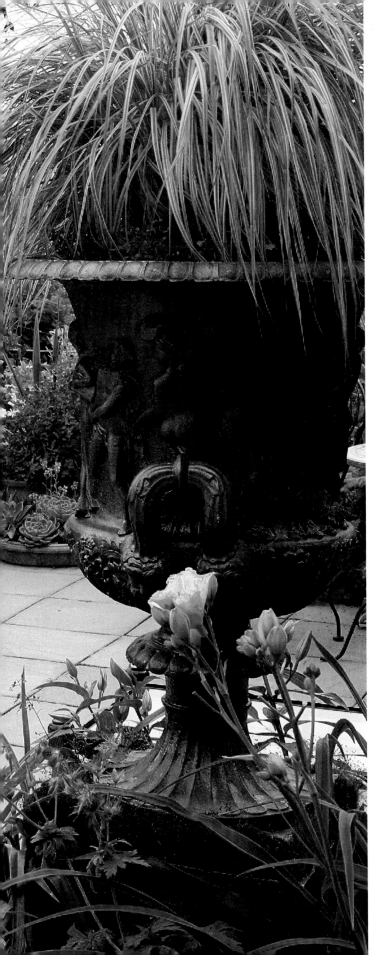

shocking
beauty

Thomas Hobbs'
Innovative Garden
Vision

PERIPLUS

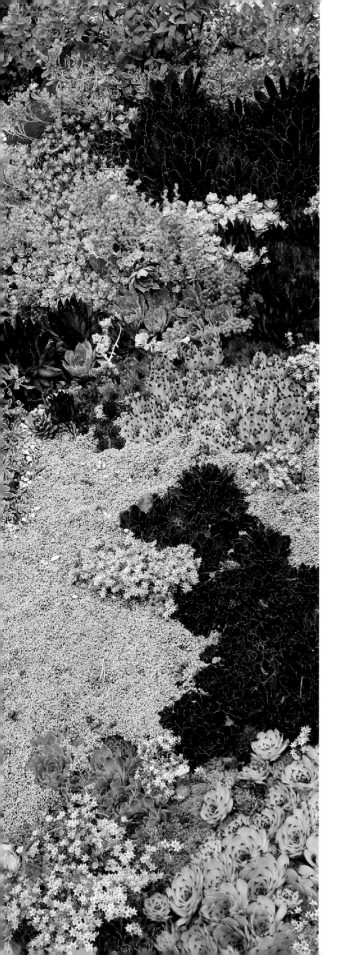

First published in the United States in 1999 by Periplus Editions (HK) Ltd., with
editorial offices at 153 Milk Street, Boston, Massachusetts 02109
and 5 Little Road #08-01, Singapore 536983.

Library of Congress Catalog Card Number: 98-89898
ISBN: 962-593-542-8

Distributed by

USA
Tuttle Publishing
Distribution Center
Airport Industrial Park
364 Innovation Drive
North Clarendon, VT 05759-9436
Tel: (802) 773-8930
Tel: (800) 526-2778

Japan
Tuttle Shokai Ltd
1-21-13, Seki
Tama-ku, Kawasaki-shi
Kanagawa-ken 214-0022, Japan
Tel: (044) 833-0225
Fax: (044) 822-0413

Southeast Asia
Berkeley Books Pte Ltd
5 Little Road #08-01
Singapore 536983
Tel: (65) 280-3320
Fax: (65) 280-6290

First edition
05 04 03 02 01 00 99 10 9 8 7 6 5 4 3 2 1

Design by Leslie T Smith

Printed in Singapore

contents

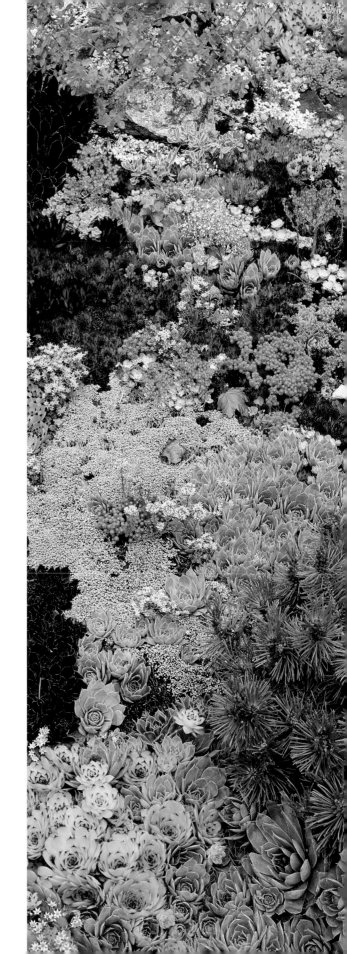

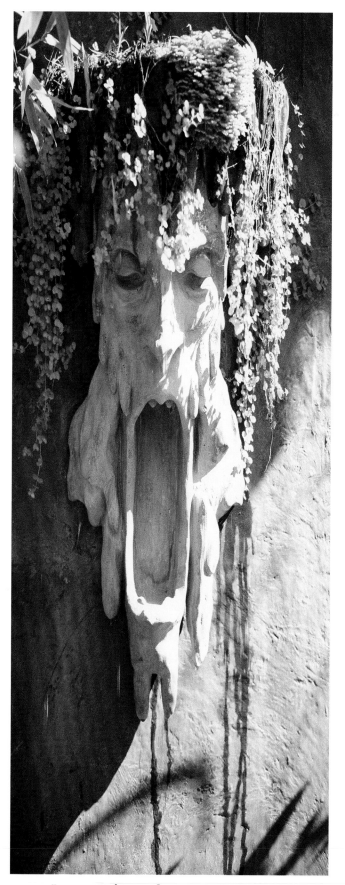

preface & acknowledgments

Because creating a garden is an endless and enormous task, it seems formidable. This is why very few people bother. I envision taking the plunge into garden creation to be something like sky-diving: a gigantic leap of faith, terrifying to some, and a commitment to keeping afloat rather than landing, pancake style. Once you have jumped, the rush hits, and gardening becomes a powerful drug.

To achieve greater visual beauty effects in our gardens is the goal toward which we garden, hoping to score. I know when I have scored; my brain tells me. What it takes to stop people in their tracks is what this book is about — the careful orchestration of plant material to cause pleasure. Beauty is always welcome, but when beauty is combined with shock the reaction is more orgasmic.

The ultimate compliment to a great garden (and gardener) is when a visitor is reduced to hobbling — there is so much to see and ask about it is impossible to take a normal step. Breaking stride is the goal of great planting. We want to be humbled and thrilled.

The ability to shock people with our gardens exists in direct correlation to the number of methods of attack we use.

The most obvious is visual stimulation through beauty — we actually need to draw more breath to handle it! This is jaw-dropping time, and there are lots of gardens and naturally occurring wonders that do this to us every time. I wonder if it is possible to faint from a beauty overdose?

Beautiful scent is another method. It is a natural reflex for me (and I hope for you, too) to close my eyes when inhaling a fantastic floral scent in order to really enjoy it to its maximum. By shutting out the visuals, the mind can magnify the pleasures given by floral perfumes.

A sense of surprise, followed by a sense of mystery are also important in enjoyment of a garden. A very pretty garden can fade quickly if it fails to gain momentum around each corner: a surprise to delight and perhaps baffle the visitor is much more memorable than another pretty rose bush. A large pot of water plants is terrific, but what about adding some smashed mirrors or handfuls of costume necklaces to the mixture?

A dreaded dark area can become a mysterious shell grotto. A baking hot Hell-slope can house a massive *Romneya coulteri* colony. By seeing the potential in all our possibilities, a garden is born.

This is not to say that everything that is beautiful in a garden is the result of our conscious intervention. Suddenly (typically, I have noticed, around year eight), a botanical knitting happens and the entire garden comes together on its own. An amazing amount of happy coincidence and unexpected successes appear deliberate, when in actuality the plants did it themselves. Some plants actually move over to where they like it better; others self-sow unexpectedly. Some plants arrive and are mislabelled, often to our horror, but occasionally as a blessing. A totally unplanned burst of color once in a while is a good reminder that you, as a gardener are really only a willing slave of Mother Nature after all.

I would like to thank the many garden owners, named and unnamed, whose creations appear in this book. Film will never capture more than a fragment of your efforts and cannot give credit for all the planning, frustration and hope you infuse into your soil. It was you who pushed me and taught me, and eventually I stepped right through the looking glass into a much richer and more spiritual communion with plants.

By making a career out of my love for plants and flowers, I have many customers and friends and combinations of the two to thank for their loyal support of my businesses. My family stayed in the background mostly, but if my mother hadn't bought me a set of botanical encyclopedias when I was nine years old I'm sure I wouldn't have learned as much as I did as a kid. Thanks Mom. Parents take note.

I would particularly like to thank Mark Stanton and Allan MacDougall of Raincoast Books for their initial and ongoing enthusiasm for this, my first book. My editor, Brian Scrivener, has managed to take my 'sermonettes' and stream of consciousness ramblings and, with designer Les Smith, has created a book I am not just proud of, but amazed with. Thanks guys!

The Photographers

This book would not have been possible without the generosity and talents of David McDonald, Jerry Harpur, Charles Price, Glenn Withey and Allan Mandell. Your ability to capture on film so specifically everything I write and think about Shocking Beauty helped make the book what I hoped it would be. I cannot thank you enough.

Lastly, I would like to thank Brent Beattie, who knows that all goes without saying.

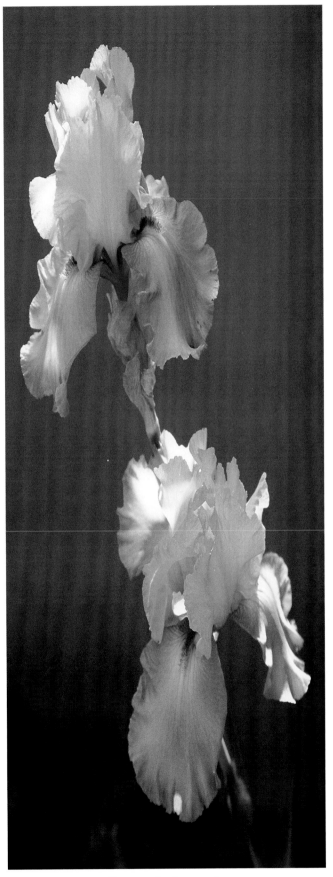

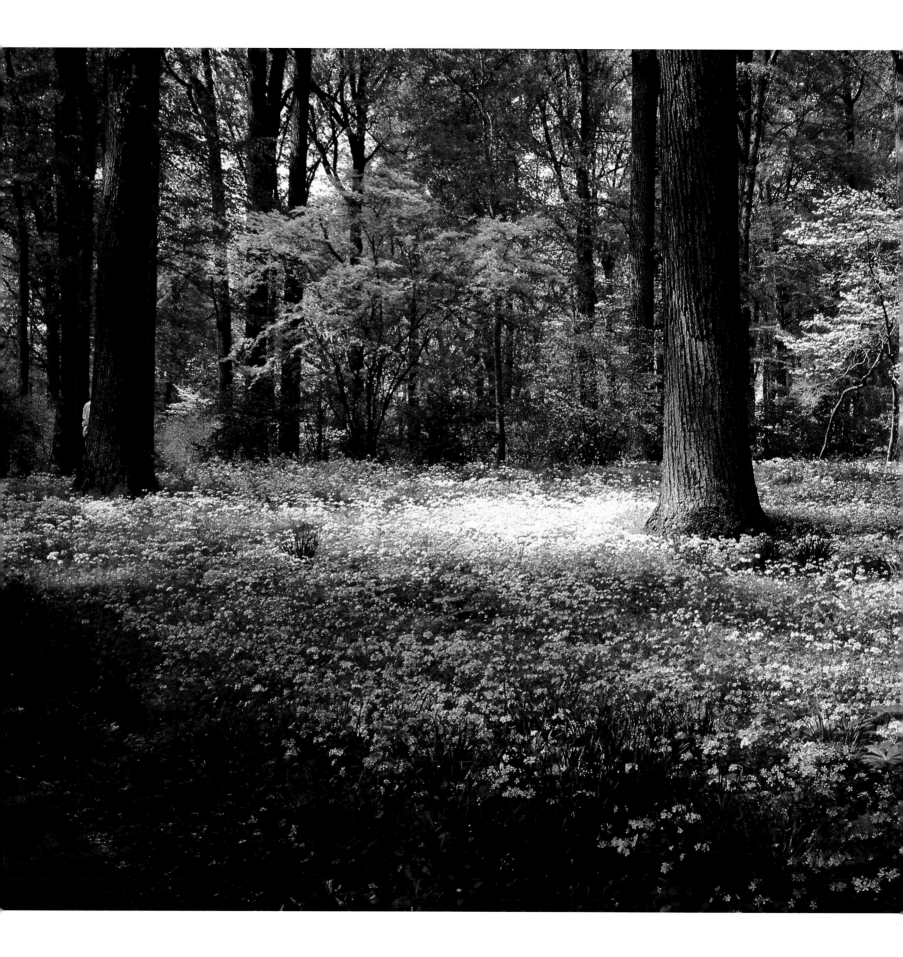

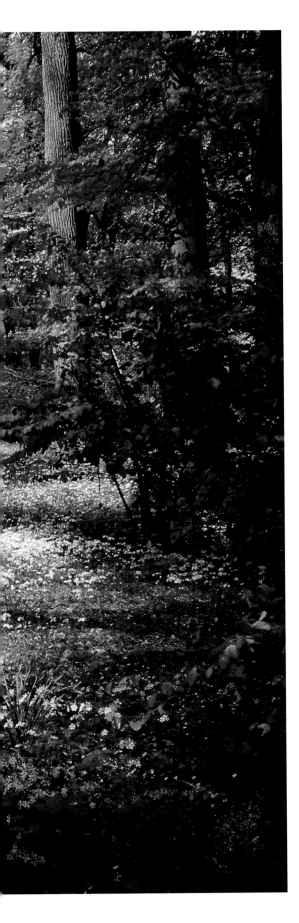

inspiration

The fuel of the creative is inspiration. It is the invisible force that allows one to make things more beautiful than they were before. Inspiration is a powerful form of energy.

I have always found inspiration to be free of charge, and I am amazed that so very few people have the power to absorb any. Like a fine mist enshrouding what you see, inspiration is ever-present, but it is only visible in a positive light. The fine mist of inspiration viewed with the right attitude reveals all the beauty and wonder around us when we become appreciative of details.

As a child, I remember playing with two dried pussy willow buds which I kept in half a walnut shell. In my child's imagination, they were cute little furry animals, safe and happy in their perfect little home. Although I had lots of other toys and friends, it is the pussy willows in the walnut shell I remember most, nearly forty years later.

Children seem born pre-charged with boundless inspiration and are often happier with their own creations than anything money can buy. It is as we grow older that our mind needs constant refueling in order to appreciate, let alone *create* anything.

LEFT Nature's breathtaking contrast in the woodland gardens of Winterthur, Henry Du Pont's estate near Wilmington, Delaware. The delicate, perfumed carpet of native *Phlox divaricata* blankets dappled-lit areas of the hardwood forest.

Seeing beauty is the creative person's top priority. People often make a career out of it. By restructuring one's priorities and giving beauty in nature a higher gear in your life, you are bound to be more inspired about absolutely everything, not just your garden.

Noticing things is what really counts. Like a good detective, the truly inspired notice small details. 'Beauty evidence' is not always obvious. It is the huge water droplets way up inside the gorgeous, brilliant-orange nodding bells of the crown imperial fritillaria (*Fritillaria imperialis*) that are the added mystery and special beauty-gift to be shared only with the observant. These droplets sit unnoticed by most, but they are one of my favorite wonders of nature. I think I like them because nobody knows exactly why they are there, nor what function they serve. Nature wastes nothing, so the mystery carries on.

Making inspired choices is what good gardening really boils down to. Every decision contributes — or takes away. An old clay pot lends a sense of history, a past, to any plant it contains, whereas a new clay pot screams 'just purchased'. What could have been an important source of inspiration becomes merely a functional object.

As in baking a cake or making a flower arrangement, when planting a garden, the result will only be as good as the ingredients. Inspired decisions translate into interesting, if not enthralling, planting and ongoing revamping in the garden. A massive dose of inspiration

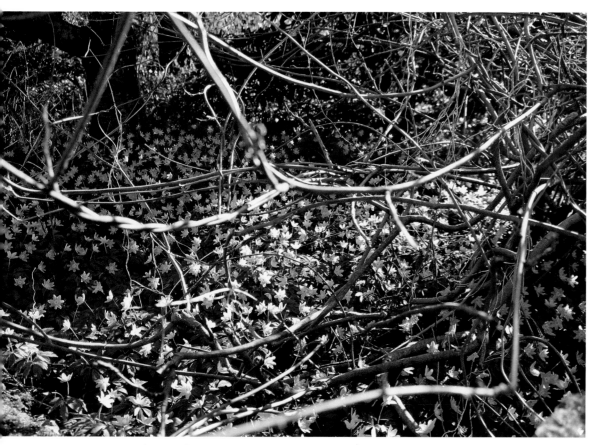

LEFT Only Nature itself could construct this beautiful, protective tangle. *Anemone nemerosa 'Allenii'* is encaged by wisteria vines, creating a stunning vignette.

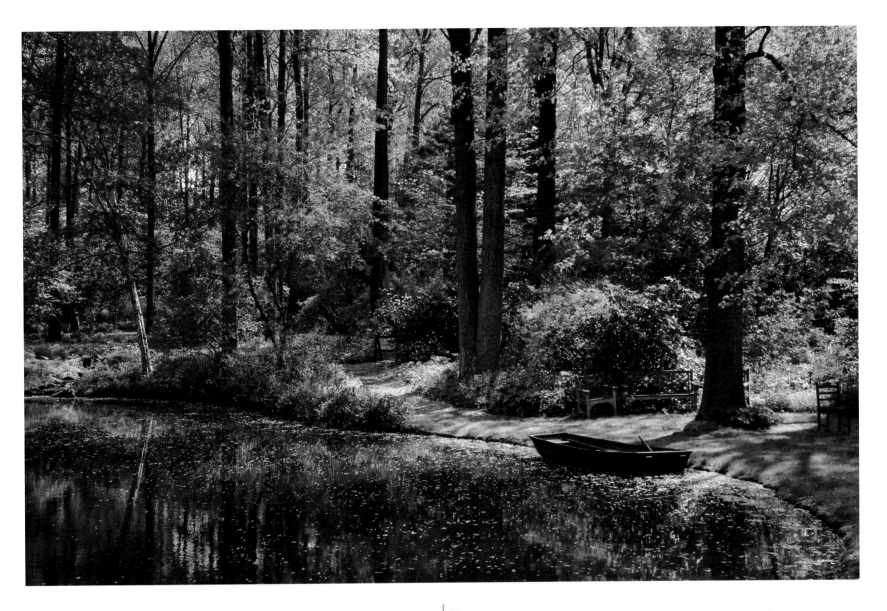

should result in drastic action, no matter how smug one may be about one's outdoor achievements. As these massive doses are very short-lived, never waste them. Be bold and never question inspiration-driven ideas. Timidity results in inactivity and a stagnant or non-existent garden.

Squint your eyes and envision what you are contemplating. If you cannot envision the desired effect, don't begin. You have not connected with the inspired energy supply, and you need to go back and restructure

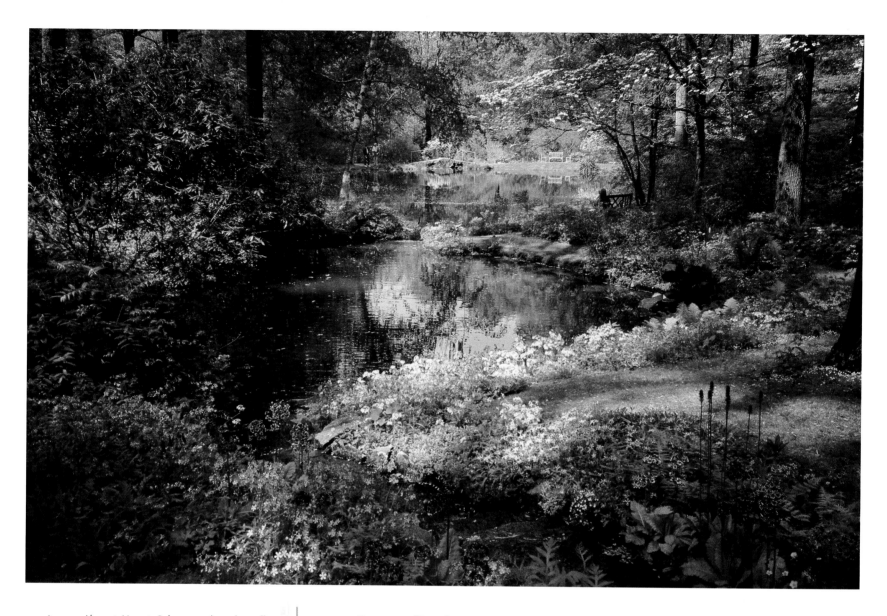

Also at Mount Cuba, a series of small, connected lakes fringed with *Primula japonica* encourages a mental flight, over and into the distance. A small footbridge deep in the picture is the turn-around point for our return flight.

priorities to allow beauty access to take control. The rewards of inspired garden activity are instantly apparent, and you will know immediately whether you did the right thing.

A total lack of inspiration is a sign of laziness. There is simply too much available to deny anybody access. Laziness smothers inspiration and deprives its victims of any sense of wonder by administering a self-defeating dose of itself. Lazy people should not garden because they end up demonstrating their nature publicly.

Be relieved (or be angry), but financial status has no power over beauty access, appreciation or its reward: inspiration. How ironic, but delicious,

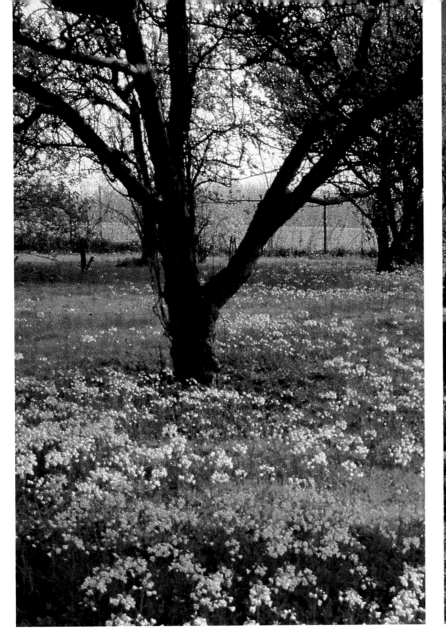

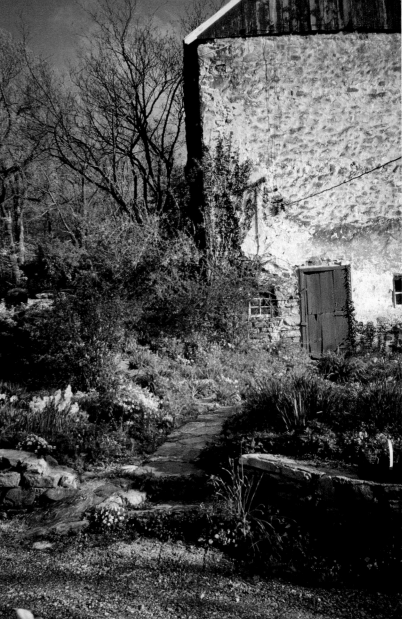

that many of the worst and ugliest gardens around us cost the most. This is what creates a level playing field in gardening, and why we should enjoy the endless supply of pleasure that plants are willing to give us.

Stopping to smell the roses is not going nearly far enough. Stopping and *entering* the roses with your beauty-absorbing sponge of a brain is the way to really enjoy them. It is a sense of communion that only the truly appreciative experience.

Sources of inspiration are everywhere, as inspiration is a very big industry. There are countless magazines, books, even garden videos, but nothing

ABOVE Keeping plantings simple creates an honest picture in the Pennsylvania garden of Joanna Reed. Appropriateness of plant choices maintains a sense of history.

LEFT Native cardamines demonstrate what the concept of naturalizing is all about in this old orchard outside of Cologne, Germany.

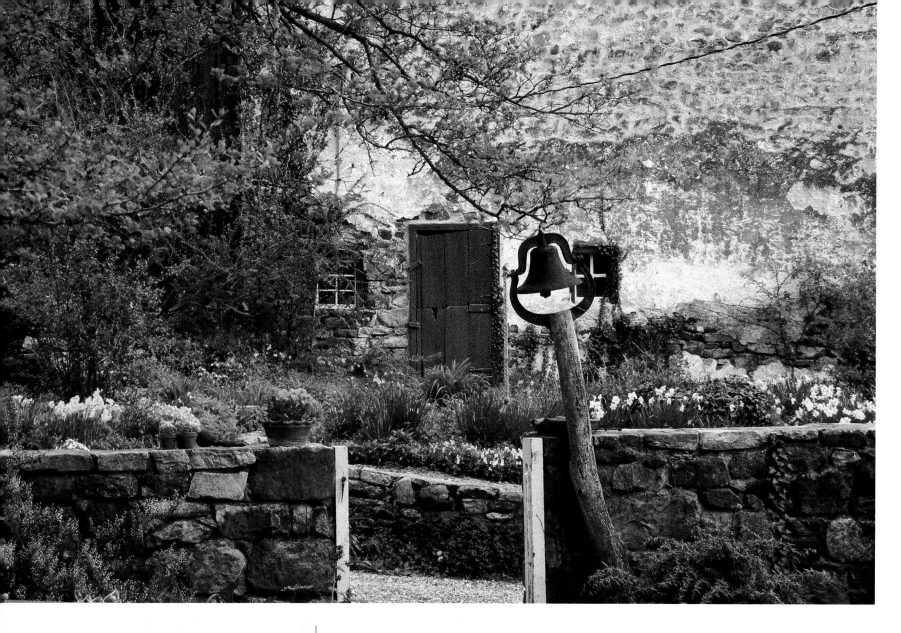

ABOVE Standing in sculptural isolation against the stone barn in Joanna Reed's garden, an old farmyard bell welcomes. Balanced by simple potted pansies in unpretentious pots, the garden entrance point is established and enhanced.

is more inspiring than the real thing — Nature itself. A walk through a botanical garden, untouched woodland or any place where one can get close to plants will open the receptors to absorbing beauty.

It may be more understandable to appreciate a pleasant perfume, because most of us are aware of our sense of smell. But appreciating beauty is not a given. It is a gift. By making the effort to see just a little bit more in everything, you are using this gift, and the more you use it, the more you will get from it. As with a breadmaker or a violin or a home gym, the resulting benefits yield in direct proportion to the effort you make.

the fuel of
the creative
is inspiration

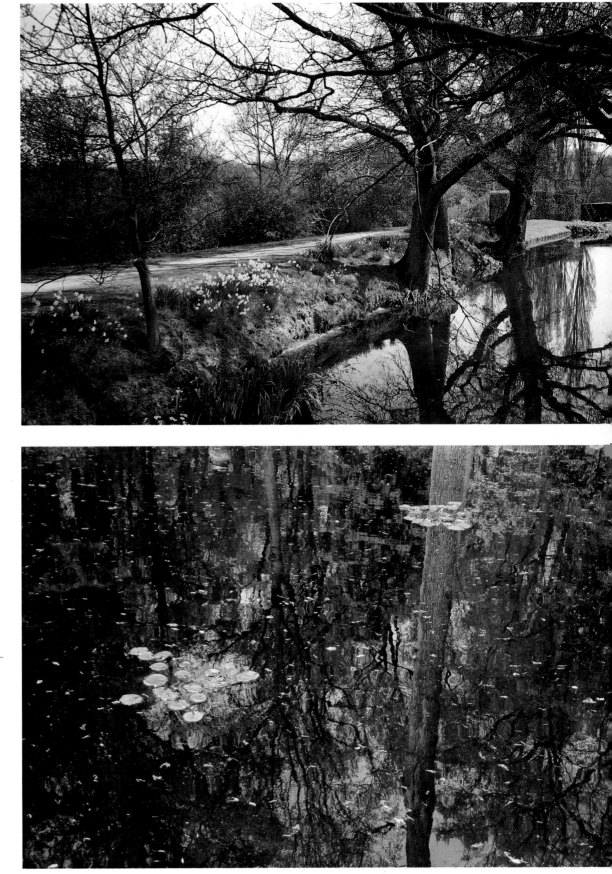

ABOVE The moat at Sissinghurst, in Kent, England, becomes doubly beautiful with the gift of reflection. Trees must enjoy their huge, decorative reflections as much as we do.

RIGHT Beautiful, impossible tapestries wait to be appreciated in still waters. Start looking for them.

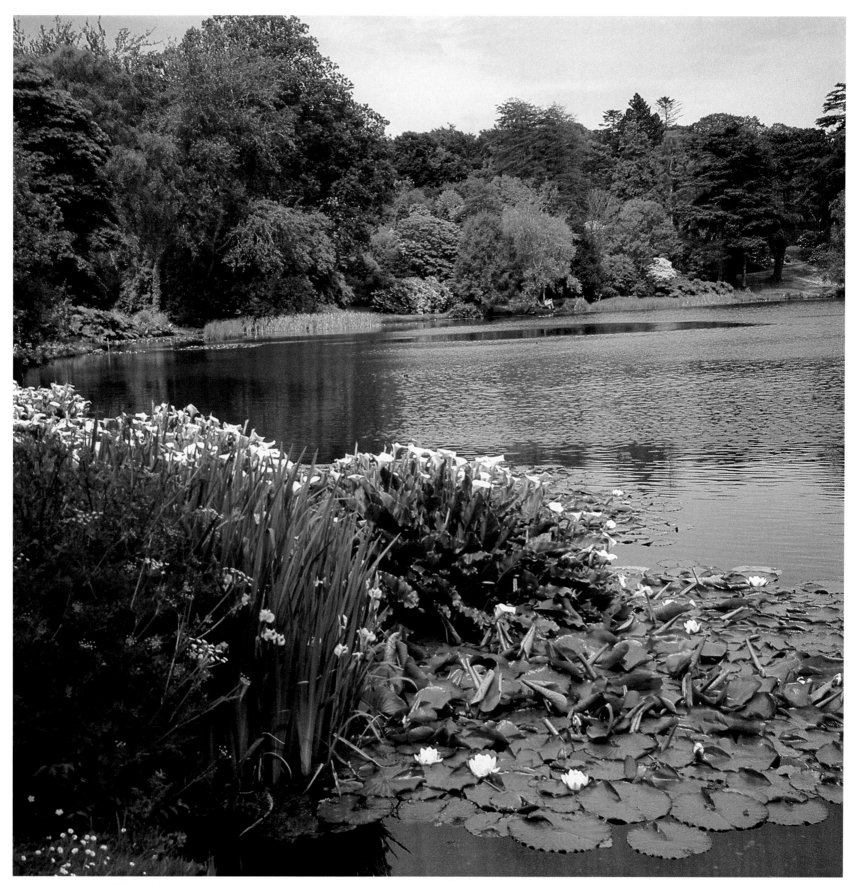

shocking beauty

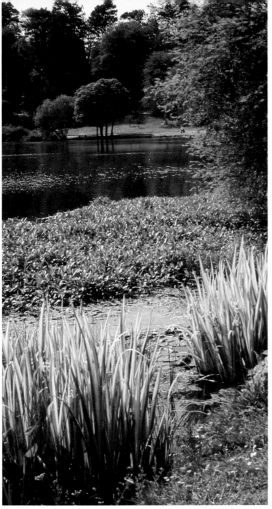

ABOVE Nearby, the variegated water iris (*Iris pseudacorus* 'Variegata') catches the light in its striped foliage and adds dramatic contrast to an otherwise tranquil vista.

RIGHT The same iris happily growing in soil and performing the same task – adding visual punch. Light-catching foliage electrifies this section of the Bellevue Botanic Garden perennial border in Seattle, Washington. Many plants are adaptable to more than one habitat, and by experimentation we are often pleasantly surprised.

LEFT At Mount Stewart In Ireland, masses of calla lilies (*Zantedeschia aethiopica*) bring the landscape right into the water, creating a floating garden and blurring boundaries.

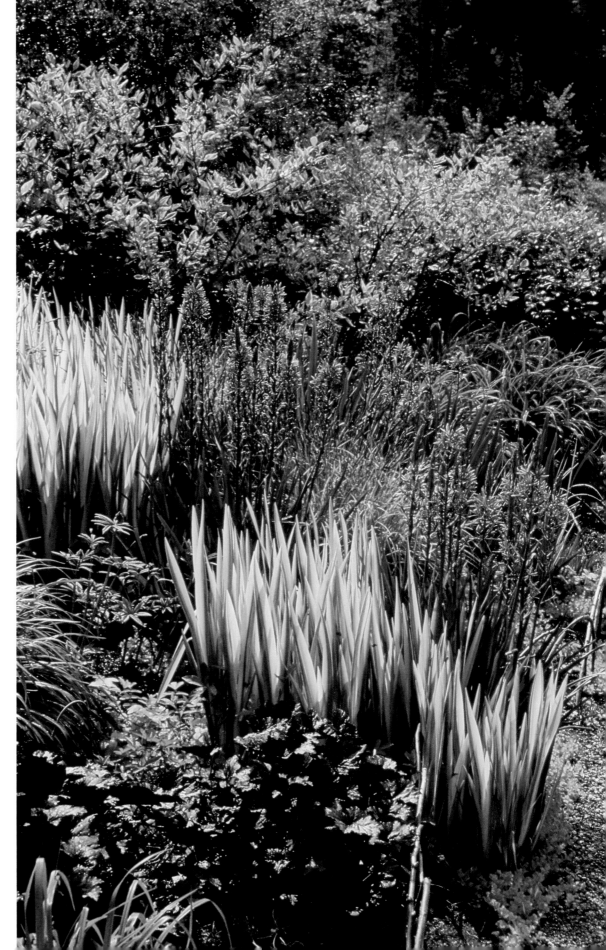

blurring

One of the mind's favorite things is to escape reality. Without needing inebriants, intoxicants or any other evils, gardeners can escape by the very act of indulging their passion. The next step is to enhance the experience.

By clever and deliberate effort, it is possible to improve upon the final vision of a garden by blurring it just a bit. Imagine an Impressionist painting in sharp focus, then imagine it the way it was painted. Which is more beautiful? More memorable? More breathtaking? Planting in soft focus by blurring parts of your garden can create moments of shocking beauty which the eye sees and the mind recognizes.

By planting a scrim using see-through plants, a haze of beauty develops that makes the whole picture much more beautiful. Flowering cherries and plums flower in a mist that delicately filters whatever is visible beyond. Some perennials like *Crambe cordifolia* create a wonderful semi-transparent cloud of flowers rising well above their leafy parts. The chewing-gum purple *Verbena bonariensis* is one of the best perennials for achieving this effect. Very rigid stems over three feet tall rise up in multi-branched thickets topped with purple bits of flowers that blend and blur with anything.

LEFT Poulston Lacey, one of Britain's stately homes, is tied into the landscape by a light haze, making the overall vision more dreamlike.

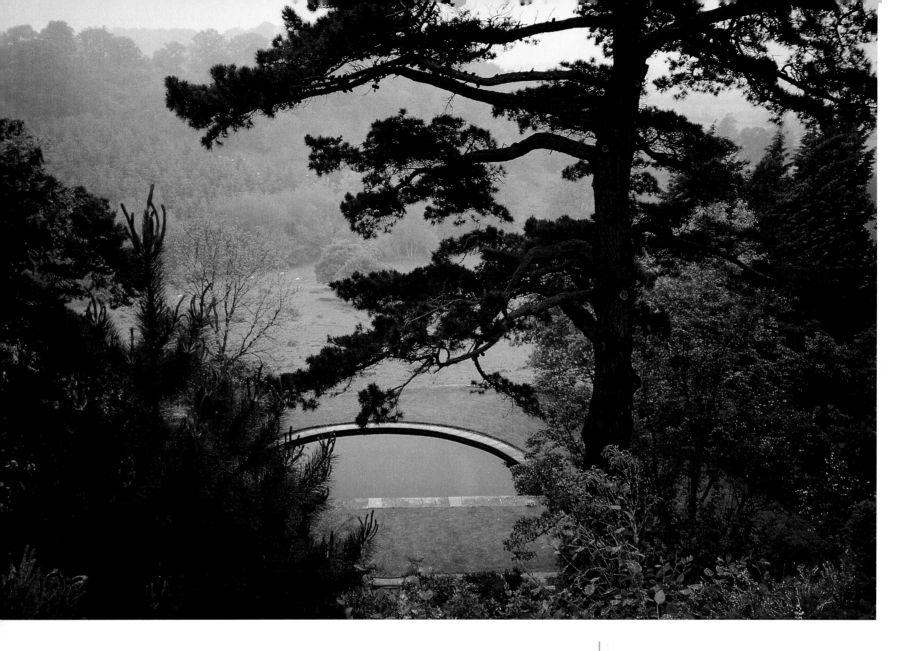

Plants with umbel-like flowers are natural blurrers. Dill (*Anethum grave-olens*) is a wonderful, carefree plant that anyone can grow; it has marvellous umbels of exciting acid-yellow flowers that bounce out at you. A fairly recent introduction for scrim effects is the blackish-mahogany-leafed *Anthriscus sylvestris* 'Ravenswing'. This ravishing sport of a green-leafed weed is garden worthy and in spring produces white flowers in large Queen Anne's Lace-like umbels. Fabulous dark stems and leaves are made to stand out even better by the high contrast of the white flowers on this self-sowing, short-lived biennial.

ABOVE Also in Britain, Kiftsgate Court surprises with a steep cliff leading to a mysterious pool. The carefully pruned pine makes the view even more beautiful by partially obscuring it.

RIGHT Wisteria has the right attitude with its random racemes – perfect for softening the picture in casual settings.

one of the
mind's favorite
things is to
escape reality

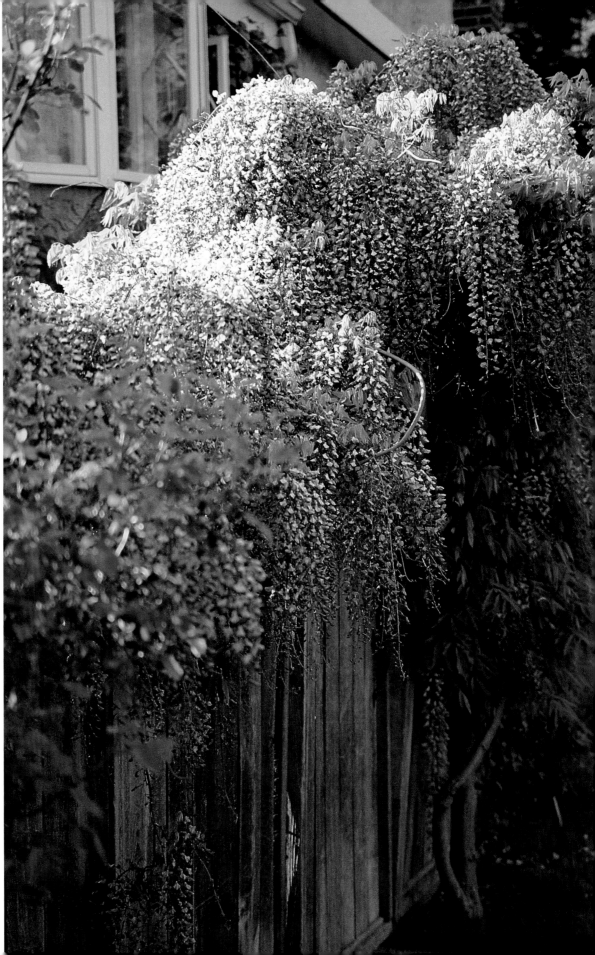

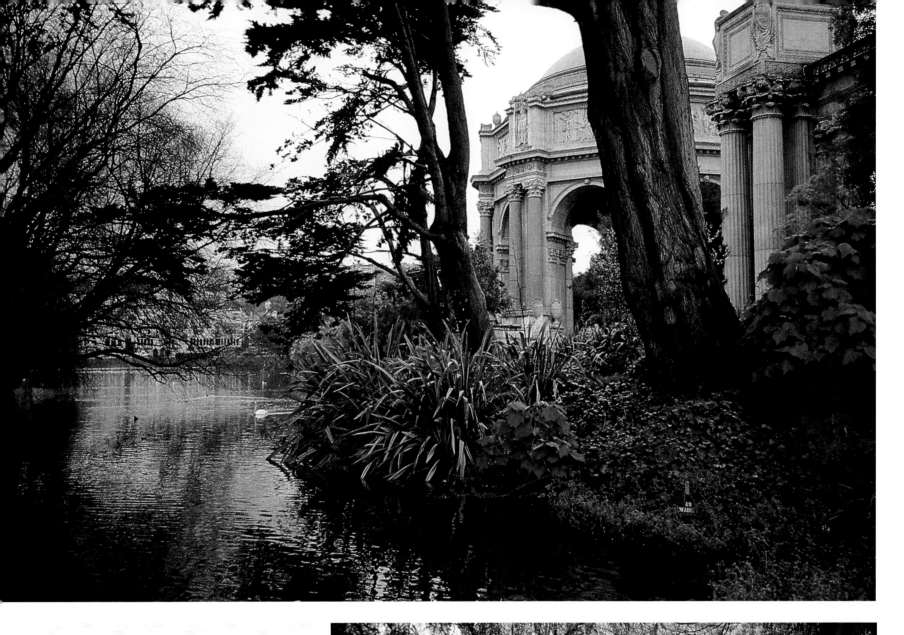

ABOVE & RIGHT In San Francisco, I am always left speechless by the beauty of the Palace of Fine Arts. All lovers of beauty must experience the same sense of awe here.

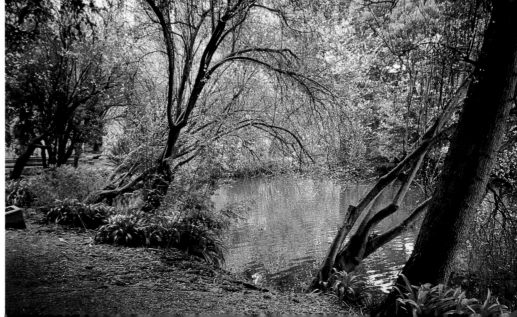

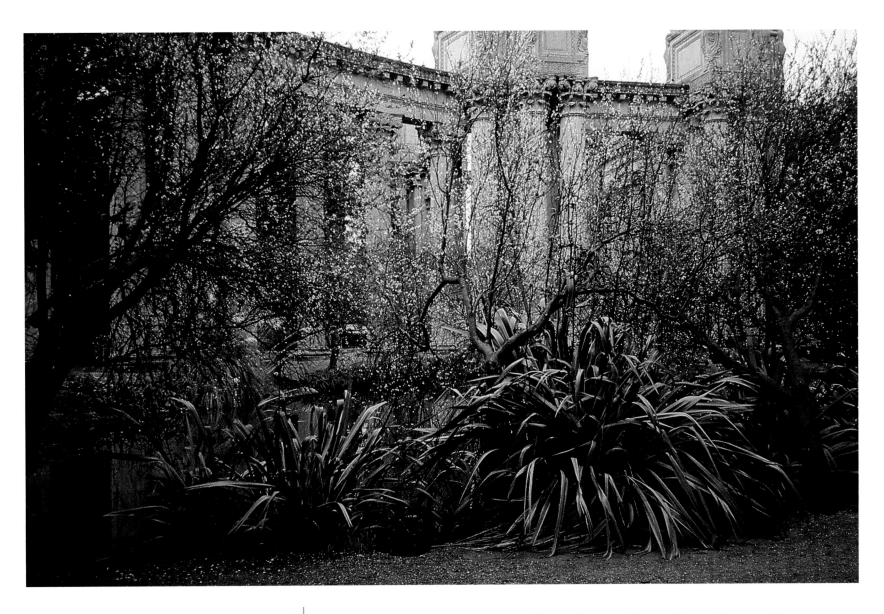

ABOVE Delicate spring blossoms create a dream-like scrim at the Palace of Fine Arts. Bold contrasting foliage of yuccas and phormiums anchors the vision and reminds us that we are still on Earth after all.

There are countless other plants that can be used to soften and haze-over planting. A few that come instantly to mind are the perennial *Patrinia triloba* with its golden-yellow blooms in a gauze of cress-like blossoms; the annuals *Nicotiana sylvestris* in tall, high-drama white and *N. langsdorffii* in cool lime green. Some poppies are naturally delicate and hazy and offer the bonus of having incredibly beautiful nodding Art Nouveau stems and buds. Annual strains selected originally by Sir Cedric Morris in England and now available from seed as Fairy Wings are an easy-to-scatter mingler for existing beds. They bloom in strange, sinister colors including greys and soft, wounded blues.

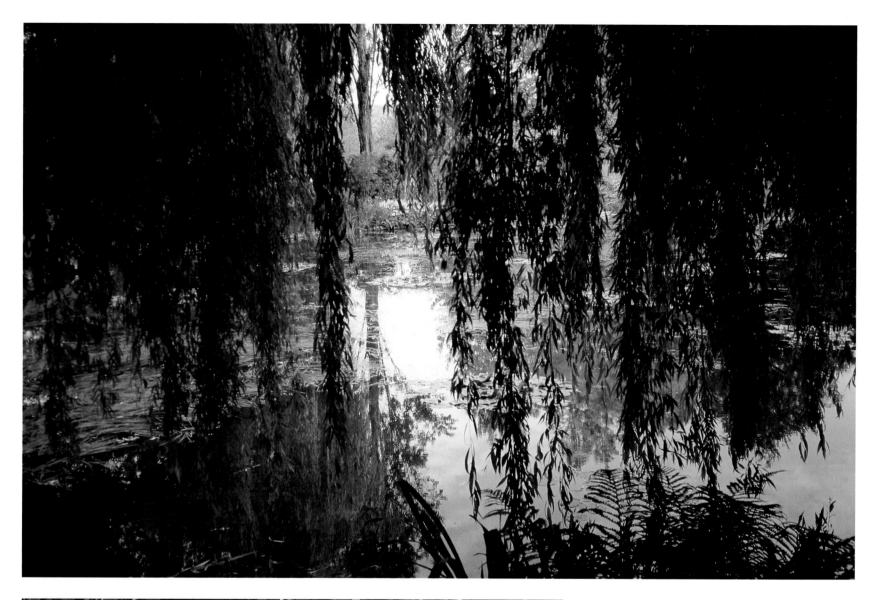

ABOVE At Giverny, Claude Monet's garden in France, a weeping willow curtains the water lily pool. This deliberate beauty vision is living Impressionism.

LEFT The annual quaking grass (Briza maxima) represents rain in a mini-vignette with Japanese irises (Iris ensata cultivar). Magic moments like this are what make a garden memorable.

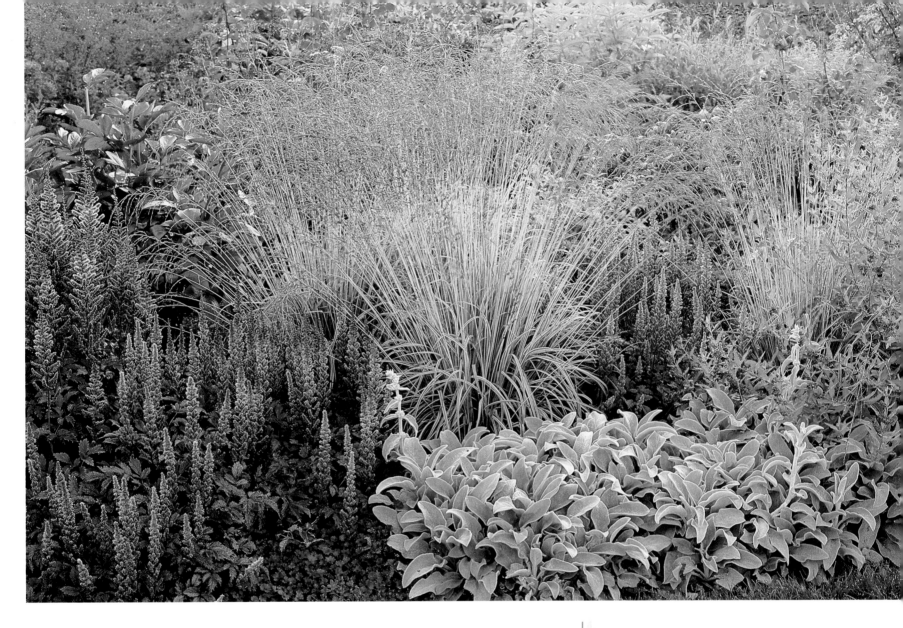

Adding atmosphere to plantings makes the brain happier with the image it processes for us, and that is when we are most satisfied as gardener, artist and creator.

ABOVE *Molinia caerulea* 'Variegata' forms autumn fountains, enlivening this planting of *Astilbe chinensis* and *Stachys byzantina* 'Primrose Heron' at the Bellevue Botanic Garden in Seattle, Washington.

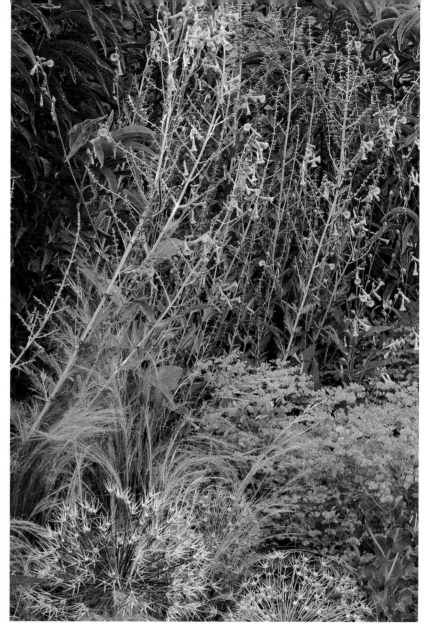

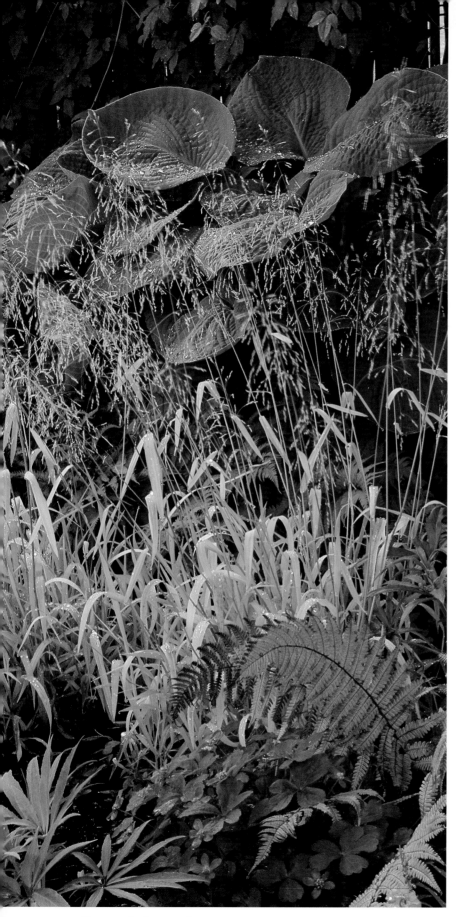

ABOVE *Perovskia atriplicifolia* mingles with the charming, lime green *Nicotiana langsdorffii* in the Seattle garden of Steve Antonow. *Euphorbia stricta, Stipa tenuissima* and *Allium christophii* all have similar densities but remain individually interesting in this beautiful composition.

LEFT Bowle's golden grass *(Milium effusum* 'Aureum') creates hazy interest in Susan Ryley's Victoria, B.C., perennial border. Maximum contrast is achieved in both color and texture with neighboring *Hosta sieboldiana* var. *elegans*.

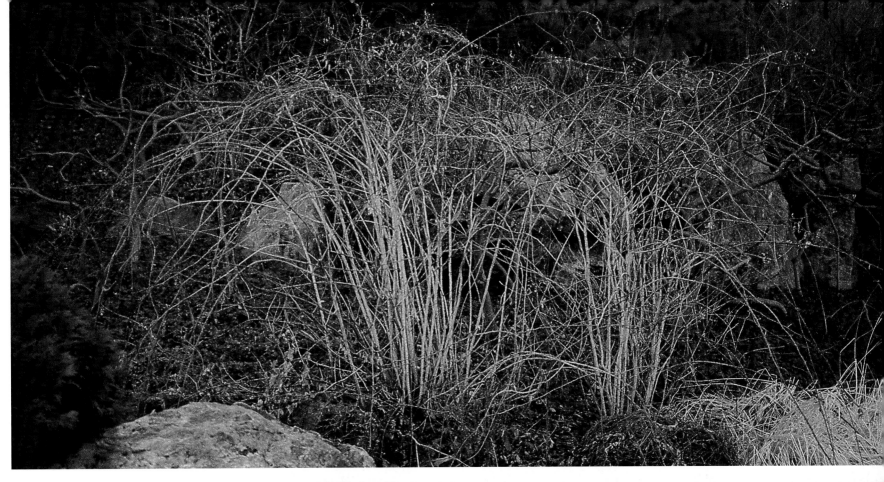

ABOVE The 'Ghost Bramble', *Rubus biflorus,* creates a startling winter vision in the Chicago Botanic Garden. Although invasive, this plant could be used a lot more to create mystery and shock in the winter garden.

RIGHT *Buddleia alternifolia* cascades over *Euphorbia wallichii.* Equally strong in color, these plants complement each other by having totally different growth habits, thus creating interest.

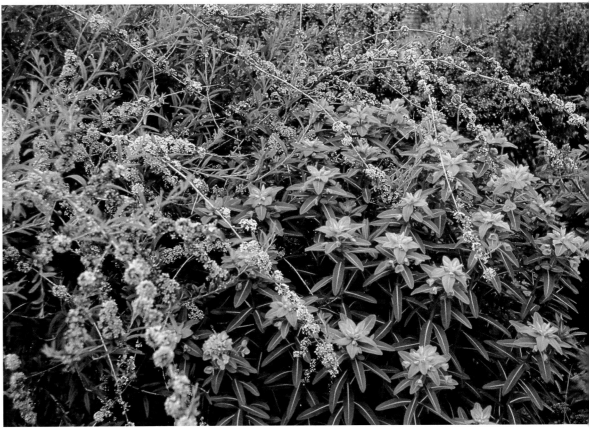

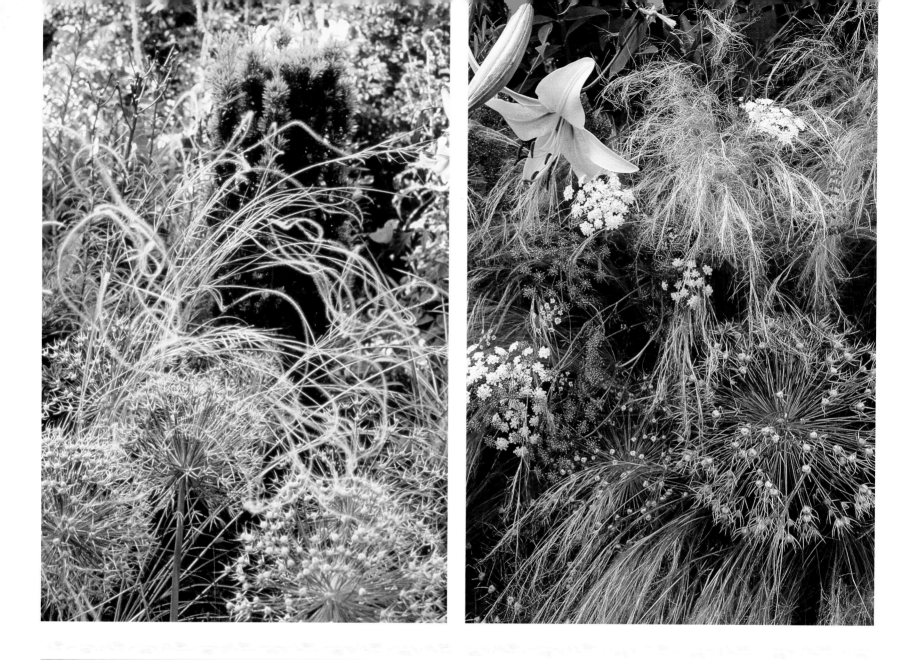

ABOVE LEFT At the Bellevue Botanic Garden in Seattle, intriguing, smoke-like seed heads of *Stipa barbata* and dried globes of *Allium christophii* flaunt Nature's beauty all over again in their dying phase. These ghosts of plants are best left in the garden, not as dried flowers indoors.

ABOVE RIGHT In Steve Antonow's Seattle garden, autumn brings on a sophisticated tangle between *Allium christophii* and *Stipa tenuissima*. Queen Anne's Lace *(Ammi majus)* mingles without interfering.

RIGHT A fairly recent arrival, *Cornus sanguinea* 'Midwinter Fire' is electrifying winter gardens with its stunning bare stems. As colorful as any flowering perennial, this type of dazzle is what gardens need most at an otherwise drab time of year.

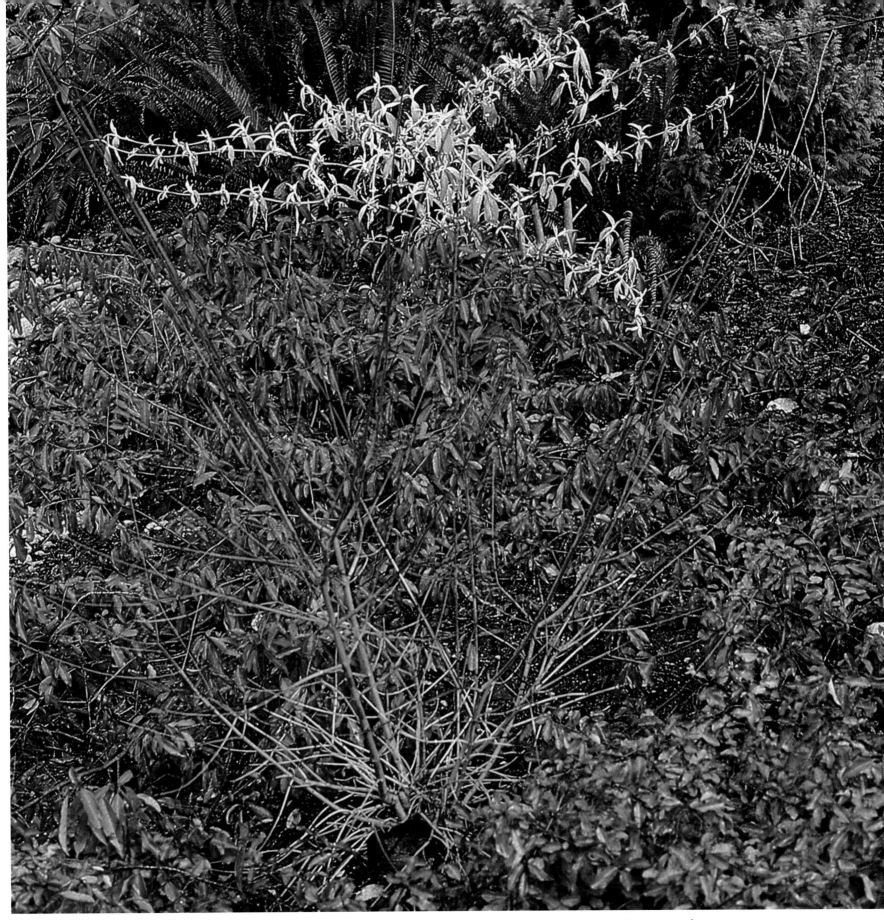

zonal denial

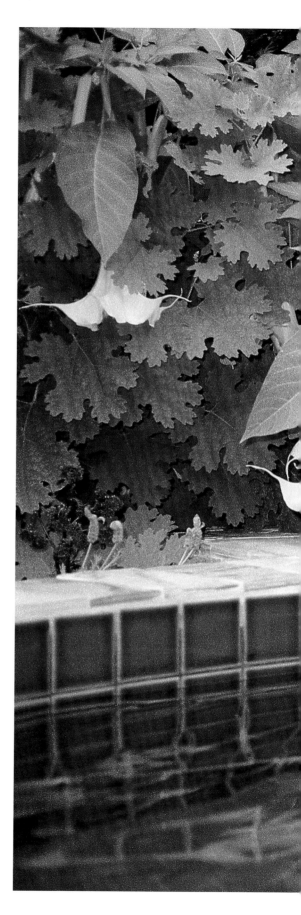

No recent catch-phrase in modern gardening has had greater impact than this one, attributed to Sean Hogan, who found himself living it upon moving to Portland, Oregon, from the San Francisco area. True plant-lovers, we are always trying to grow things that are probably not hardy in our home climate, but are so tempting and delicious that we will plant them anyway. All hope of their survival is based on our refusing to accept the alleged restrictions of our climate. Like a form of bragging, we always add a zone or two to reality in hopes of being able to grow forbidden fruit — plants that need a milder climate than we are given.

The creative gardener relies on new and exciting leaf textures, flower spikes and colors, on over-sized, scale-disorienting plants to add to the mix. Through zonal denial we extend the range of plant selections we can use to achieve dramatic effects unattainable otherwise.

This form of garden escapism goes back to Victorian times at least, when public plantings included masses of cannas, bananas, agaves and other oddments. Like everything else, it has fallen out and now back into fashion. Keen amateurs and cutting-edge plantspeople are already fully involved with

RIGHT Intoxicatingly fragrant trumpets of *Brugmansia versicolor* dangle seductively over my tiled pool, creating a grotto of sensual overload.

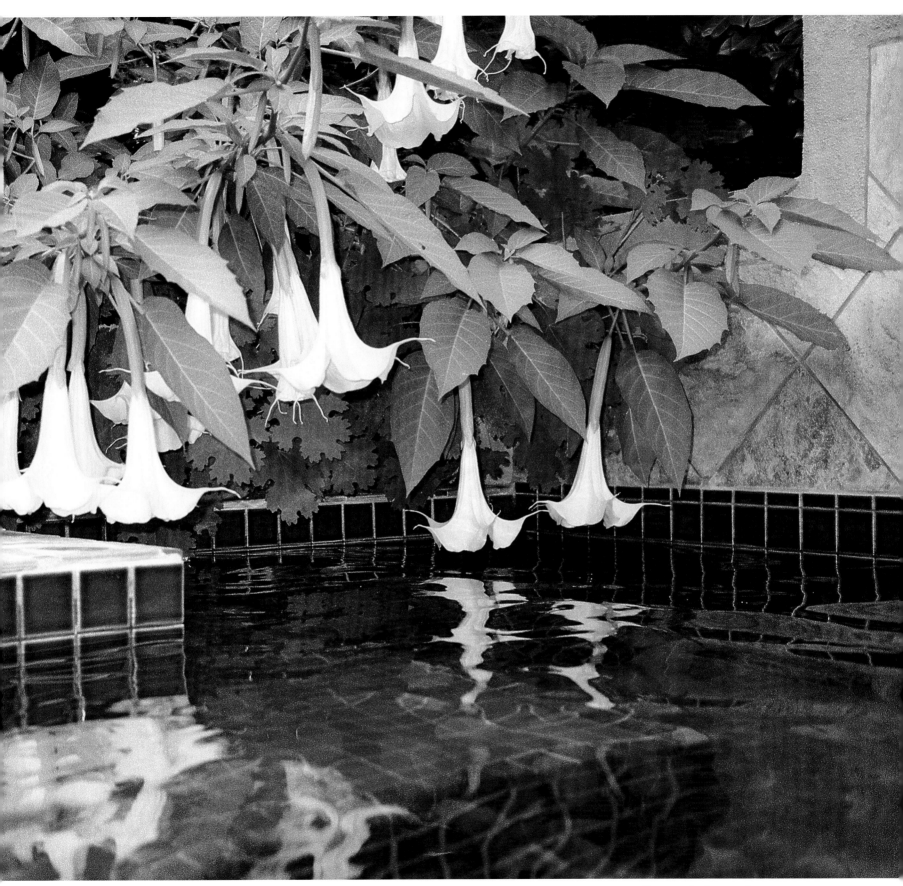

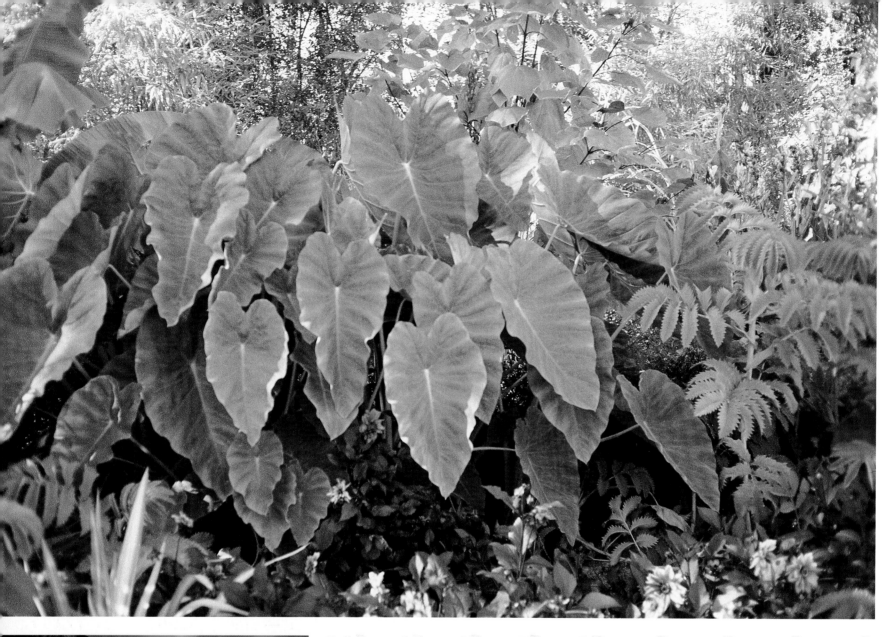

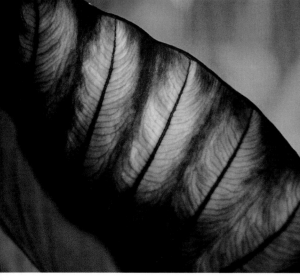

ABOVE *Colocasia esculenta* thrives in Linda Cochran's garden on Bainbridge Island, near Seattle. This form of taro is somewhat hardy if well-mulched. *Melianthus major* (right) is dwarfed by the luxuriant stand but stands out by having glaucous blue foliage and saw-tooth leaf edges. The dwarf dahlia 'Fascination' adds intriguing dark foliage and tolerable pink flowers.

LEFT Photographer Jerry Harpur captures the magic in one aged leaf of *Colocasia esculenta* 'Black Magic' in my garden.

stretching the envelope of what they plant outdoors, and the trend is only getting stronger.

I often wonder who started planting 'Monkey Puzzle' trees (*Araucaria auracana*), native to Chile, all over my city of Vancouver, nearly one hundred years ago. This plant has proven to be hardy at the edge of its tolerance-to-frost zone, even though it is thousands of miles away from home.

Gardening without fear means taking risks that saner heads would never contemplate. Including unexpected, zone-denying plant selections in your garden will never fail to get a reaction.

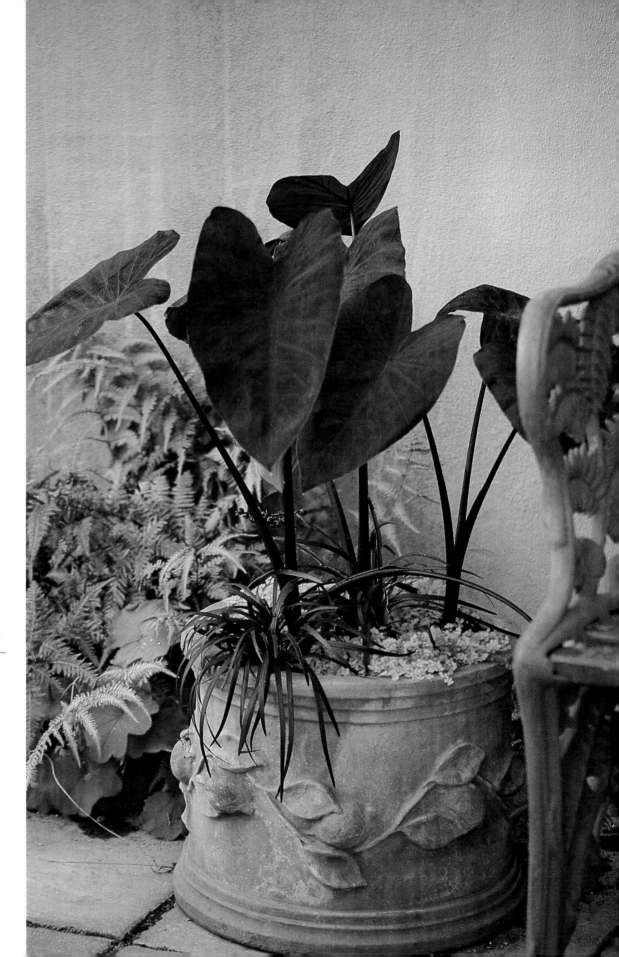

LEFT *Colocasia esculenta* 'Black Magic' deserves up-close appreciation and an inspiring container. I have it in a terra cotta pot from Impruneta, Italy. A touch of black mondo grass, *Ophiopogon planiscapus* 'Nigrescens', reinforces the black theme, and Golden Baby Tears (*Soleirolia soleirolii* 'Aurea') adds contrast.

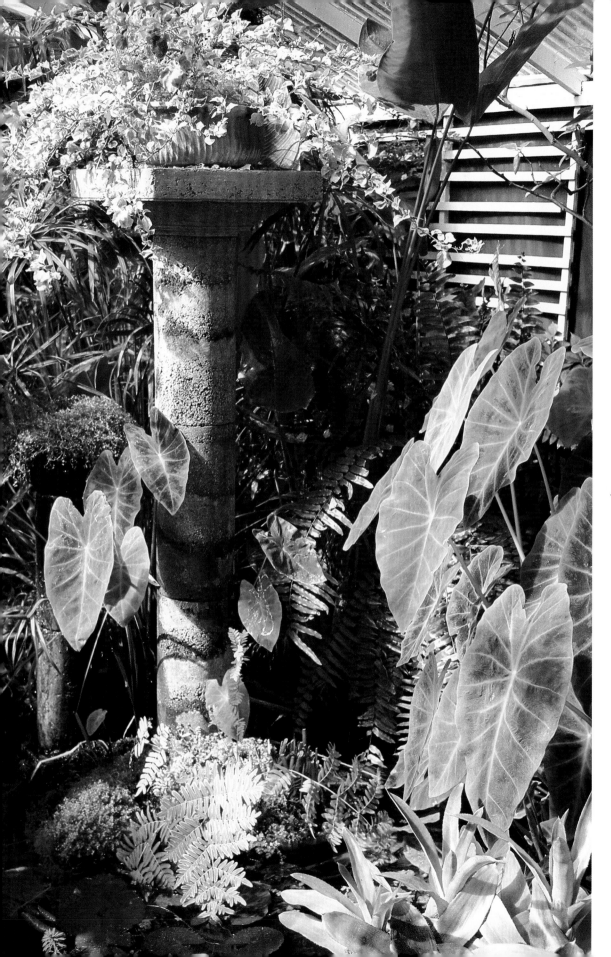

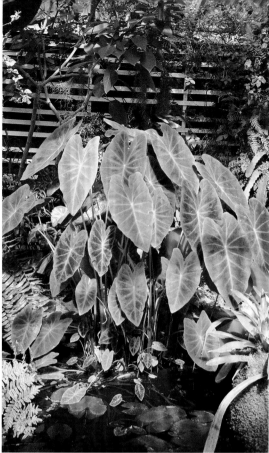

ABOVE & LEFT The Royal Taro, (*Colocasia esculenta* 'Illustris') thrives in a protected garden room at Little and Lewis sculpture garden near Seattle. Those afflicted by zonal denial syndrome would have no problem using this very beautiful taro in the open outdoors as well.

RIGHT A late autumn frost defines and beautifies the spiky drama of my front border. *Yucca recurvifolia*, *Euphorbia characias* and the hardy palm *Trachycarpus fortunei* will all endure much worse than this.

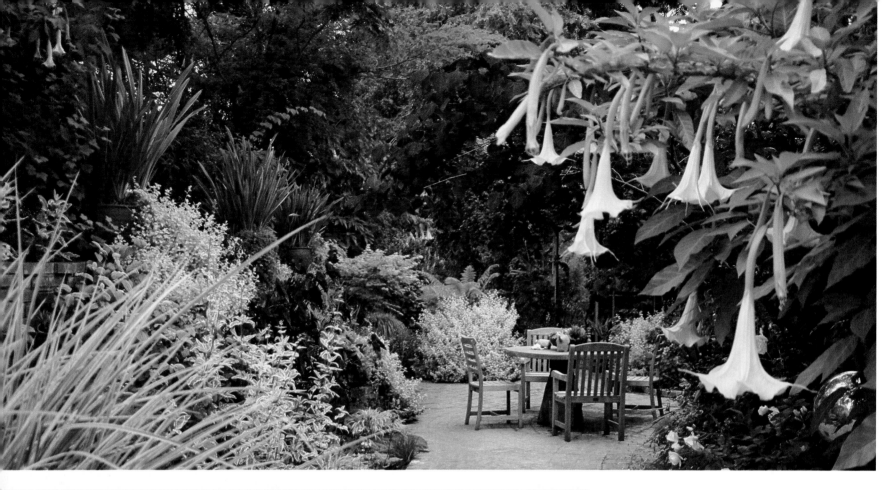

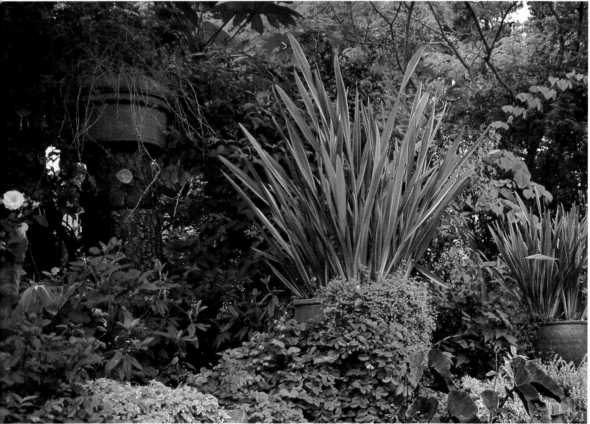

ABOVE The maroon foliage of *Cercis canadensis* 'Forest Pansy' and hanging trumpets of *Brugmansia versicolor* create a sense of enclosure in Bob Clark's Berkeley garden. Dramatic wall pots of upright phormiums add definition and exotic impact to this outdoor room.

LEFT Potted phormiums atop a brick wall brought to life. 'Houseplant' begonias realize their true potential when liberated from tiny indoor pots. The lime green scrambling *Helichrysum petiolare* 'Limelight' mingles with *Cineraria* species and a tsunami of other interesting foliage.

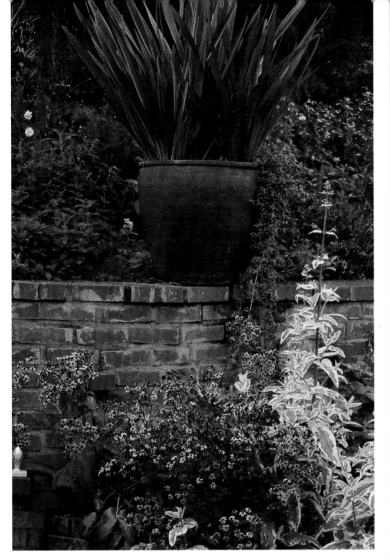

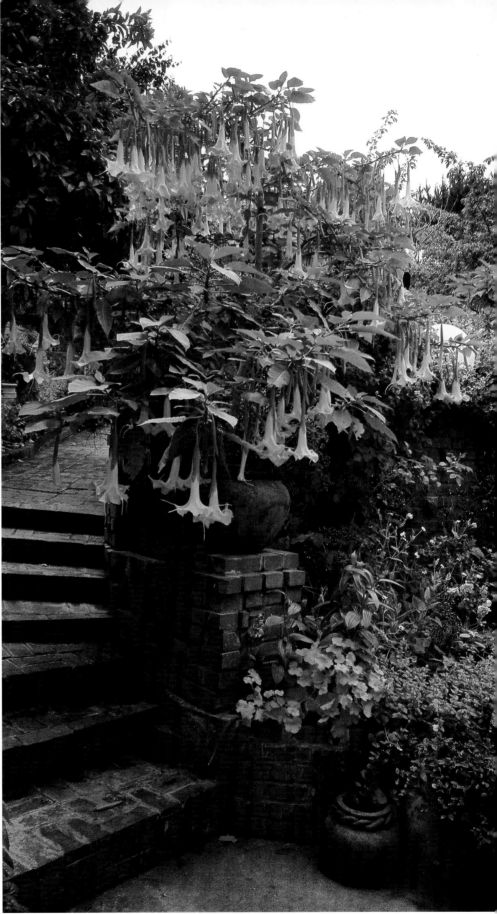

ABOVE *Scrophularia auriculata* 'Variegata' is an easy-to-grow pseudo-exotic. Its highly variegated foliage seems so tropical, yet it is very hardy. Seed-grown cinerarias provide a jolt, as does a carved stone sculpture by Bay area artist Marcia Donahue.

RIGHT By keeping it well-fed and vigilantly watered, Bob Clark's potted *Brugmansia* thrives and seduces visitors to venture up the brick stairs.

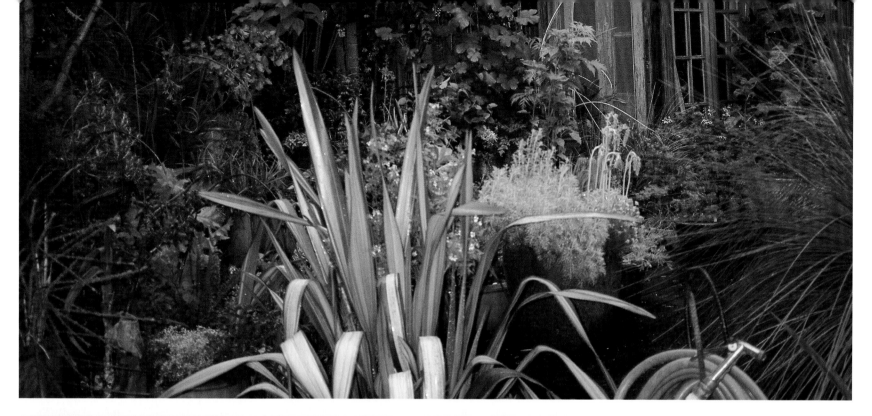

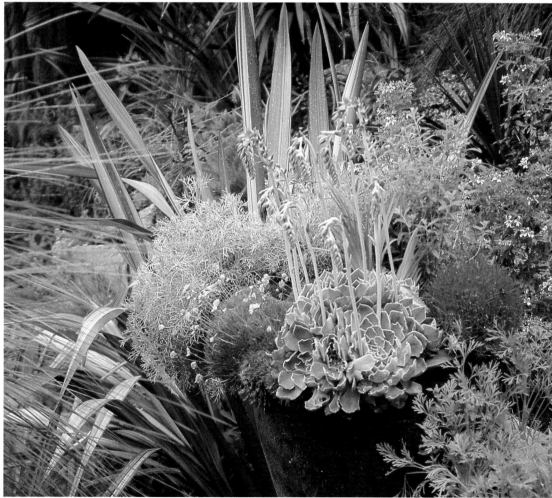

ABOVE & LEFT The gorgeous spears of *Phormium* foliage add a new dimension to Roger Raiche's pot groupings in his Berkeley garden. Colder-climate gardeners can create the same effect by using potted examples and over-wintering them indoors.

RIGHT Lush, bold *Phormium* foliage transforms this garden bed. Powerful in leaf shape and color, such a plant grabs our attention at once. The contrasting *Elaeagnus* x *ebbingei* 'Gilt Edge' is made more conspicuous and desirable by association with a plant with which it has nothing in common.

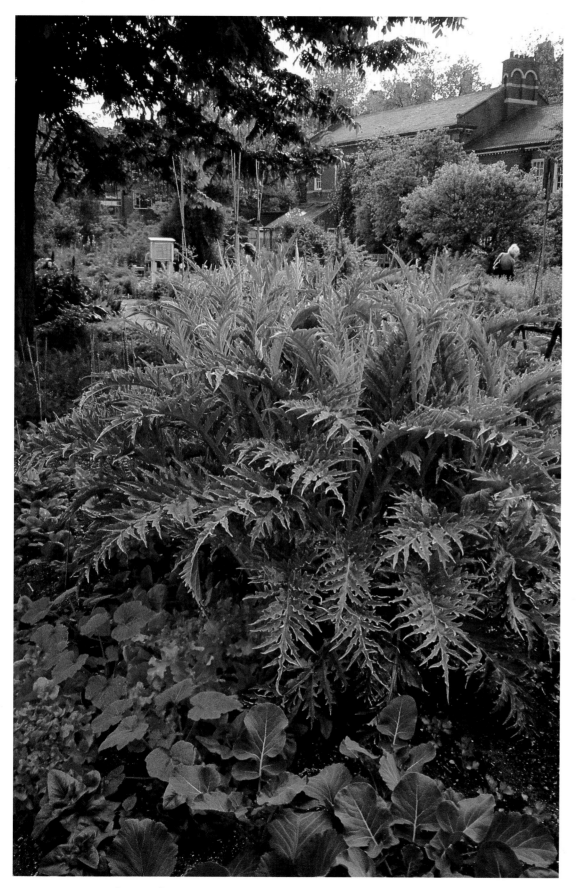

gardening
without fear
means taking
risks that
saner heads
would never
contemplate

LEFT The cardoon, *Cynara cardunculus*, produces luxuriant silver foliage and is not even tropical. Use it for big-time drama in a sunny, well-drained spot.

ABOVE This purple-infused form of *Melianthus major* was spotted by a sharp-eyed California nurseryman in a batch of seedlings. We must always be on the lookout for oddballs that show up when and where they are least expected. Often this is where the best new plants come from.

RIGHT The saw-tooth leaves of *Melianthus major* really do smell like peanut butter if bruised or even touched. I dislike this smell so much I no longer grow this plant!

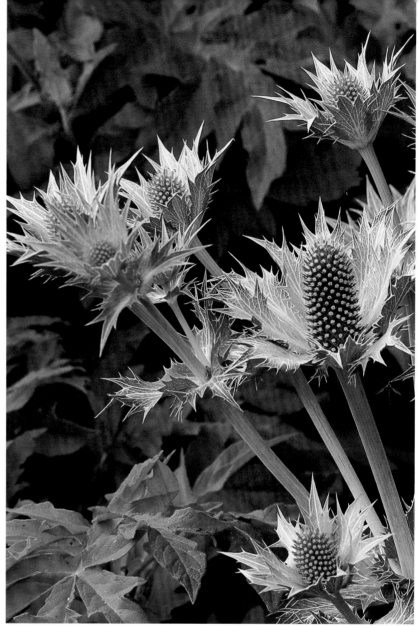

ABOVE Eryngium giganteum has a protea-like exoticness about it. A hardy, sun-loving perennial, it self-sows unexpectedly and is a potential candidate for theatrical, tropical charade planting schemes.

LEFT The recently introduced *Plectranthus argentatus* 'Longwood Silver' deserves long-term popularity. Trouble-free and gorgeous anywhere, the celadon-green foliage is covered in soft, silvery velvet hairs that invite stroking. Pale lavender flowers appear on long stalks at branch tips in late summer, adding even more beauty to this true winner.

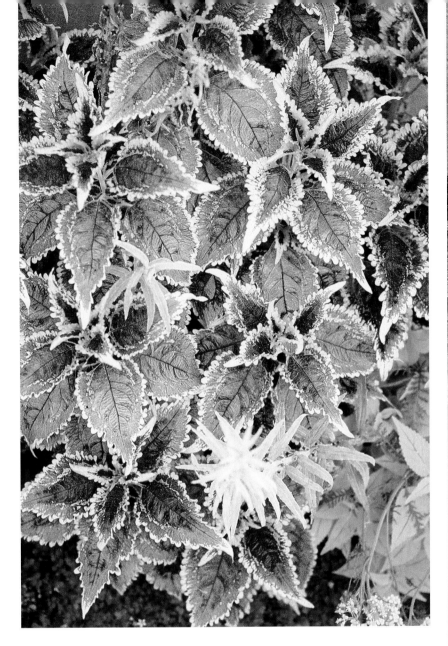

ABOVE. Coleus 'El Brighto' dazzles me with its ever-changing foliage concepts. Here it is in an orange phase, which will be perfect with the *Oenothera versicolor* 'Sunset Boulevard' I planted with it. The Oenothera's rusty-peach blooms will emerge atop its grey-green branches in a botanical surprise.

RIGHT Coleus 'Coral Glo' reacts to light levels. In darker, rainier June, I love its blackness. In hotter, sunnier July, I see how it got its name as it lightens up and takes on a glow, proving to me that plants 'tan', just like people do.

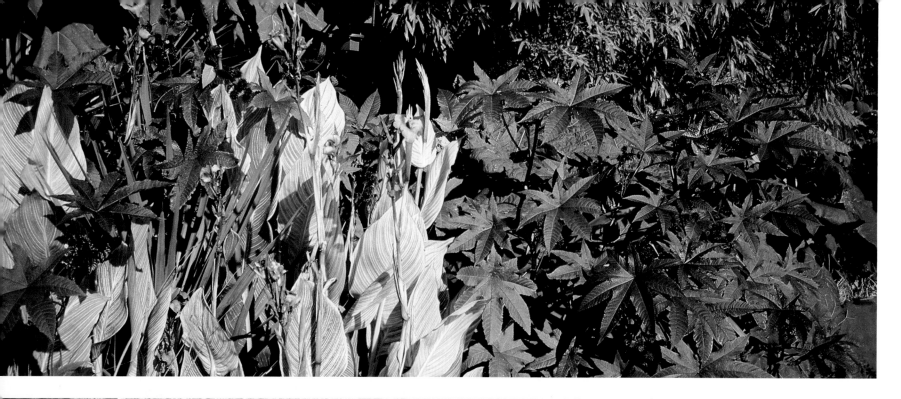

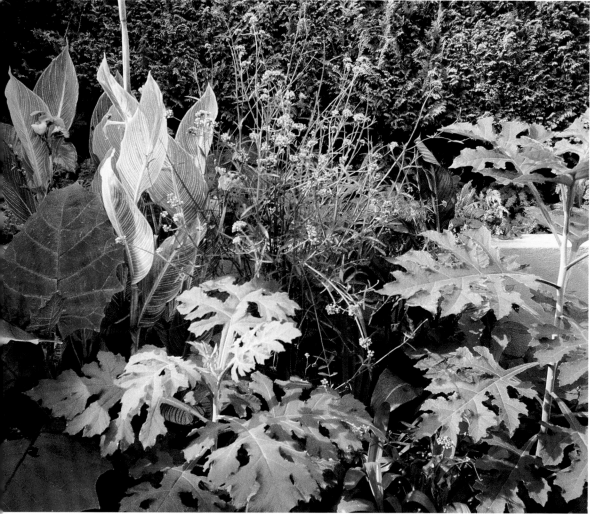

ABOVE The Castor Oil Bean, *Ricinus communis* 'Carmencita', is easy to grow from seed and provides inexpensive, bold effects for bedding out. *Canna* 'Bengal Tiger' is readily available and benefits by having totally different foliage shape, color and flowers from its neighbor in this garden by Seattlite Ben Hammontree.

LEFT A melange of kooky foliage in my own garden includes (from l. to r.) *Coleus* 'Coral Glo', *Solanum quitoense* with huge purply-velvet leaves, *Canna* 'Striped Beauty' and *Verbesina turbacensis* with softly felted stems and enormous, purple-veined leaves. Recently arrived from Mexico, it eventually reached six feet in height and showed no sign of blooming before severe frost claimed it.

RIGHT. The stunning variegated *Canna* 'Phaisson' enlivens an area of my terrace. I brought 'Peach Cheeks' marguerite from England and am wild about it with a self-sown *Euphorbia dulcis* 'Chameleon' in a large oval terra cotta pot, 'Firetail', *Polygonum amplexicaule*, heats things up under my tropical-looking but very hardy *Aralia elata* 'Variegata'.

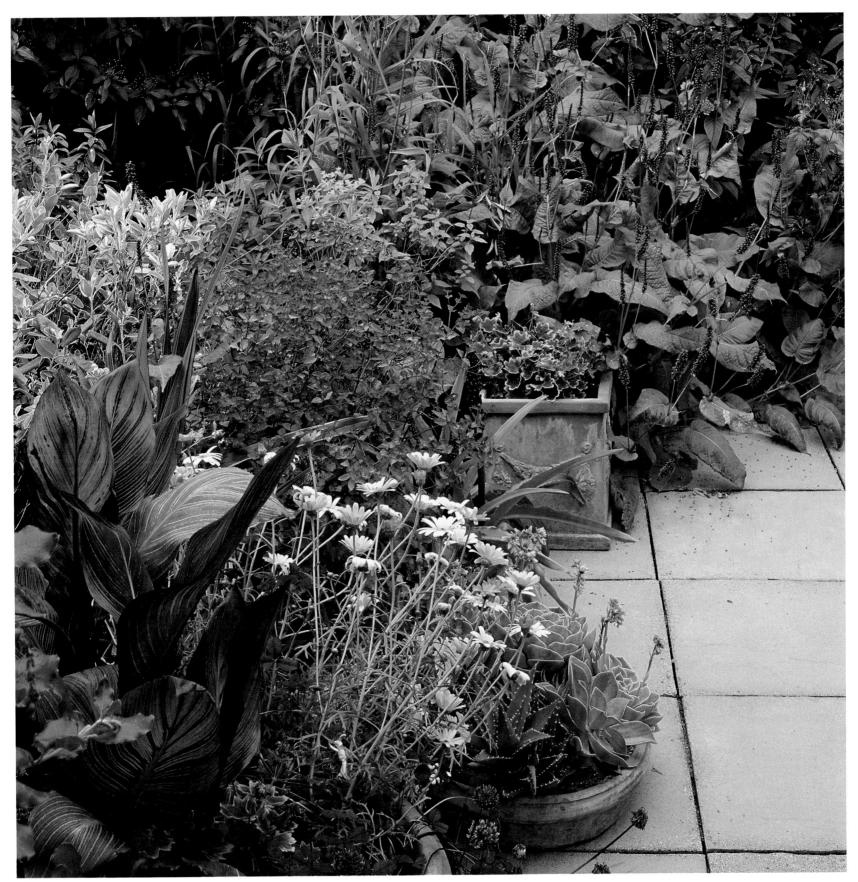

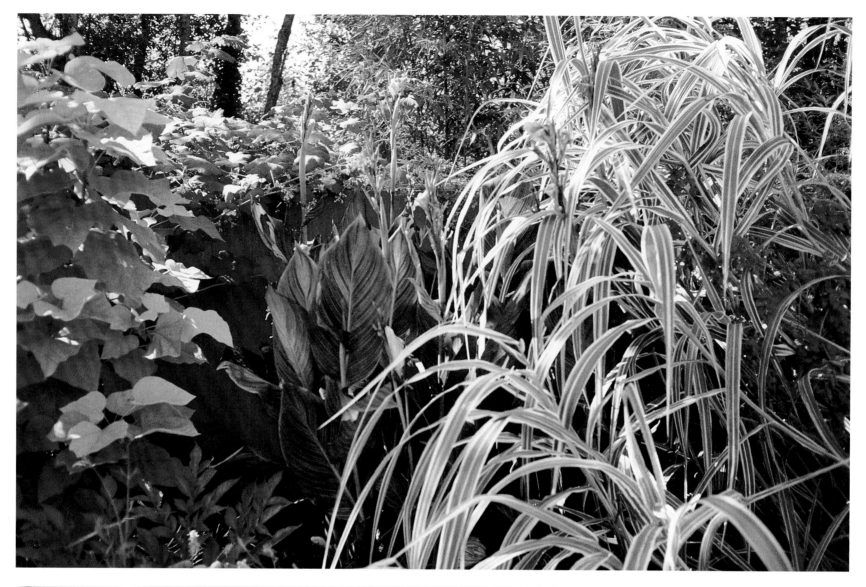

ABOVE A bold move in Linda Cochrane's Bainbridge Island garden near Seattle. The golden-leaved *Catalpa bignonioides* 'Aurea' receives even more visual power by feeding from the stunning blue wall behind it. Lighter colors always win. *Canna* 'Phaisson' and *Arundo donax* 'Variegata' are both interesting on their own and strong enough to compete visually with this powerhouse planting.

LEFT Detail of *Canna* 'Phaisson'

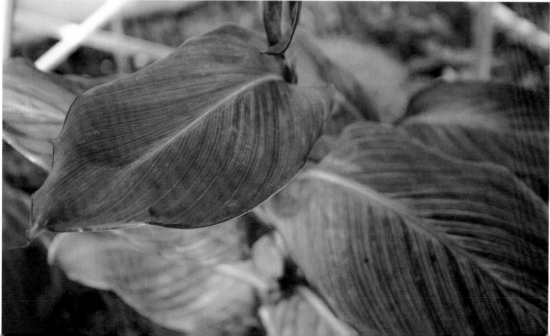

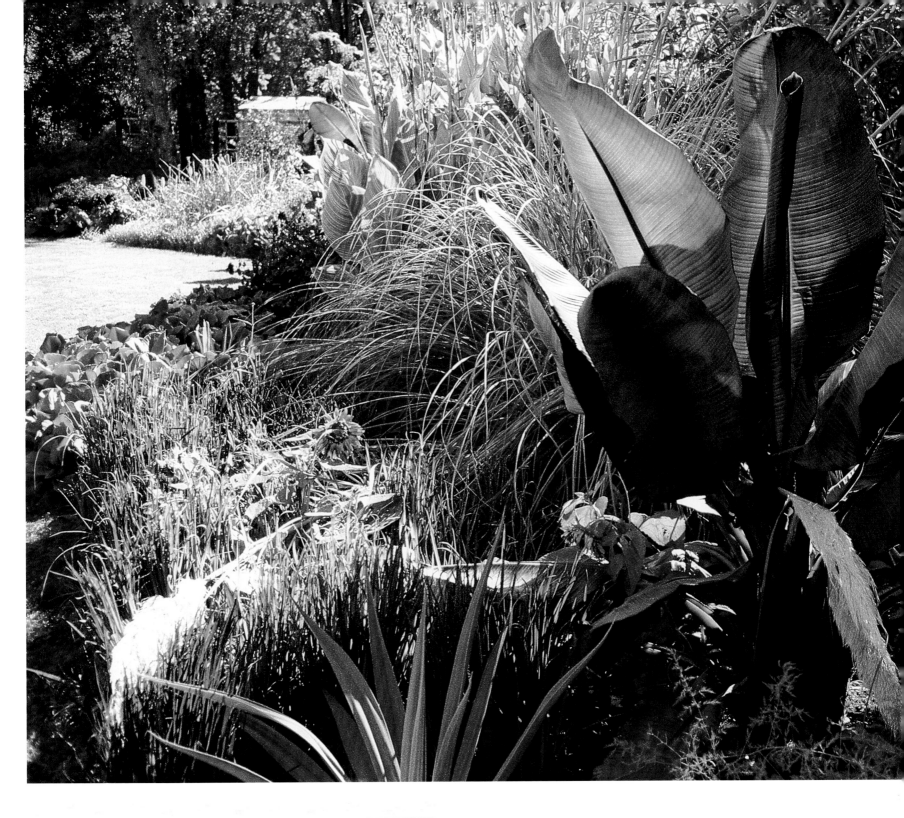

ABOVE *Ensete ventricosum* 'Maurelii', the red-leaved banana, packs a powerful punch of mega-drama into Linda Cochran's grassy border. Blood grass, *Imperata cylindrica* 'Rubra', echoes the redness of the banana, and a subtle sense of belonging is established.

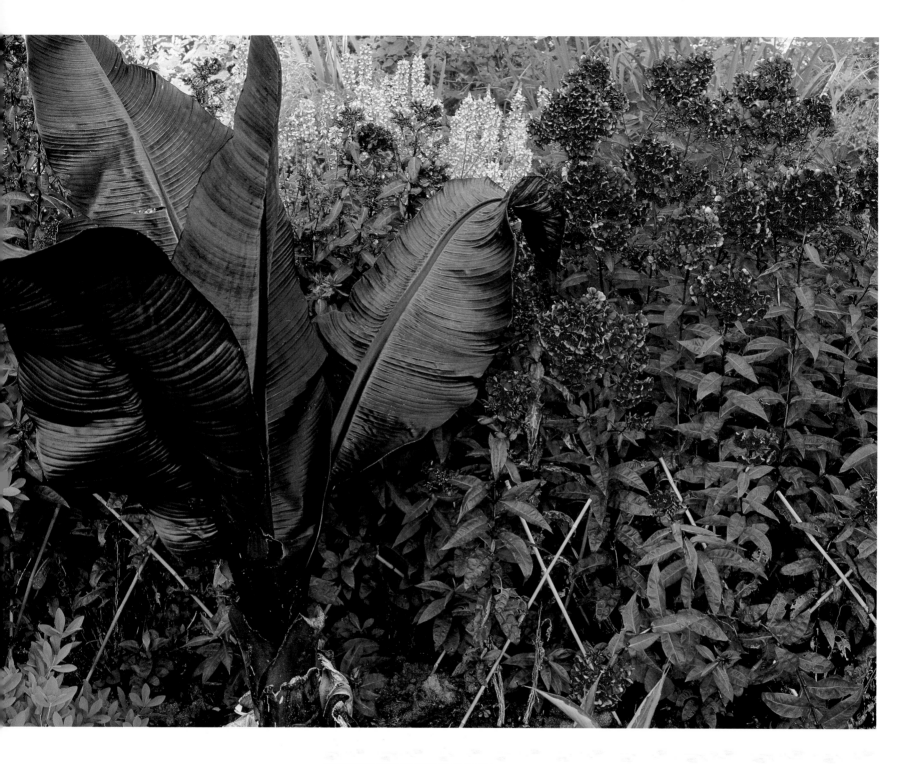

ABOVE Magical reflections of neighboring color allows *Ensete ventricosum* 'Maurelii' to take on fabulous magenta tones. This enhancement of existing color is a garden trick we have learned from the fashion industry.

RIGHT At Heronswood Nursery, in Kingston, Washington, an escape to a tropical island awaits garden visitors. The hardy banana *Musa basjoo* thrives in a woodland clearing mini-lake. Here, zonal denial meets Gilligan's Island.

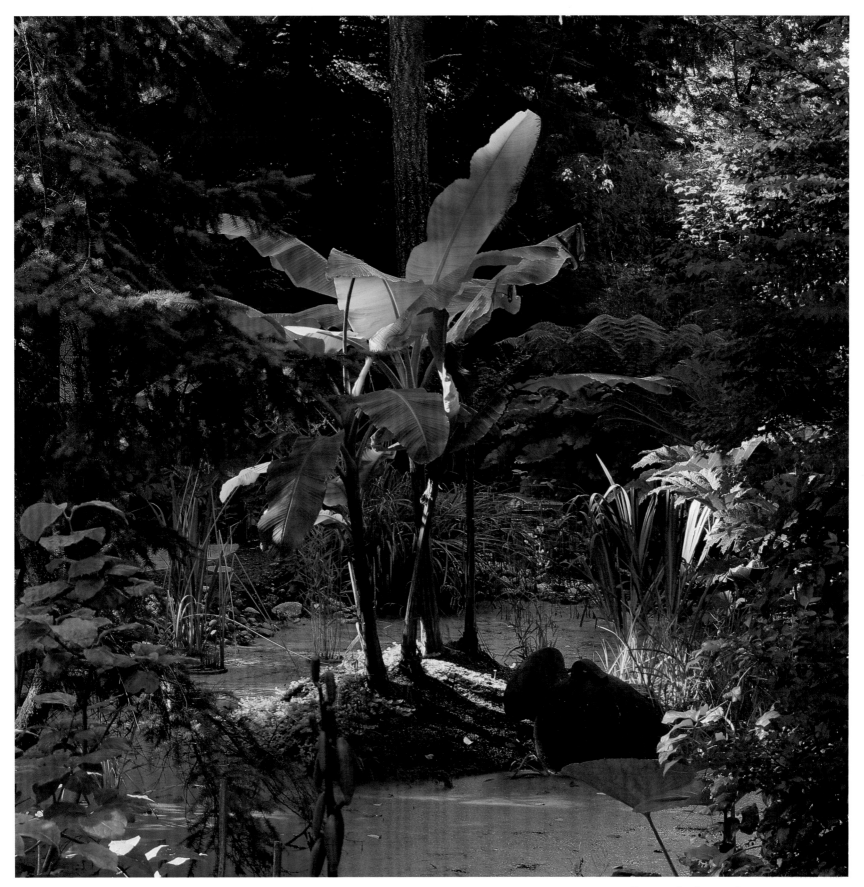

good neighbors

The most important aspect of planting is the selection of plants that will not only succeed but also look terrific together. This takes as much experimentation as it does knowledge. Creating tapestries of plant material means leaving no bare earth exposed to break the rhythm of flowers and foliage — no easy task.

First, plants that are to reside together must be expected to receive the same treatment, levels of maintenance and devotion. Temperamental treasures cannot be expected to thrive if mixed in with regular plantings. Instead, group them in prominent, star positions where they will not get lost or disappear.

Because it is instant glamor, instant beauty that we want, it is very tempting to crowd too tightly. Plants are accustomed to competition, and the strong really do survive. So, I say, plant a little tighter. Feel a bit guilty. By the time anything goes terribly wrong it is usually season's end and time to re-think anyway. At least by then your plants will be substantially bigger and maybe even dividable. Planting heavy always looks better than trying to explain what your vision was meant to be.

RIGHT A blinding sea of *Lysimachia nummularia* 'Aurea' is punctuated with *Iris sibirica* foliage. When in bloom, the iris will repeat the shade of blue of the *Ajuga reptans* flowers. Three common, easy-to-grow plants smartly combined in the Bellevue Botanic Garden perennial border in Seattle.

Tapestry effects range from the up close and amazing to the grand sweep and breathtaking. Either way, the harmonies created by texture and color depend on repetition and contrast to be memorable. By repeating a plant periodically, a confidence comes through, as if you are saying to the observer, "I *know*." The eye uses repeated plants as markers, and thus an area becomes defined. By including contrast in a planting, neighboring plants are made more noticeable. This is a good way to draw attention to a favorite plant: surround it with contrasting, lower-growing neighbors.

LEFT A delicate balance of foliage effects using *Lonicera nitida* 'Baggesen's Gold' to cascade lightly over *Lamium maculatum* 'White Nancy'. Because both plants are evergreen, this combo maintains year-round interest.

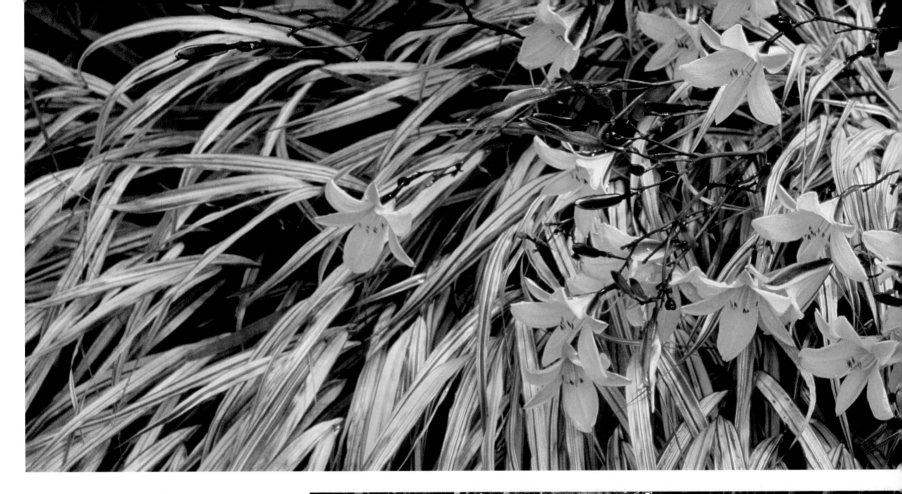

ABOVE Two plants combine to create one effect. The outstanding grass *Hakonechloa macra* 'Aureola' finds itself in bloom by 'borrowing' flowers from *Hemerocallis* 'Golden Chimes'. The well-chosen daylily is refined and elegant, whereas most varieties would visually overpower this scene.

RIGHT Foliages of contrasting shapes create visual interest and get our attention. At Filoli, near San Francisco, *Acanthus mollis*'s bold, scalloped jaggedness holds its own against the rigid vertical uprising of *Phormium tenax*.

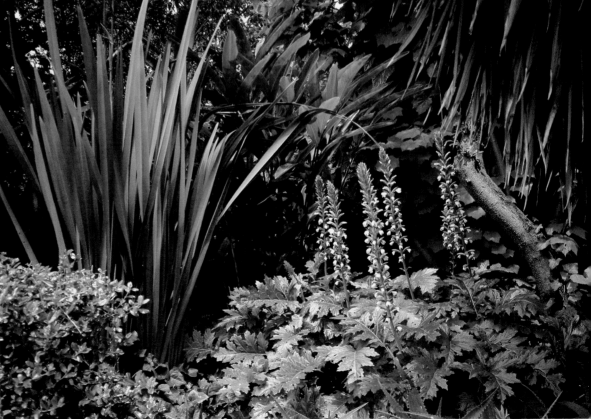

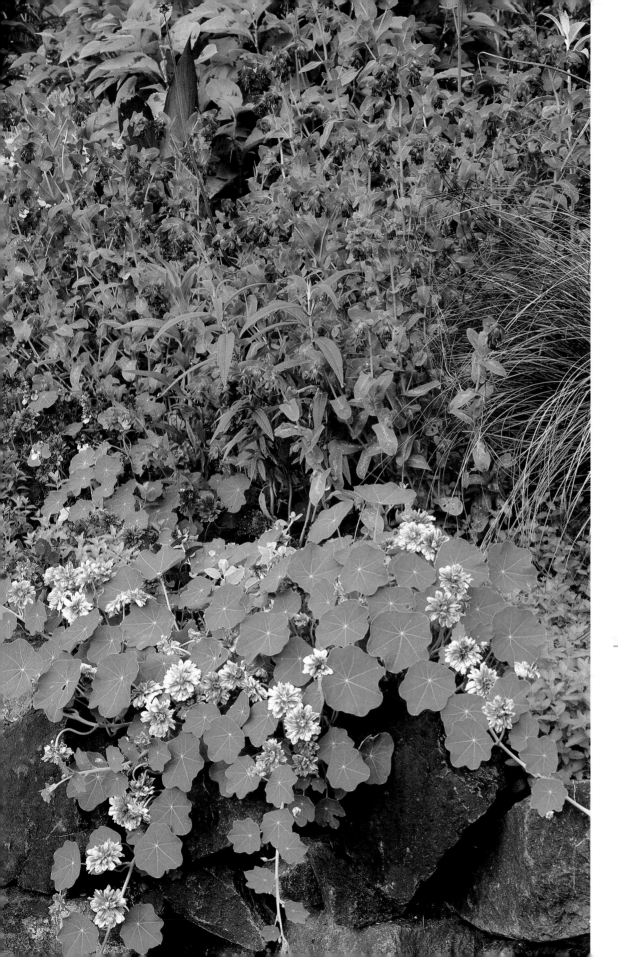

Solid plantings look better if they also have a broken surface. Avoid flatness and vary heights as much as you dare. Tallest plants can be used right at the front once in a while. They need not be always in the back. By creating a bumpiness, things look more natural, and plants will mingle and use each other for support. Low areas or dips can open interesting views to deliberately located plant treasures or sculpture. Even small areas suddenly seem interesting if planted in thoughtful, eye-stopping density. Gardeners with little space can collect and grow many more types of plants by painting with plants.

LEFT Planting the exciting *Cerinthe major* 'Purpurascens' atop a rock wall allows for close-up appreciation. The fabulous, cutting-grown nasturtium, *Tropaeolum* 'Apricot Twist', ties the scene together by cascading happily and blurring the rock edge.

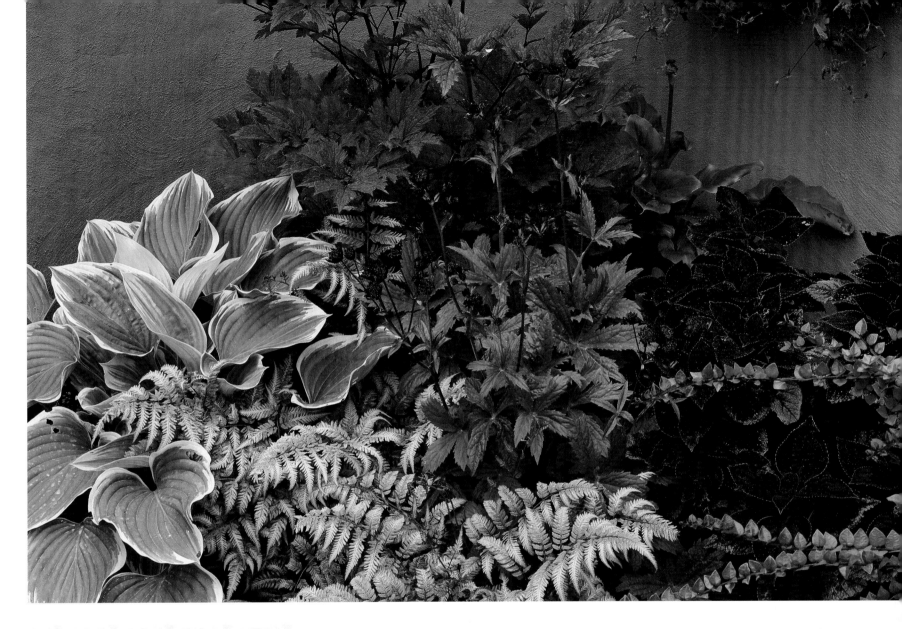

ABOVE In my own garden, *Hosta* 'Regal Splendor' anchors a tapestry grouping. *Cimicifuga simplex* 'Brunette' backs the red-flowered *Astrantia major* 'Ruby Wedding'. Picking up on these colors are *Coleus* 'Coral Glo' and, for the truly observant, the Japanese Painted Fern, *Athyrium nipponicum* 'Pictum'. A few traces of the exciting new evergreen Honeysuckle, *Lonicera nitida* 'Red Tips', cascade into the picture on the right.

Good neighboring plants often provide a 'color echo' for one another. This pleases the eye because one plant or its flowers are a shade darker or lighter than its neighbor. An apricot tulip, mixed with another tulip just a shade darker, instantly becomes more interesting than a mass of all the same thing. Some leaves are variegated in cream or gold; a color echo can be picked up in a neighboring lily or any other flower with blossoms of that same shade. It always works!

Harmonious combinations are absolutely endless. They can be very subtle or stunningly brazen. Good gardens are composites of good plant associations that are well grown and maintained. By realizing how much or how

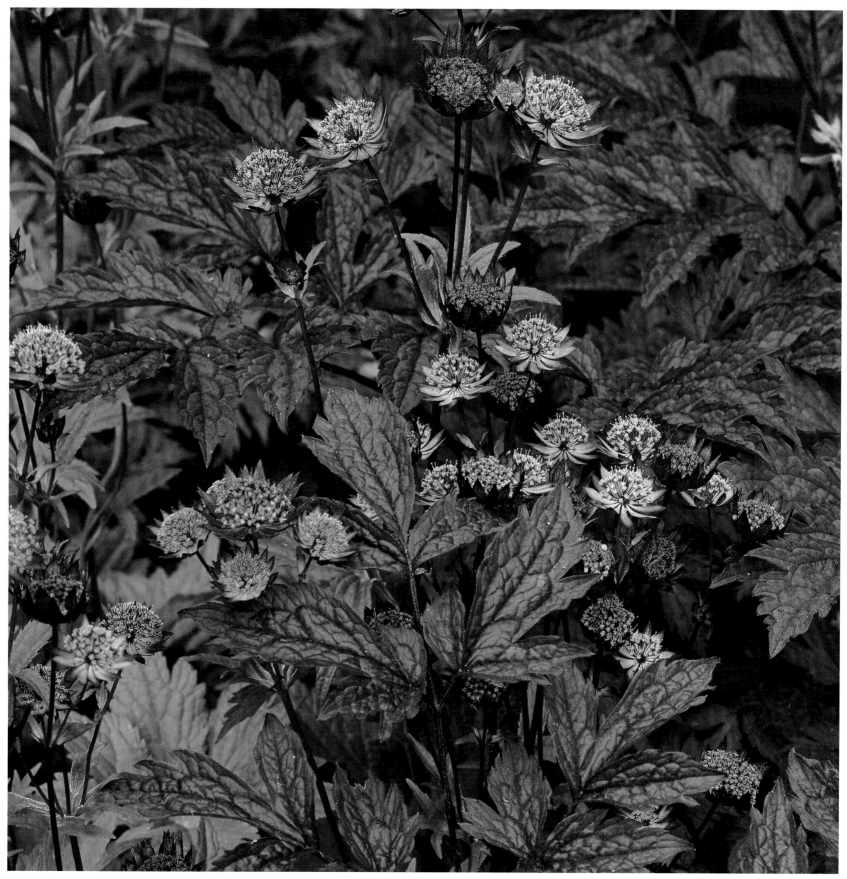

little effort you are willing to put into any one area of your garden, it is possible to plant accordingly. An honest appraisal of commitment-to-investment in your plants will make you a good neighbor, too.

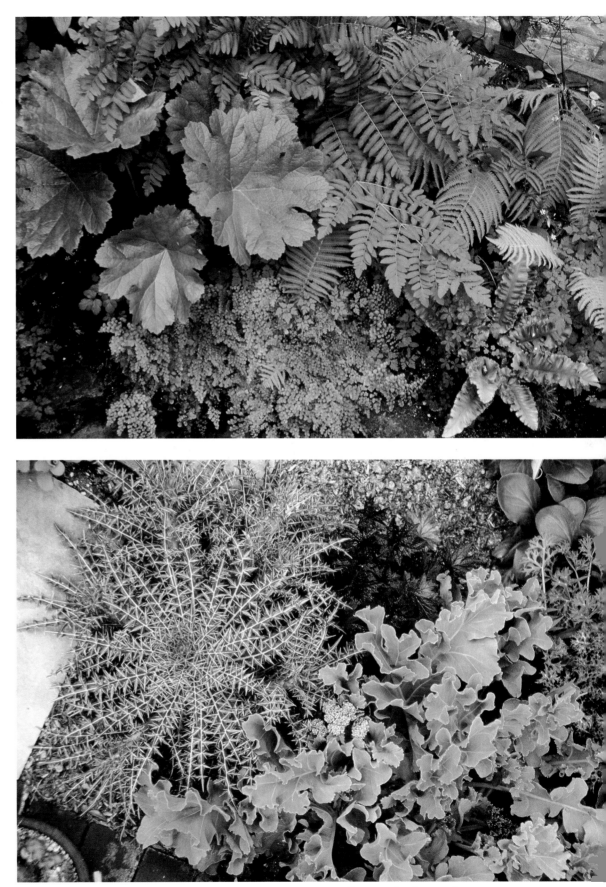

LEFT *Astrantia major* 'Ruby Wedding' blooms happily amongst neighboring *Cimicifuga simplex* 'Brunette' foliage, creating a whole new hybrid vision.

ABOVE RIGHT A moist, shady pocket creates opportunity. Plants that thrive in such conditions create a flowerless tableau. Bold umbrellas of *Darmera pelpata* match the shiny leaf surface of Hart's Tongue Fern, *Asplenium scolopendrium*, yet are totally different in shape and scale.

RIGHT Heat- and sun-loving *Ptilostemon afer* is a very beautiful 'thistle', made even more fierce looking by being beside the succulent blue leaves of Sea Kale, *Crambe maritima*. The brown foliage of *Geranium sessiliflorum* 'Nigricans' adds a new color to the grouping, joined by the cut-leafed *Eryngium bourgatii* on the far right.

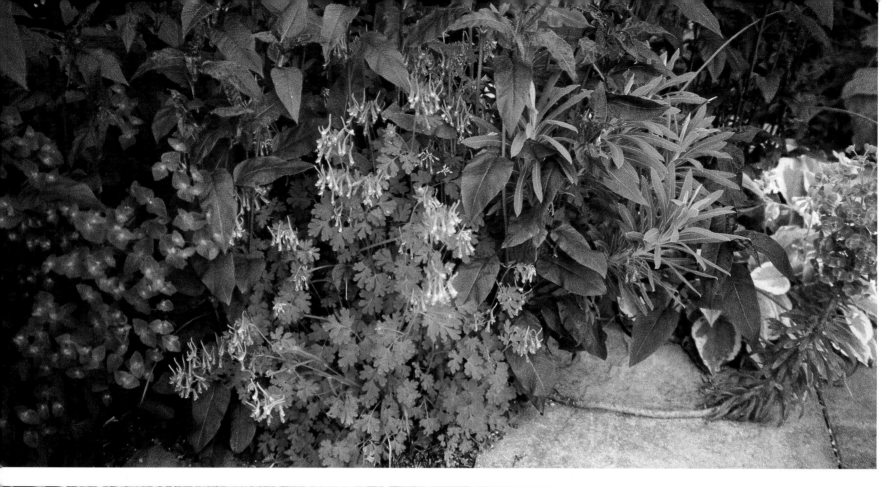

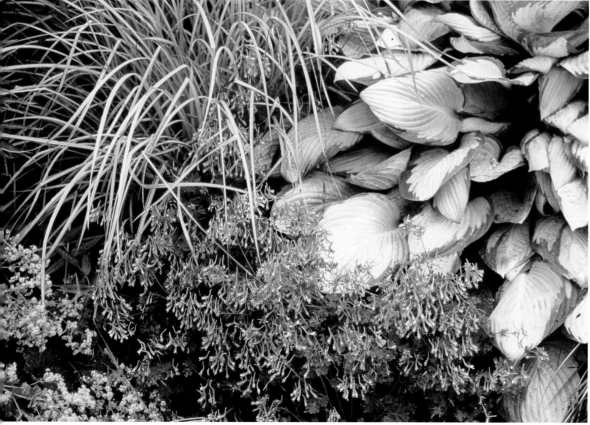

ABOVE Sometimes a plant is transformed by its neighbors. Here *Corydalis flexuosa* casts an accidental but exciting blue neon glow onto the dark plum foliage of *Lysimachia ciliata* 'Purpurea' in my own garden.

LEFT A sunnier effect using *Corydalis flexuosa* 'Blue Panda' is achieved by planting golden-foliaged neighbors. *Hosta* 'Gold Standard', *Carex elata* 'Bowles Golden' and *Alchemilla mollis* all have individual interest but share in shades of chartreuse, thus creating one foil for the featured plant.

RIGHT In my garden, the Asiatic hybrid lily 'Lovelite' was a free bonus from a bulb company. The stunningly variegated dwarf canna 'Pink Sunburst' performs a perfect color echo. Further along, Asiatic hybrid lily 'Cosmic Blast' mingles with soft-toned *Anthemis tinctoria* 'Sauce Hollandaise'.

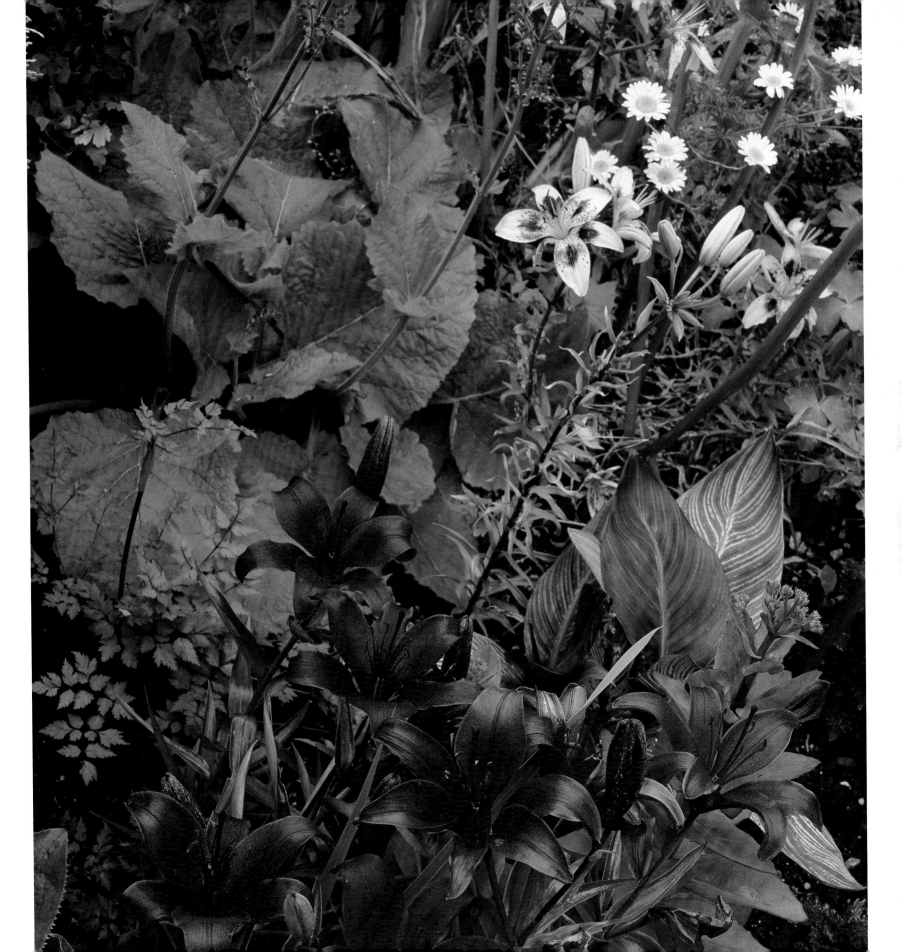

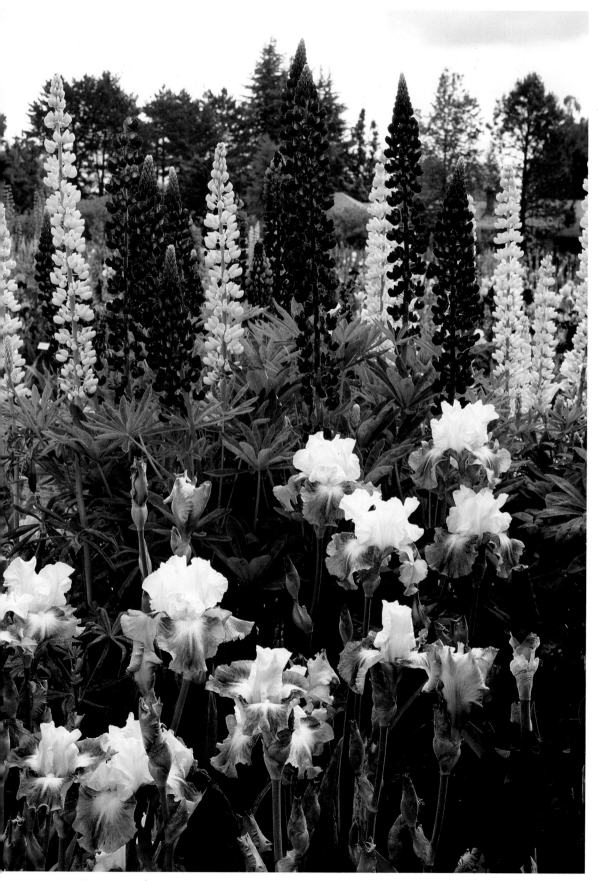

planting
heavy always
looks better
than trying to
explain what
your vision was
meant to be

LEFT Hybrid irises are at the top of my beauty list. They bloom for much longer than people think, and come in color combinations unattainable in any other flower.

RIGHT *Iris* 'Edith Wolford' is readily available and so easy to please. Blooms from this very vigorous variety continually unfold for at least four weeks.

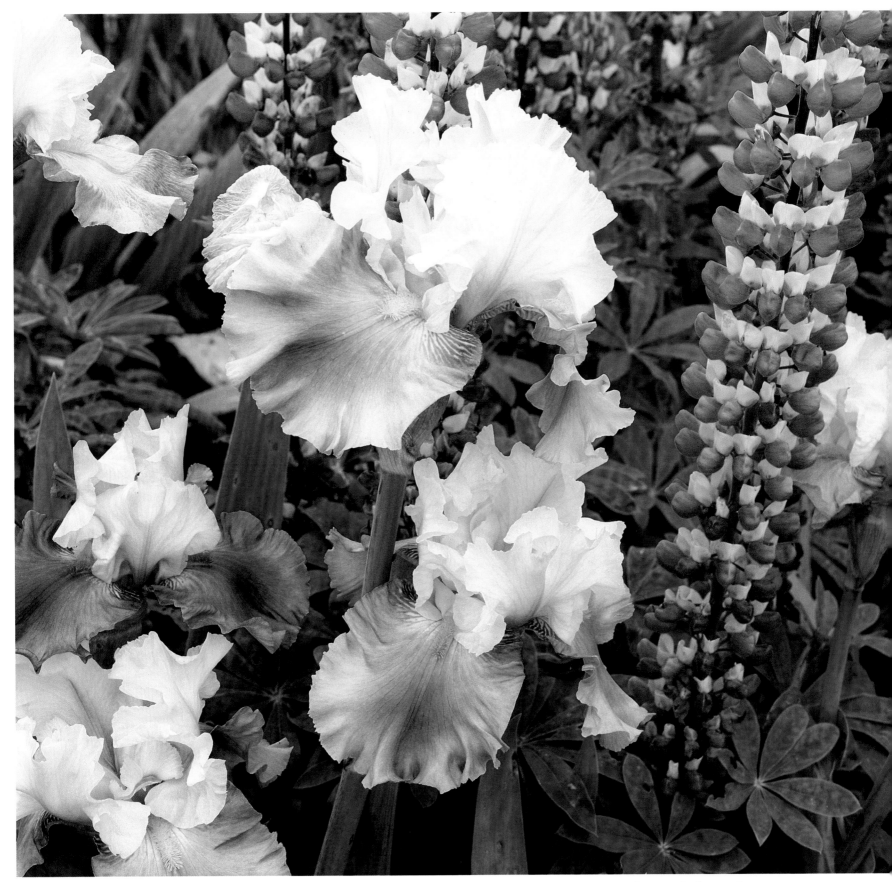

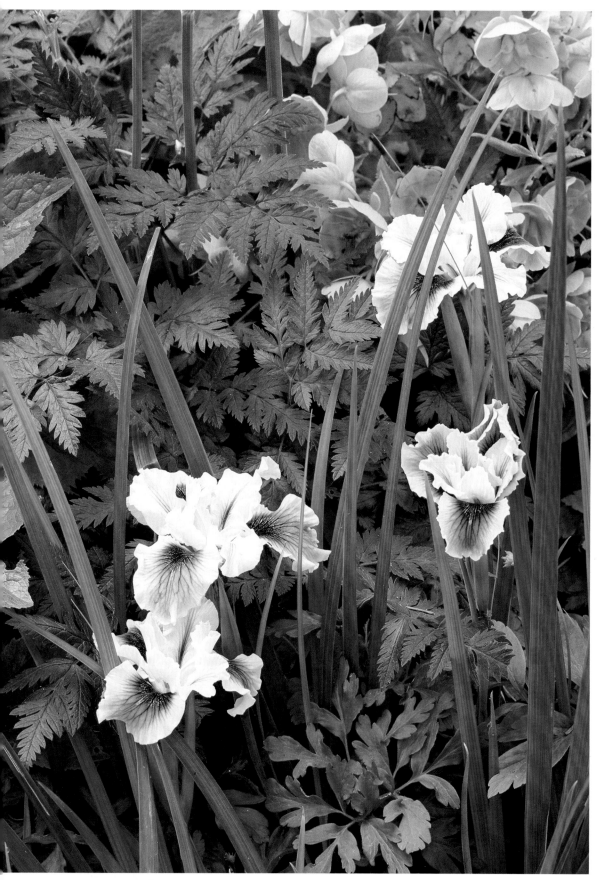

good gardens
are composites
of good plants
associations

LEFT A West Coast hybrid iris of unusual coloration and beauty uses neighboring foliage of *Anthriscus sylvestris* 'Ravenswing' to create a flattering background for its exquisite crème brulé-colored flowers.

RIGHT Breathtaking, monstrous *Rheum palmatum* 'Atrosanguineum' rises from a bed of harmless Forget-Me-Nots, *Myosotis scorpioides*, in Rosemary Verey's garden at Barnsley House. Lily flowered tulip 'China Pink' reiterates the shocking flower stalks just emerging from the monster. Wow!

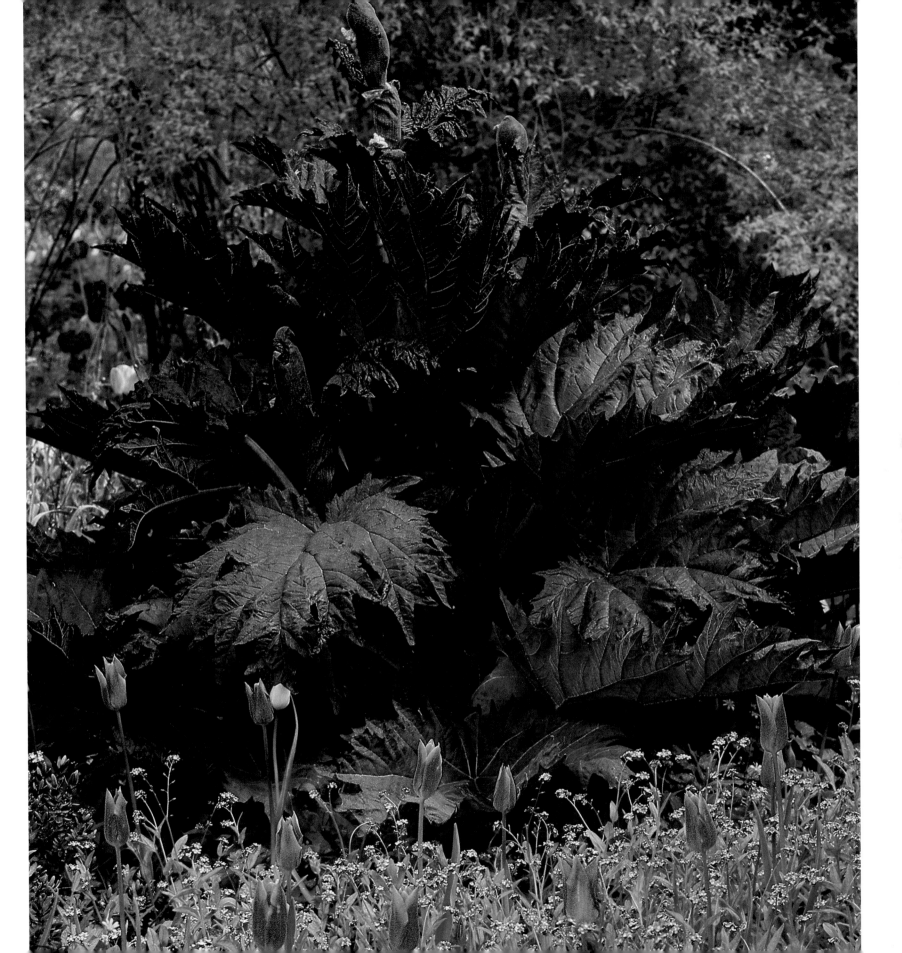

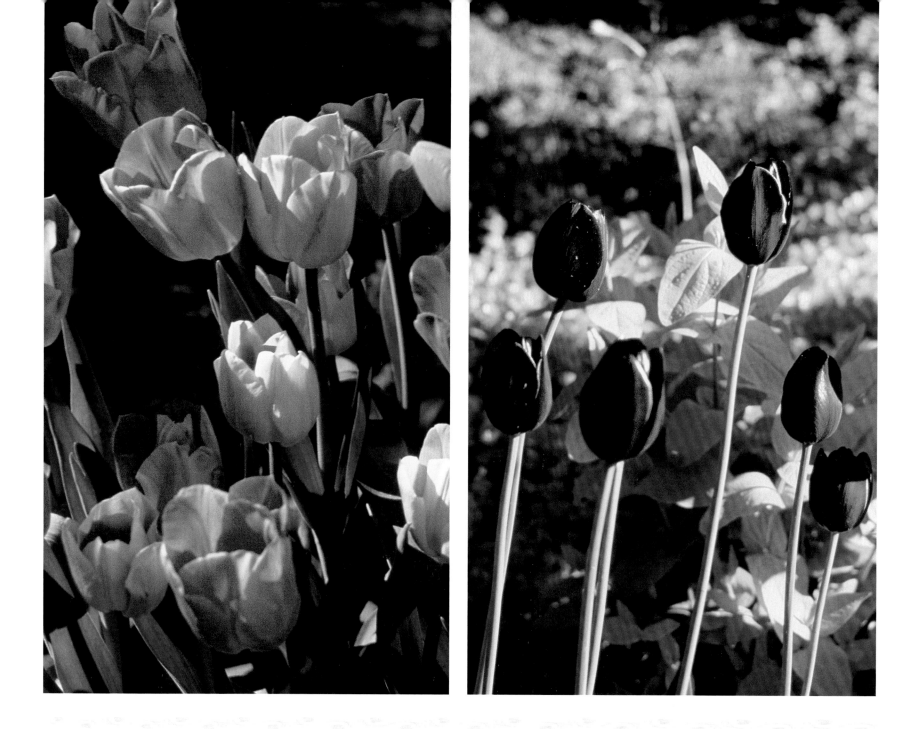

ABOVE By mixing two tulip varieties of similar shades, colors are enhanced. Here 'Apricot Beauty' blends with 'Beauty Queen' in a ravishing display by Charles Price and Glenn Withey in Seattle.

ABOVE RIGHT Creating a background of acid-green foliage using *Hypericum* 'Summergold' makes certain that the near-black tulip 'Queen of the Night' doesn't disappear.

RIGHT A dwarf, yellow-flowered kniphofia grabs even more attention when the equally shrill verbena 'Homestead Purple' is used as a ground cover. Powerful, blinding combinations like this are only wonderful once or twice per garden.

ABOVE Self-sown Golden Millet Grass, *Milium effusum* 'Aureum' brings life to a spring carpet of *Aubretia*, *Ajuga reptans* and a Golden-leafed Mock Orange, *Philadelphus coronarius* 'Aureus', at VanDusen Botanical Garden in Vancouver.

RIGHT In this low-maintenance perennial planting, hostas, tiarellas and ferns mingle with pink-flowered forget-me-nots and primulas. Because all these particular plants enjoy similar conditions in nature, they are happily growing together in a similar situation in the garden.

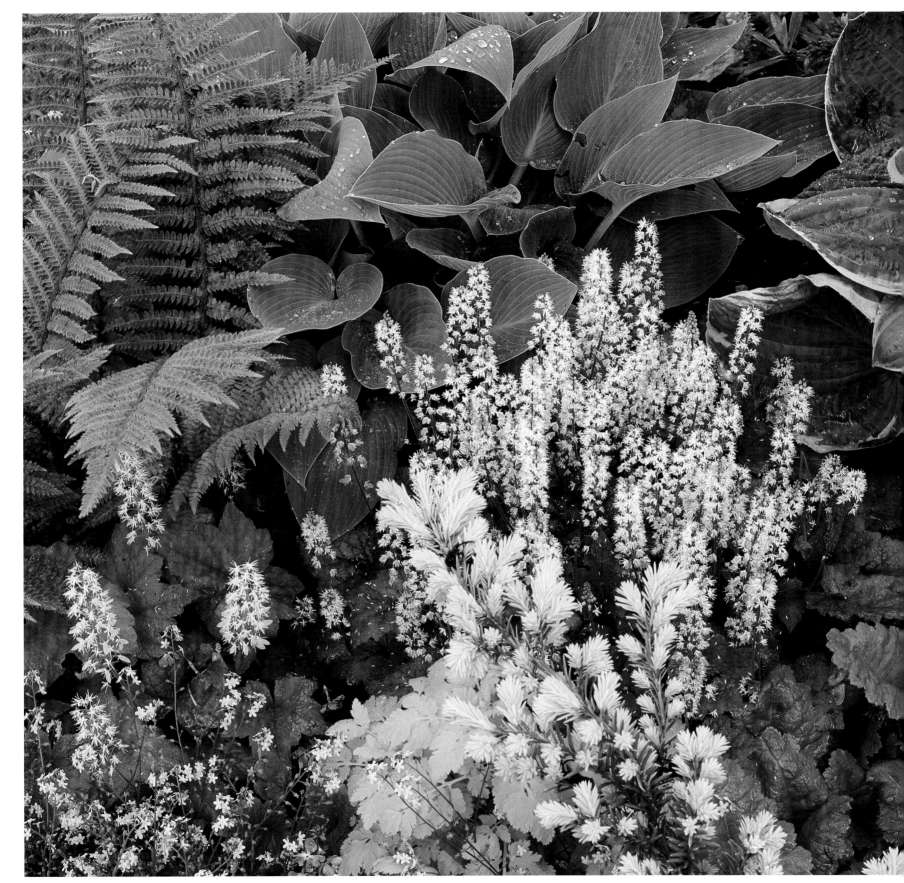

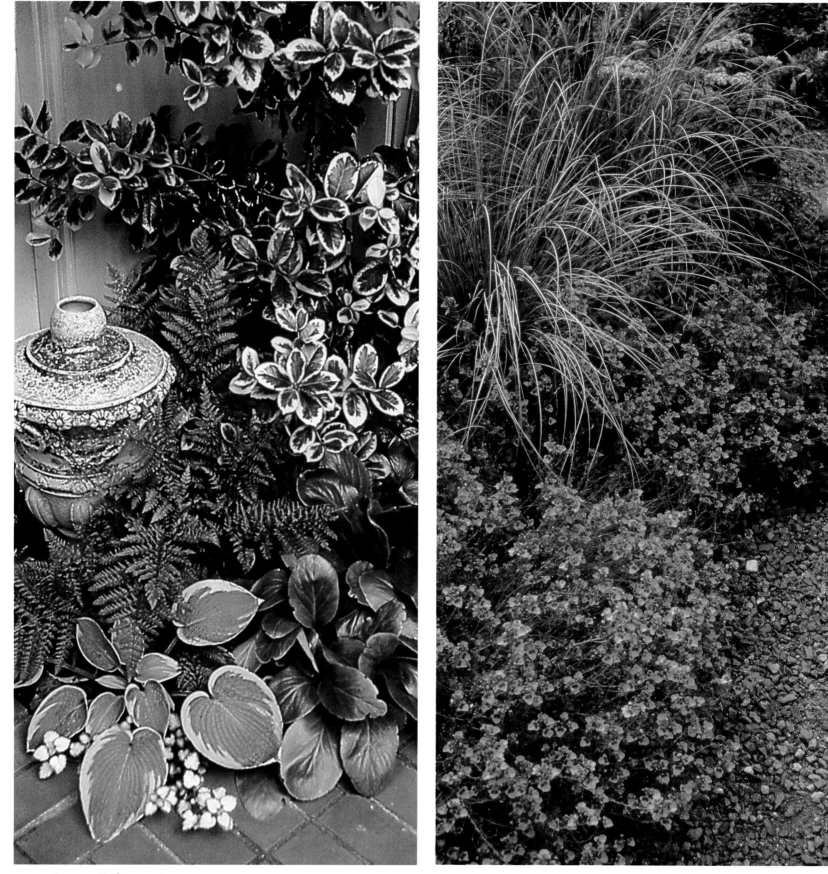

FAR LEFT A small corner pocket becomes special by including variegated foliages and a tasteful urn as focal point. Year-round interest is provided by variegated holly 'Golden King', bold, evergreen *Bergenia* 'Bressingham White', *Helleborus orientalis*, ferns and *Hosta tokudama flavocircinalis*.

LEFT *Diascia barberae* 'Coral Belle' spills attractively onto the gravel path at Heronswood Nursery in Kingston, Washington. *Carex buchananii* takes on a salmon hue simply by being close by. These brown sedges are invaluable in today's modern planting schemes.

ABOVE The new growth of many *Pieris japonica* cultivars is outstandingly colored. Although it is such a common garden shrub, one never sees it used to advantage when spring bulb season comes around.

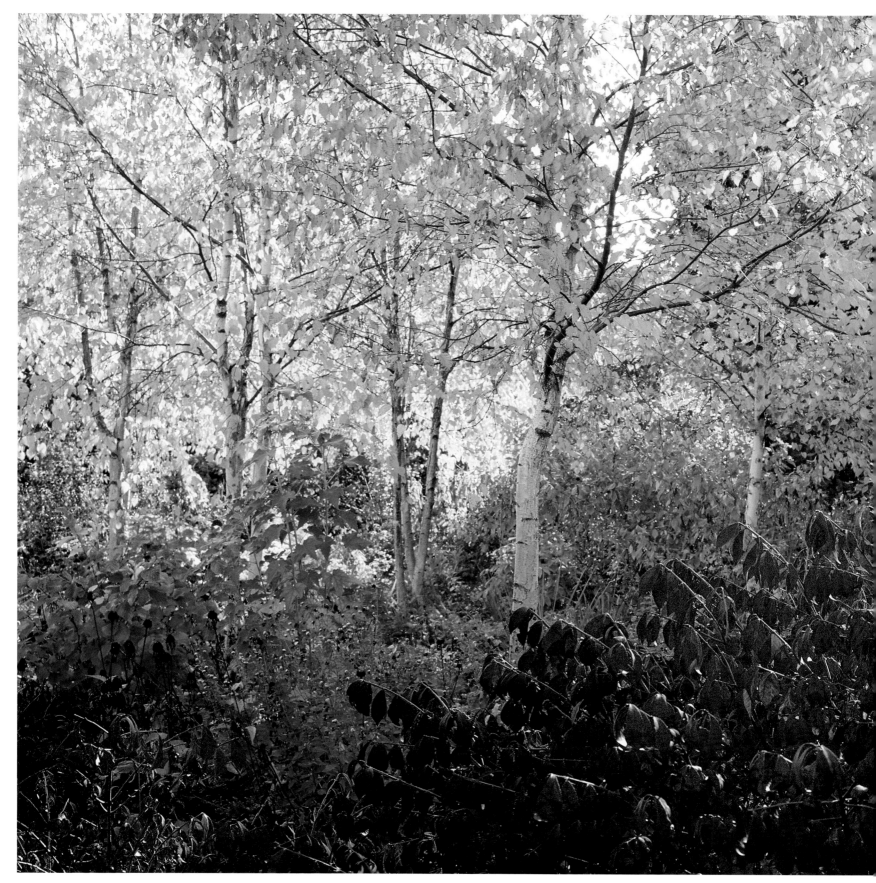

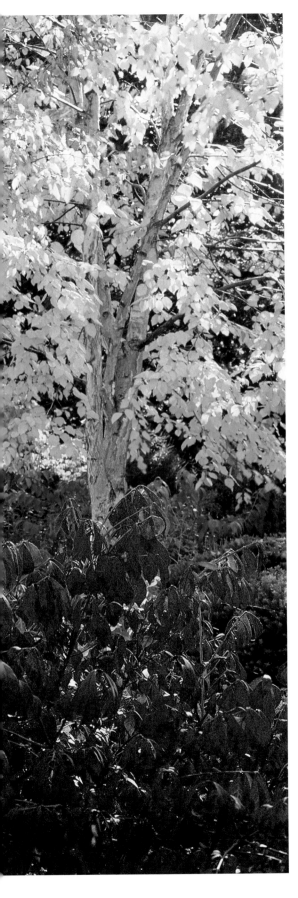

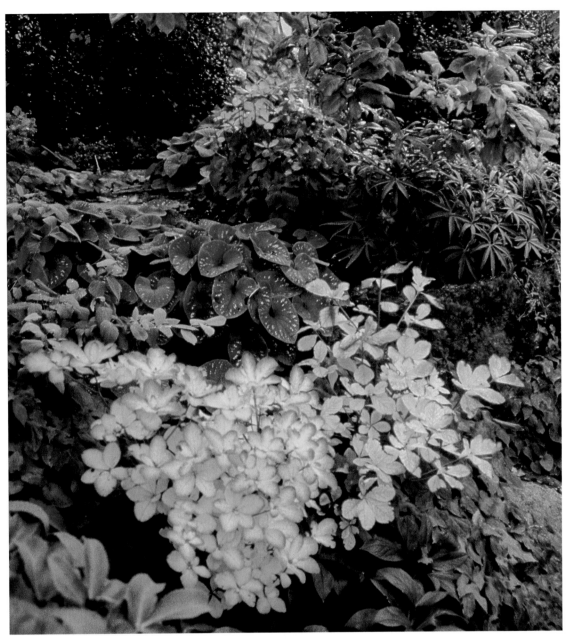

LEFT Trees can be good neighbors, too. Here, *Betula papyrifera*, the Paperbark Birch, is used to create a gardenable woodland. *Euonymous alatus* creates an understory groundfire of Autumn beauty.

ABOVE A composition of different foliages includes the silver-speckled *Brunnera macrophylla* 'Langtrees', but the autumn color of a deciduous azalea steals the show in this Seattle garden by Charles Price and Glenn Withey.

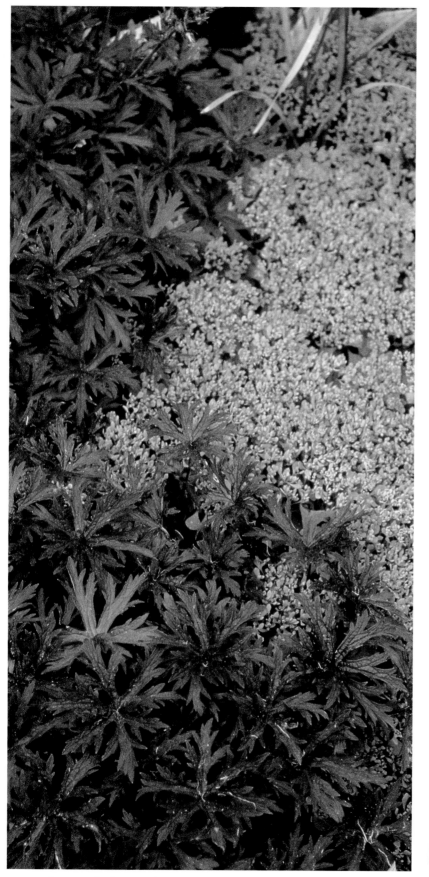
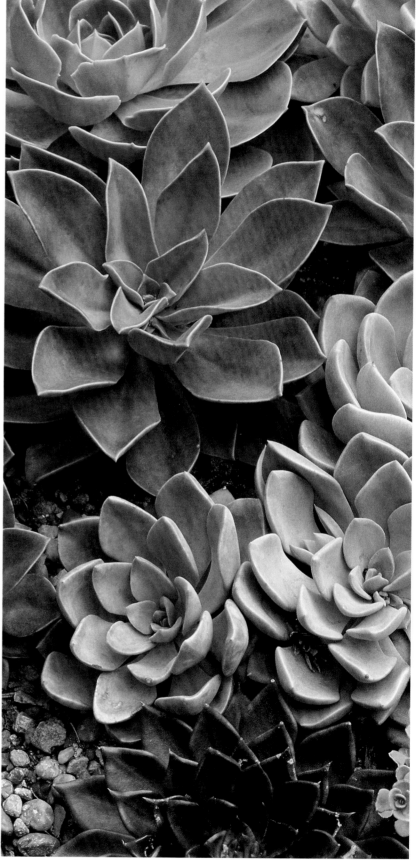

BY repeating
a plant
periodically, a
confidence comes
through, as if you
are saying to the
observer,
'i know'

FAR LEFT *Geranium pratense* 'Midnight Reiter' has coppery-purple foliage anyway, but it is the *Sedum cauticola* that makes sure we see purple in this virtual carpet of foliage texture.

LEFT Echeverias come in many colors and make excellent bedding plants. All need lifting before frost but happily overwinter indoors in bright light.

RIGHT An amazing living tapestry in the O'Byrne garden in Eugene, Oregon. Sempervivums flow with ground-hugging *Raoulia australis* in an undersea-like micro-garden. Only meticulous culture could result in such a perfect display of plantsmanship.

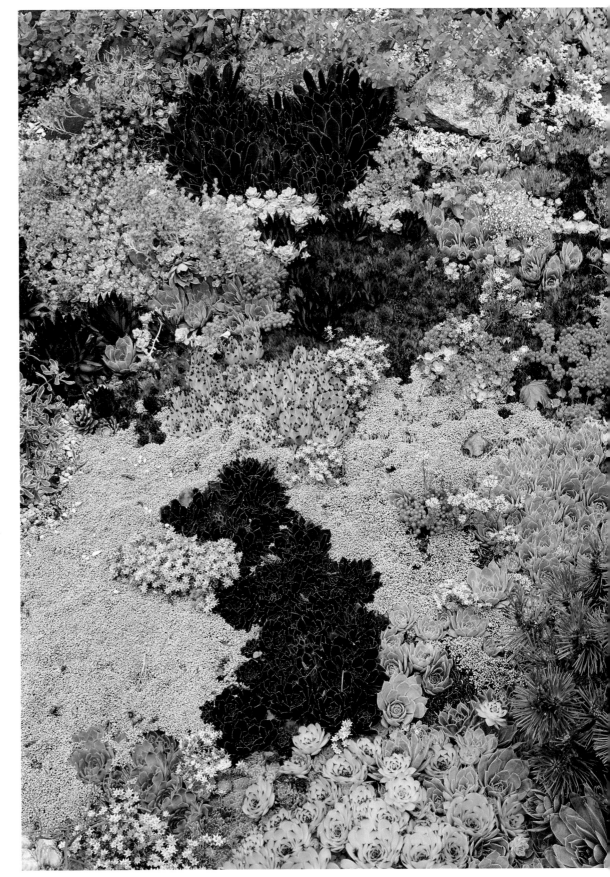

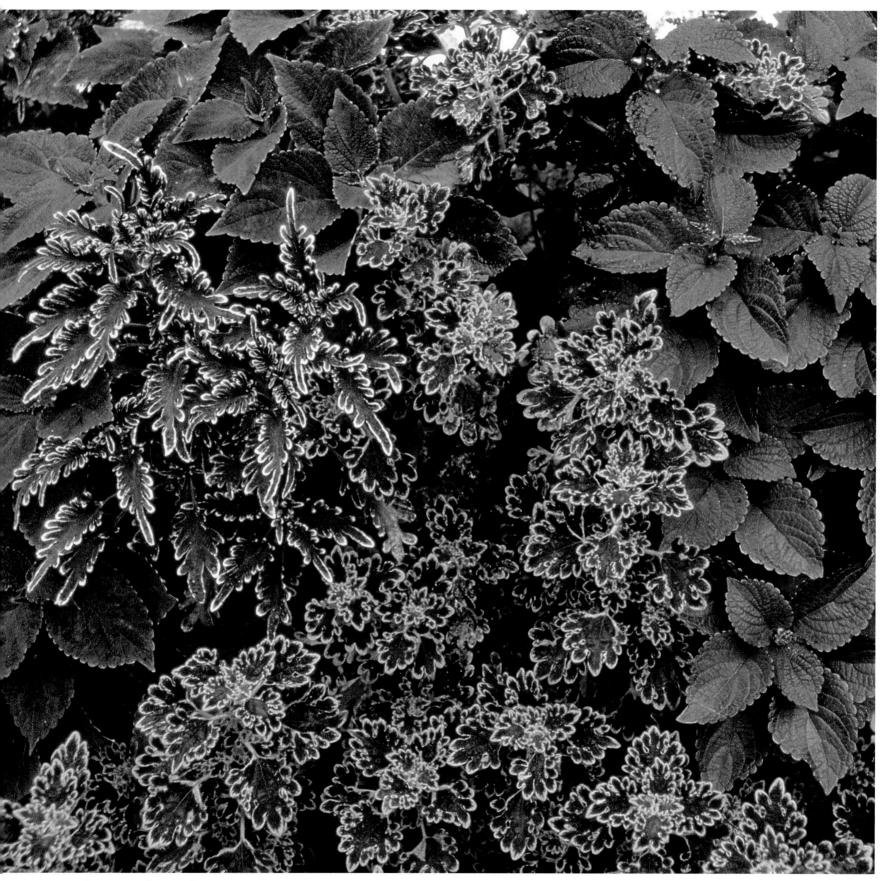

ABOVE RIGHT Coleus have re-awakened our interest for mad colors and crazy foliages. They perform important color tricks when mixed with perennials. Here, a masculine, gun-metal-toned harmony is achieved with *Coleus* 'Black Magic', Japanese Painted Fern, *Athyrium nipponicum* 'Pictum' and the tender annual *Alternanthera dentata* 'Rubiginosa'.

LEFT Coleus at Wave Hill, in the Bronx, New York.

RIGHT In Sonny Garcia's San Francisco garden, the chartreuse-edged, bronze-splotched leaves of *Pelargonium* 'Vancouver Centennial' ignite a neighboring cuphea. The variegated *Helleborus argutifolius* 'Pacific Frost' adds another form of variegation and interest all year.

High Tension

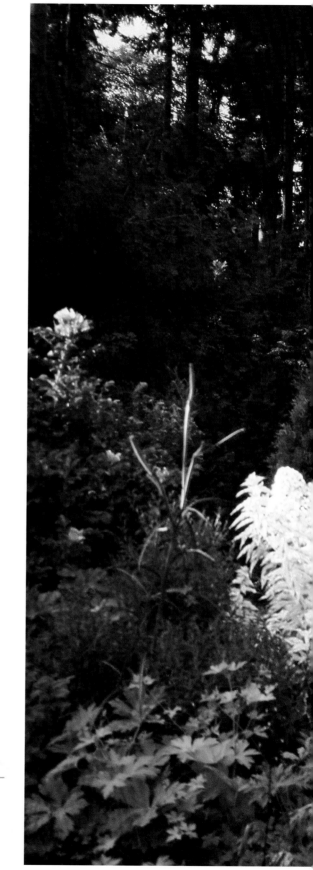

Feeling comfortable in a garden, or with your garden, is not always a good thing. Complacency is an enemy that slips in and stalls, numbs or replaces creativity. By introducing 'High Tension' concepts into the garden, using colors and leaf shapes as electric elements of design, you can be kept awake and on your toes.

For example, lime green is a high-tension color. It has a whole range of subtle variations, ranging from florescent yellow to dayglo shamrock. By carefully using this very powerful and magical color, you can make plants noticeable by proximity and contrast.

Slipping what I call 'color equivalents' into plant compositions by balancing the power of the shade of each plant involved results in garish but attractive harmony. An orange daylily can be matched to its color equivalent in a just as powerful (or just as subtle) lime-green-colored accent plant. If a weaker color partner is used it will disappear or look chlorotic (iron deficient) instead of stunningly clever.

Effective shocking beauty planting only works when all the players, the plants involved in each planting effort, are contributing equally to the final beauty vision.

RIGHT Sunlight on two hardy perennials electrifies a woodland border at Heronswood Nursery in Kingston, Washington. The variegated phlox 'Nora Leigh' and variegated grass *Molinia caerulea* 'Variegata' reflect more light with their paler foliage.

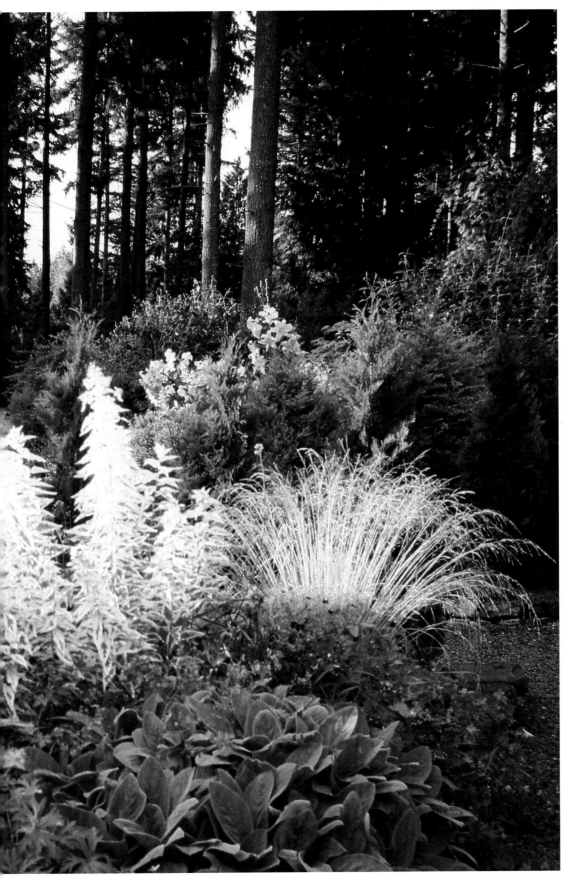

ABOVE (Detail) *Phlox paniculata* 'Nora Leigh' is grown for its outstandingly variegated foliage, not for its insipid flowers. Vigorous and less vigorous forms of this variety are in circulation, and if you get a good form it makes a handsome addition to your perennial beds.

Non-contributors are a waste of money and space. Extra-powerful plants are best planted alone or in blocks of themselves rather than visually weakened by mixed plantings. Very dramatic foliage plants such as colocasias and cannas usually dominate the picture and deserve superstar positions.

Very jagged and saw-toothed foliages are terrific for adding visual interest to potted plantings or garden beds. No one wants to cuddle up to a six-foot-tall 'Scotch Thistle', the very beautiful, furry, white-leaved *Onopordum acanthium*, but this stunning biennial candelabra of fierce prickles is always welcome in my garden and self-sows throughout the neighborhood. Many eryngiums have wonderful leaves as well as flowers. Some of the lance-leafed species like *E. agavifolium* form stunning agave-like rosettes of spiny, tufty foliage as well as sturdy spikes of olive-drab teasle-like flowers. In late fall I like to spray paint these with unusual colours as they stand in the garden, using automotive touch-up paints in metallic gun-metal shades. Why not?

Highly variegated foliage is a good 'trouble-maker'

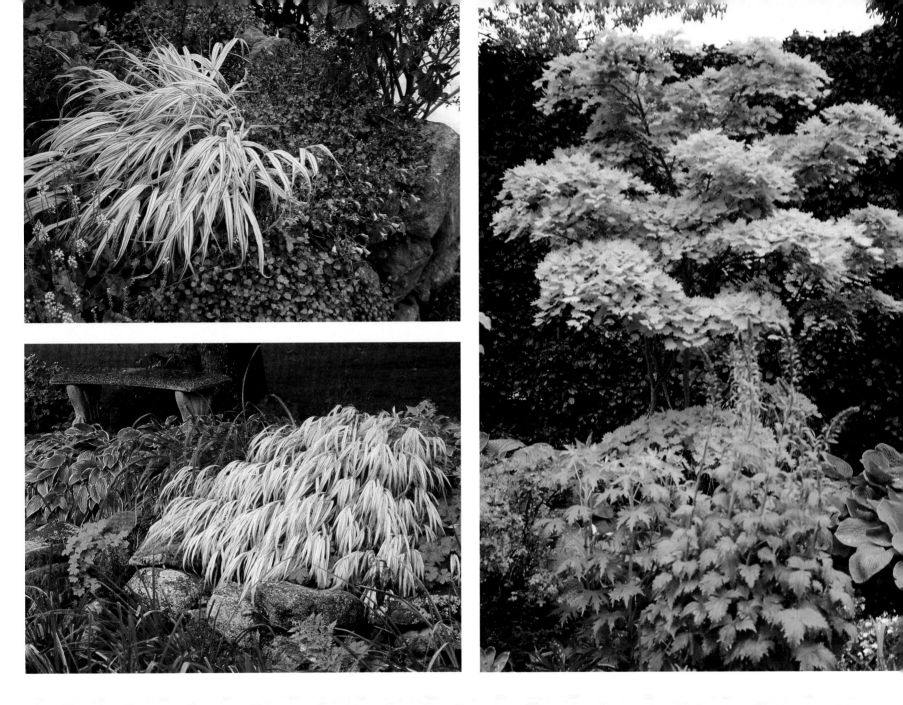

FACING PAGE Hypericum x inodorum 'Summer-gold' rises out of a creeping mass of matchingly shrill *Lysimachia nummularia* 'Aurea' at Heronswood Nursery. The somehow scary *Angelica gigas* plants will provide startling contrast with their hornet-encrusted, wine-red balls of flowers atop six-foot stems. *Rheum* 'Ace of Hearts' adds bold foliage texture and visually anchors this grouping.

ABOVE & TOP Few perennials are as useful in today's gardens as the lovely Japanese grass *Hakonechloa macra* 'Aureola'. Terrific as a foliage contrast in mixed company, or on its own, this surprisingly hardy workhorse has a unique water-fall effect to its cascading branches.

ABOVE At Kiftsgate Court in England, prominence is brought to a golden-leaved Japanese maple by planting it in front of a dark purple Copper Beech hedge. We are much better able to appreciate the tree's golden tones by having a backdrop against which to see it. Maximum contrast in foliage color is much more tolerable than it is in flowers.

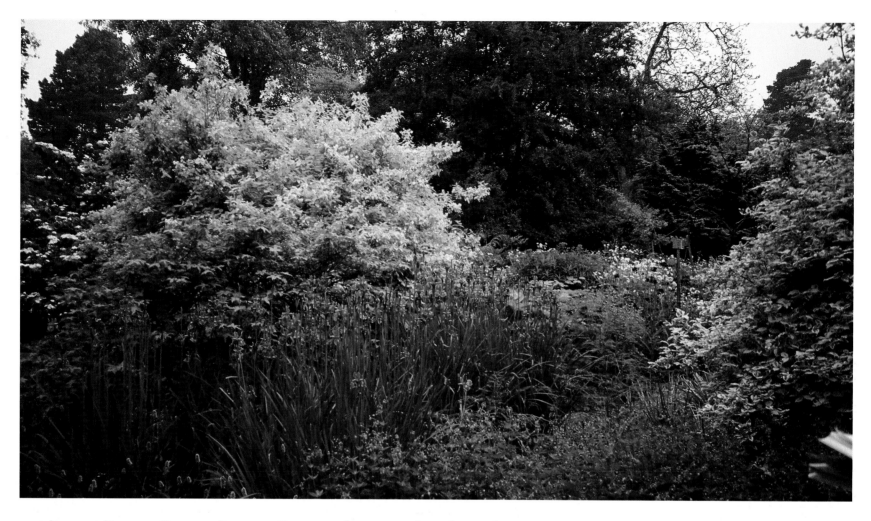

ABOVE A well-placed, golden-leaved Mock Orange, *Philadelphus coronarius* 'Aureus', made me notice the swath of blue *Iris sibirica*. Imagine this picture without the golden foliage and you have a typical garden scene of no interest.

to play around with in the garden. Lots of coleus are so variegated and flamboyant that they must be placed carefully. Few plants can compete with the interesting, remarkable shades in coleus foliage. But planting plain-leaved plants with them creates contrast, buffering a super-powerful eye-catcher with a neutral but worthwhile neighbor.

A word of caution: planting too many patterns too close to each other is guaranteed to lose all effectiveness. Other variegated-leaved plants must be spaced, dotted about or used as highlights only, to avoid total confusion — what I call the Visual Pizza Syndrome.

The goal of high tension planting is to make an attractive vision that is memorable and different — hopefully stunning. As none of us know our threshold of beauty, the keen gardener can always experiment and take it one step further. Remember: 'No risk' means 'No art'.

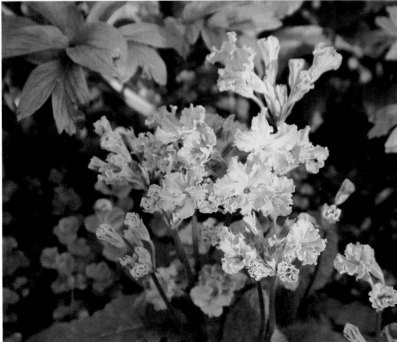

ABOVE 'Hummingbird' Tulips are a thrilling choice for spring bedding. So many tulips are simply uninteresting clichés. 'Viridiflora' like this one and 'Spring Green' maintain some *botanical interest* which makes them truly beautiful.

ABOVE RIGHT The golden hop, *Humulus lupulus* 'Aureus', is very dangerous, not for its electrifying foliage color, but because it is an unstoppable garden thug. Even so I still would not be without it.

LEFT *Primula* 'Francisca' was saved from a garbage pile forty years ago. This very vigorous, green-flowered beauty has now been tissue-cultured and appears in gardens worldwide.

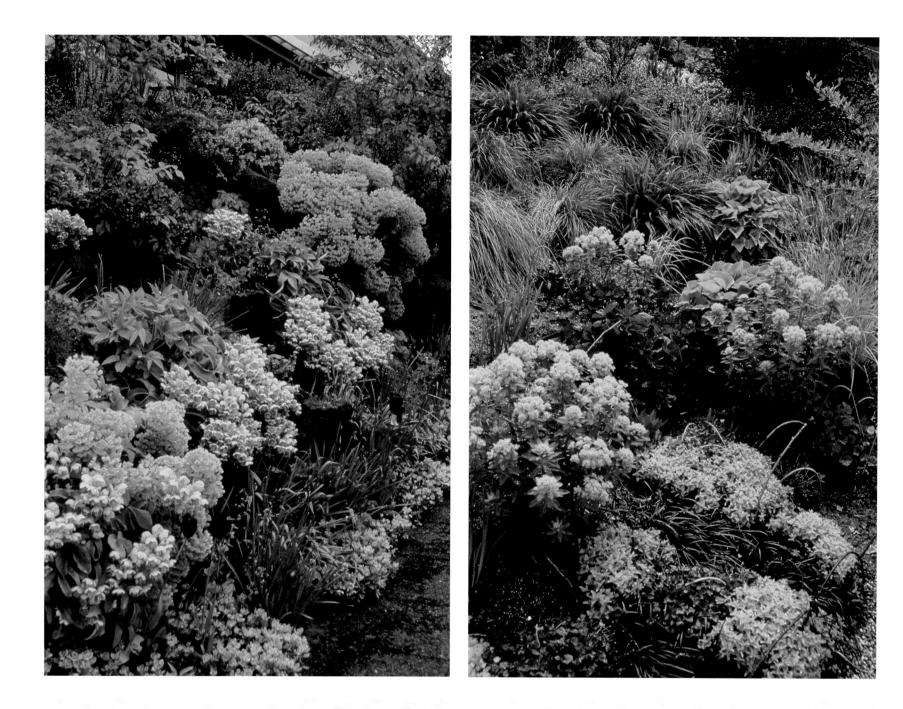

ABOVE In Seattle's often drizzly, overcast spring climate, garden designers Charles Price and Glen Withey dazzle passers-by with a bank of *Euphorbia characias wulfenii* and *Helleborus argutifolius*. Very dark tulip 'Queen of the Night' and sombre, near-black *Helleborus orientalis* hybrids make contrast of the situation.

ABOVE RIGHT Another Withey-Price planting scheme in Seattle, this time using *Euphorbia palustris* to enliven a planting of black and brown-leaved neighbors.

RIGHT *Carex morrowii* 'Sparkler' dazzles amongst a mulch of bowling balls in Marcia Donahue's 'I have seen the future' garden in Berkeley, California.

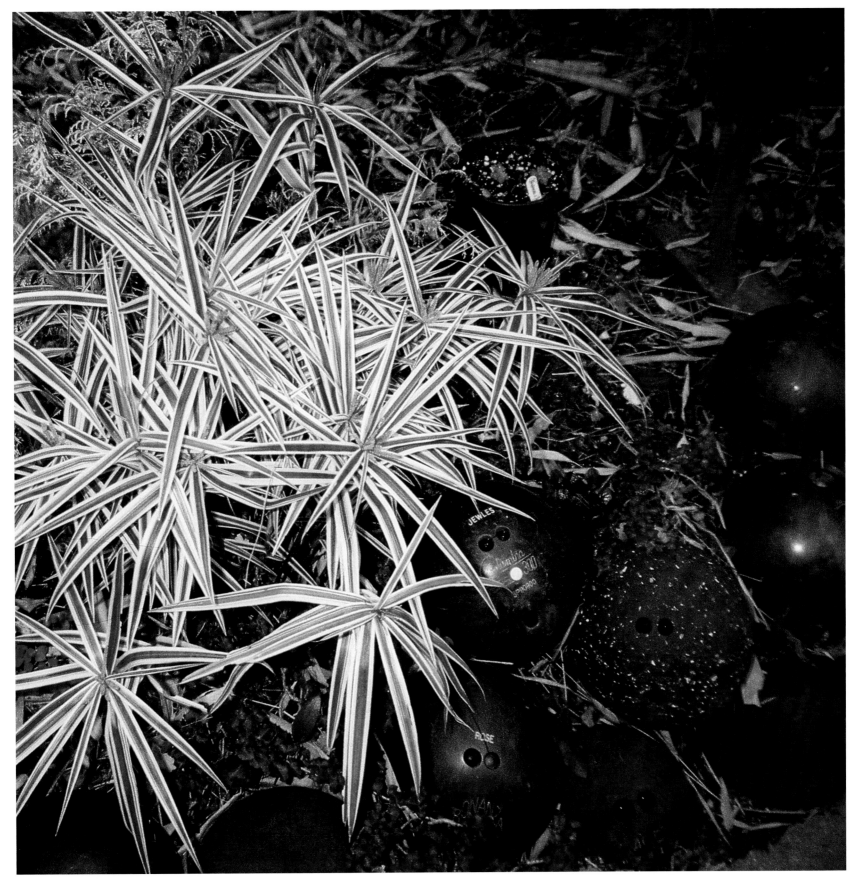

color
cause & effect

It was Gertrude Jekyll who said "People forget that green is also a color." I think what she meant was that people tend to overdo the variety of colors in their gardens when it comes to flowering plants and would be better off relying more on foliage. I could not agree more. Color can be a gardener's worst enemy. It can suddenly sabotage perfectly lovely plants with a burst of out-of-place bloom.

Because they affect our moods, colors must be used as if by prescription. Careful administration of color will ensure a successful result in the garden. Tossing color about recklessly can result in a nauseating chaos.

Think through to the mature garden vision you intend. Each plant added to a garden area should enhance, transform or reinforce existing plantings. Knowing how powerful a plant's leaf, flower and autumn shades may be will allow for successful placement. Color surprises in the garden are rarely pleasant, and waiting years for something to bloom had better be worthwhile!

Color comes from more than just our plants. Inanimate objects often contribute to the success or failure of a garden by their color. Fences, houses, garages, even your neighbor's buildings, all figure into the overall palette you

RIGHT At the Eiseli Vineyards in California's wine country, the magic of paint is perfectly demonstrated. The safe teak garden furniture has been transformed by a coat of clear, lime green paint. Visual balance is created with an appropriate planting of orange Hemerocallis and grasses. What would have been attractive but neutral becomes important and memorable.

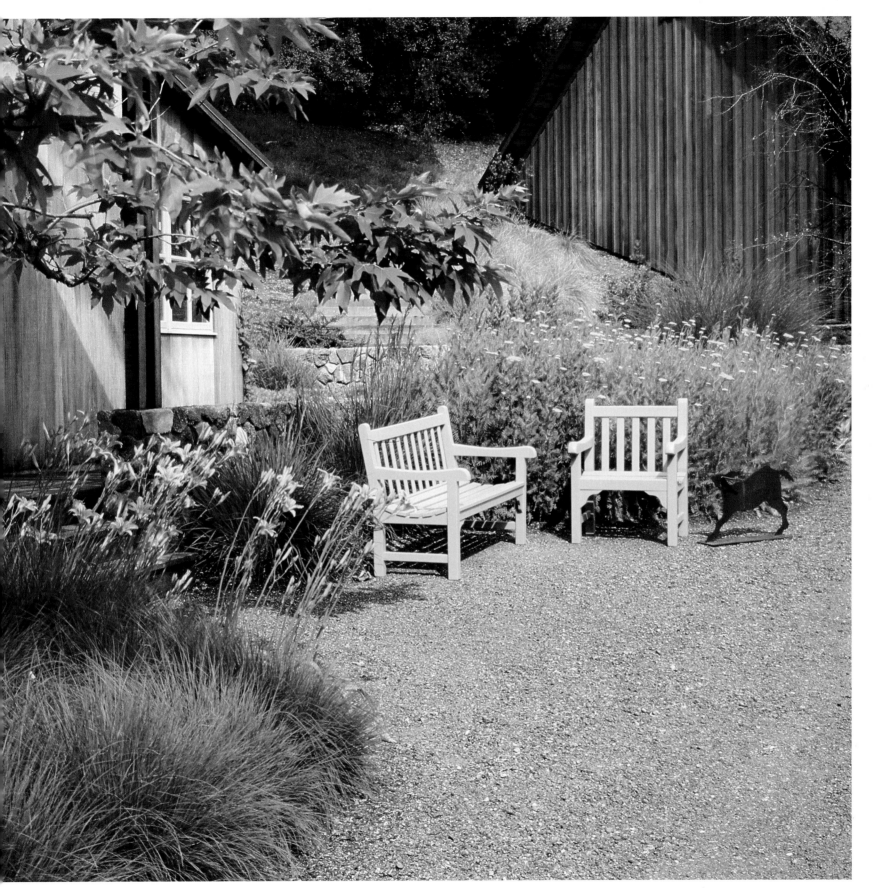

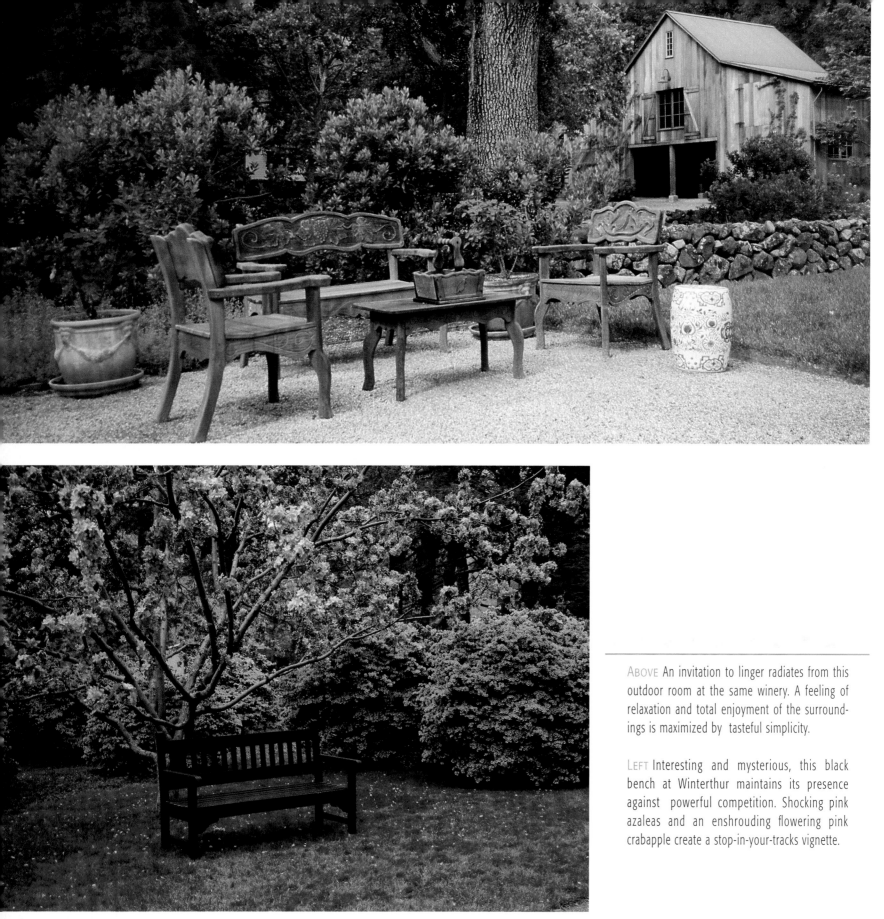

ABOVE An invitation to linger radiates from this outdoor room at the same winery. A feeling of relaxation and total enjoyment of the surroundings is maximized by tasteful simplicity.

LEFT Interesting and mysterious, this black bench at Winterthur maintains its presence against powerful competition. Shocking pink azaleas and an enshrouding flowering pink crabapple create a stop-in-your-tracks vignette.

are dealing with in your garden, and what a difference a paint job makes. I find it impossible to garden against a white house. It is like trying to cuddle up to a big white refrigerator. Plants look best against an earthier color like putty or beige or stone. We also feel more relaxed, more grounded and more creative away from blinding white light.

Realizing that color is a powerful tool and possible weapon, act accordingly. Controlling color is what makes the world of your garden tick. As creators of beauty, we gardeners need to handle color with extreme care.

RIGHT By using a neutral sage colour, garden designer Wesley Rouse of Southbury, Connecticut, has given a mundane garden bench a new pedigree of taste. The double-flowered datura 'Black-Currant Swirl' blossoms are an equally muted shade of purple.

ABOVE This free-standing moongate/arbor of 'Heavenly Blue' morning glories in Wesley Rouse's garden enthralls and lures the viewer to investigate. The use of a celadon-sage green paint color adds greatly to the overall vision.

LEFT An unusually beautiful pampas grass, *Cortaderia richardii*, announces the gate to Steve Antonow's Seattle garden. *Clematis* 'Betty Corning' adds visual balance, while the very beautiful *Centaurea cineraria* ssp. *cineraria* splashes silver at bottom right. The saying, "You only get one chance to make a first impression," holds true for gardens, too.

RIGHT A surrounding scrim of see-through perennials creates just enough privacy in the rural Washington garden of Patrick North and John Roberts. Flowering *Heuchera* 'Palace Purple', *Stipa gigantea*, *Ballota pseudodictamnus* and *Erigeron karvinskianus* mingle in carefree, sun-loving abandon.

ABOVE A verdigris urn allows the eye to focus in a section of the North–Roberts garden. Without a focal point, such sophisticated, airy planting might be digested too quickly.

LEFT Linda Cochran's bold color statement uses foliage, flowers and paint to dazzle. Golden *Catalpa bignonioides* 'Aurea' and *Verbena* 'Homestead Purple' scream against their blue background, creating an incident of pure pleasure.

RIGHT In garden designer Helene Morneau's California garden, the climbing rose 'Vielchenblau' seems even more purple by absorbing color from its no-accident purple neighboring door. Great planting should have a hidden agenda.

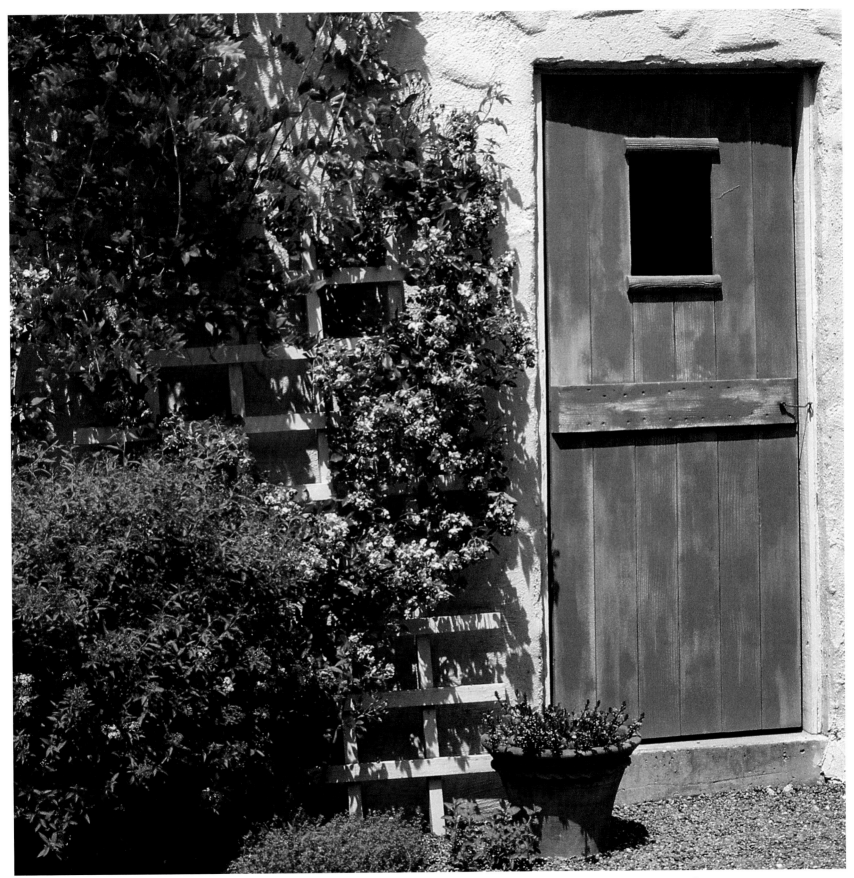

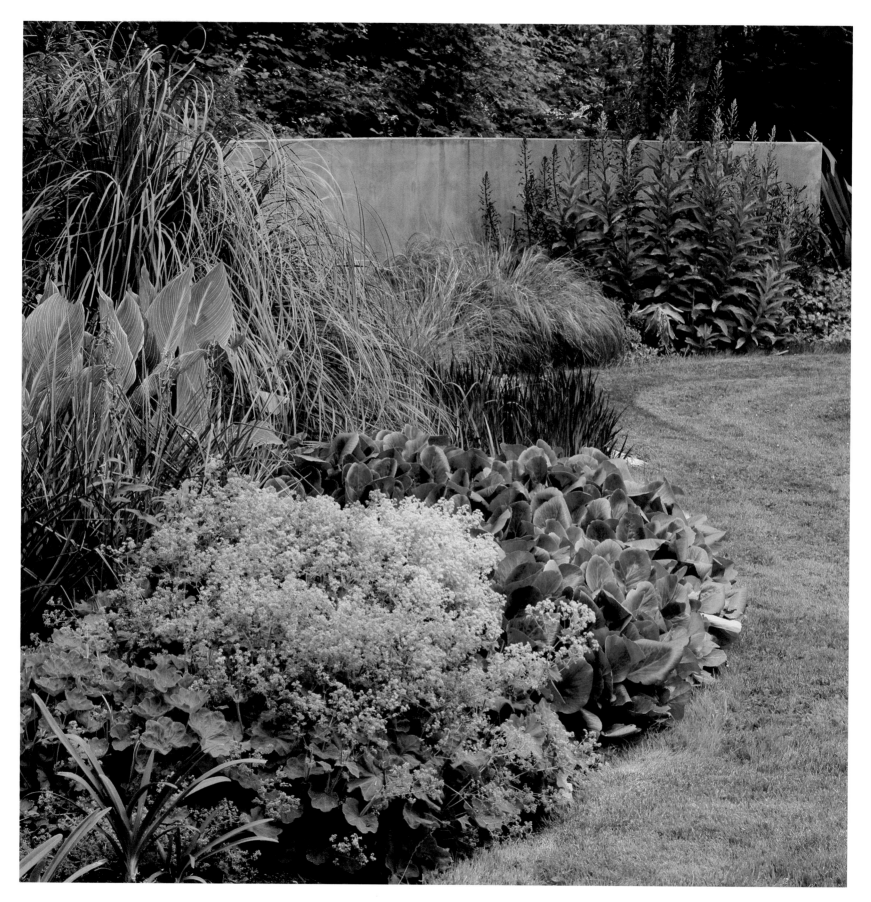

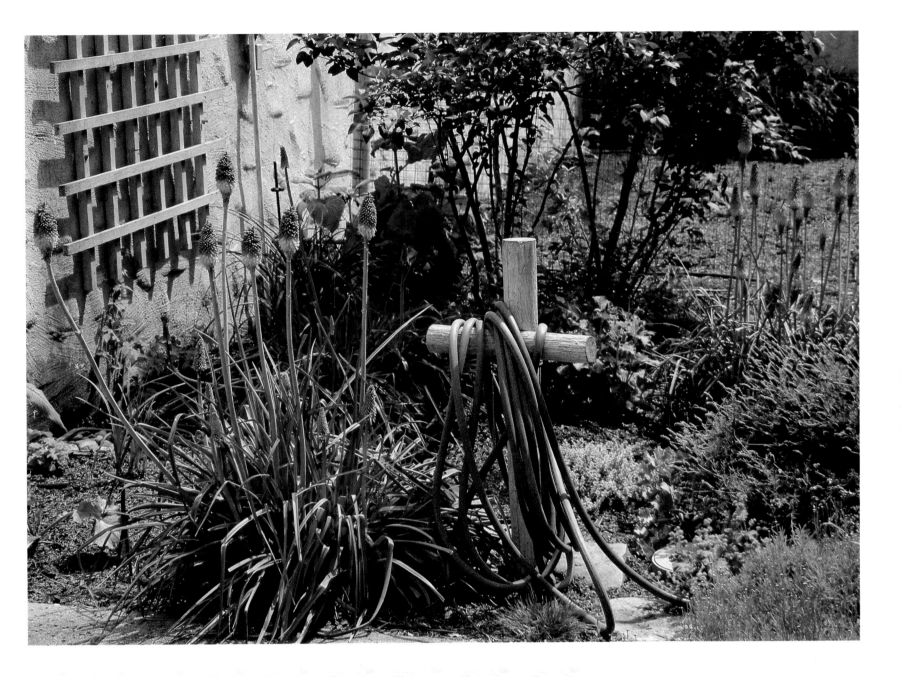

LEFT Here Linda Cochran uses faded terra cotta as the color to enhance plant material. *Lobelia tupa* and the red-tipped blood grass *Imperata cylindrica* 'Rubra' create heat amongst bronzy grasses and texture-charged perennials like Bergenias and *Achemilla mollis*.

ABOVE A garden hose need not be hidden away. Here, California garden designer Helene Morneau uses a well-chosen hose as sculpture and a perfect color echo for the nearby clump of blooming kniphofia.

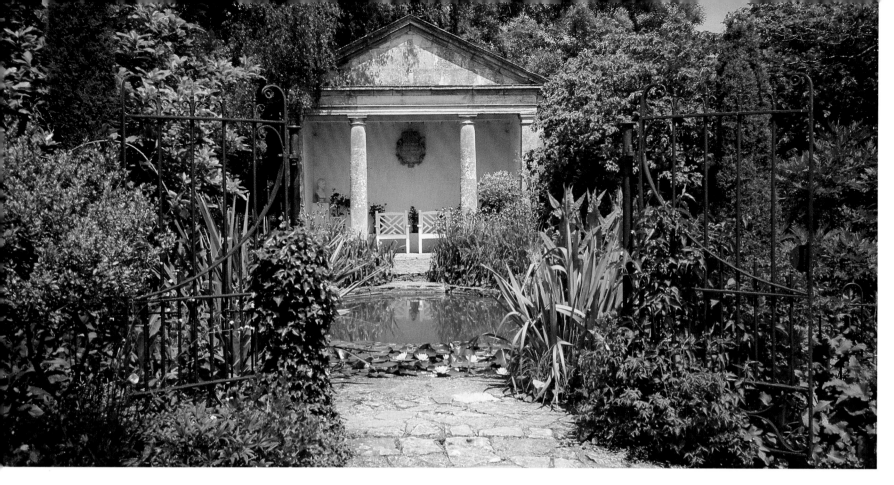

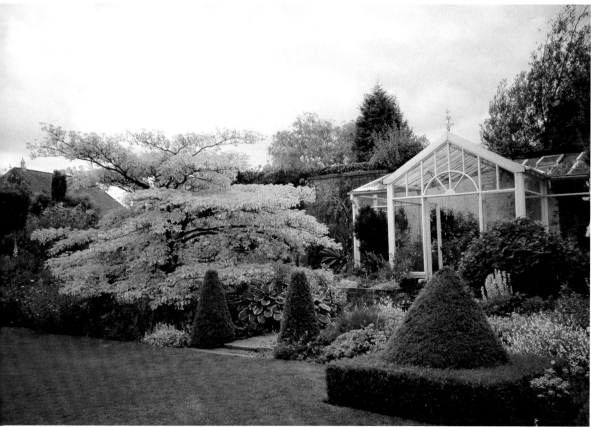

ABOVE Iron gates become magical when painted dark blue at Rosemary Verey's garden, Barnsley House. Now these gates seem connected to the extaordinary garden vision of the temple folly they frame. Black paint would leave them a lot less energized.

RIGHT detail of above

LEFT In Dublin, Ireland, Helen Dillon masterfully balances garden superstar *Cornus controversa* 'Variegata' with a beautiful greenhouse. Only an elegant structure such as this could compete successfully with the layered architecture of this magnificent dogwood.

shocking beauty

staging incidents

Enjoying our outdoor spaces is gardening's reward, and the concept of deliberately adding elements to increase enjoyment is what I call 'staging incidents'. People have always done it - whether it was simply adding a birdbath or creating Versailles.

Sophisticated gardeners need more than a birdbath to get their jollies. Incidents must stop you in your tracks. Gardens lacking in incidents are the gardens we soon forget about and file away in our minds under "dull" or "nice plants."

Adding non-living elements to the garden is risky and can backfire. I remember touring one garden and getting the distinct impression that this homeowner must have a lifetime pass to the wholesale giftware mart. Incidents should be witty or beautiful or both. This criterion should eliminate anything that can be store-bought, as no credit is earned by simply buying something and plunking it down in the garden. Gardeners knows that they must earn their pats on the back.

A creative person will have no trouble staging an incident or two in his or her garden, but for those poor, uncreative people this subject could be a real problem. (The fact that most uncreative people do not garden is, in this case, a blessing and probably saves us lots of ugly disasters.)

LEFT Opportunity is open for interpretation. Beauty nourishes our mind, which in turn nourishes our body and soul.

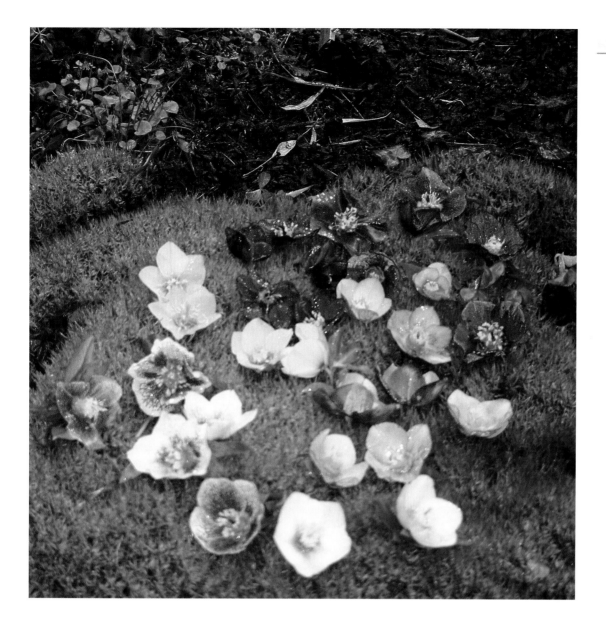

LEFT Since the flowers of *Helleborus orientalis* always hang downwards, why not pick some and place them out in the rain on a bed of moss, like this display in the Obyrne garden in Eugene, Oregon? Hellebores are cult plants – no one owns just one – and their power of addiction creates true plant addicts.

RIGHT At Heronswood Nursery, in Kingston, Washington, a dramatic sculptural fountain/ruin by sculptors Little & Lewis rises up in the woodland garden. This recent addition creates a nucleus for the dizzying array of incredible plants Dan Hinkley and Robert Jones have planted nearby.

The old maxim, "If in doubt, leave it out," applies strongly to the incident concept, as I think you have to believe strongly that what you do adds to the overall picture. If you are not certain it will, that is probably a good indication that it will not. Lack of confidence and staging incidents are opposites that do not attract.

One of the best things about incidents is that they do not have to be permanent. A deliberately placed floating flower, a tapestry of arranged autumn leaves or a touch of glitter glue on your grasses' plumes in autumn are not long-term commitments to anything, except to visual beauty and its appreciation. Installing a water feature or an entire folly, on the other hand, is a commitment that you had better be certain you will enjoy ten years from now. Weighing the permanency of what you are contemplating is a big factor to consider.

The appreciation factor is greater when we anticipate something being temporary, anyway. A fleeting display

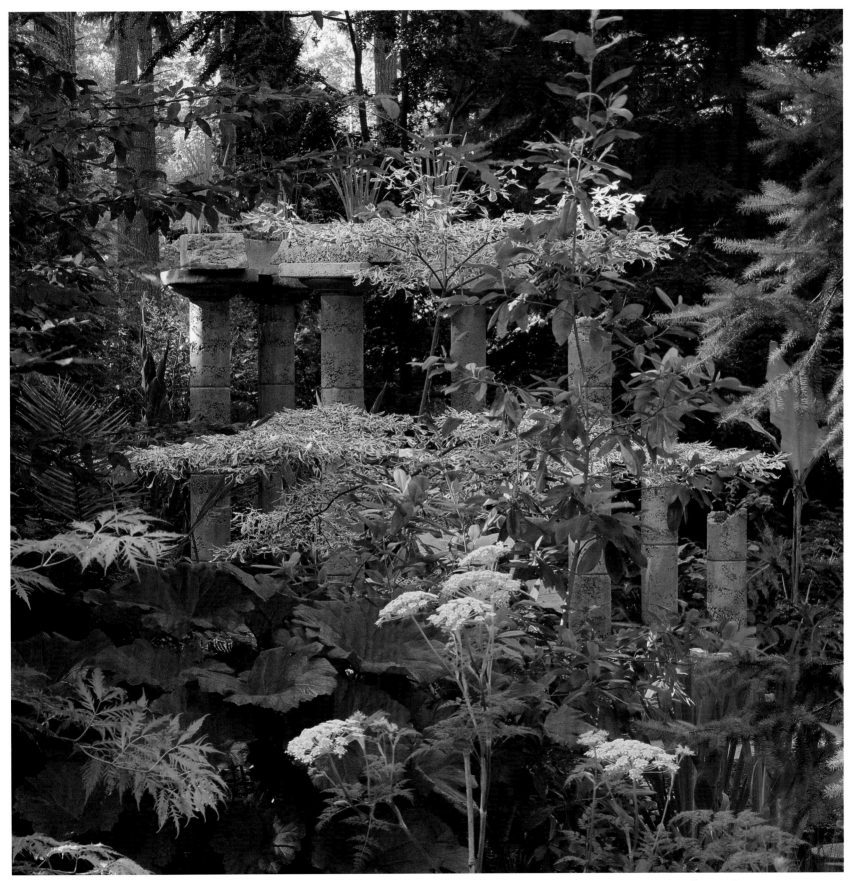

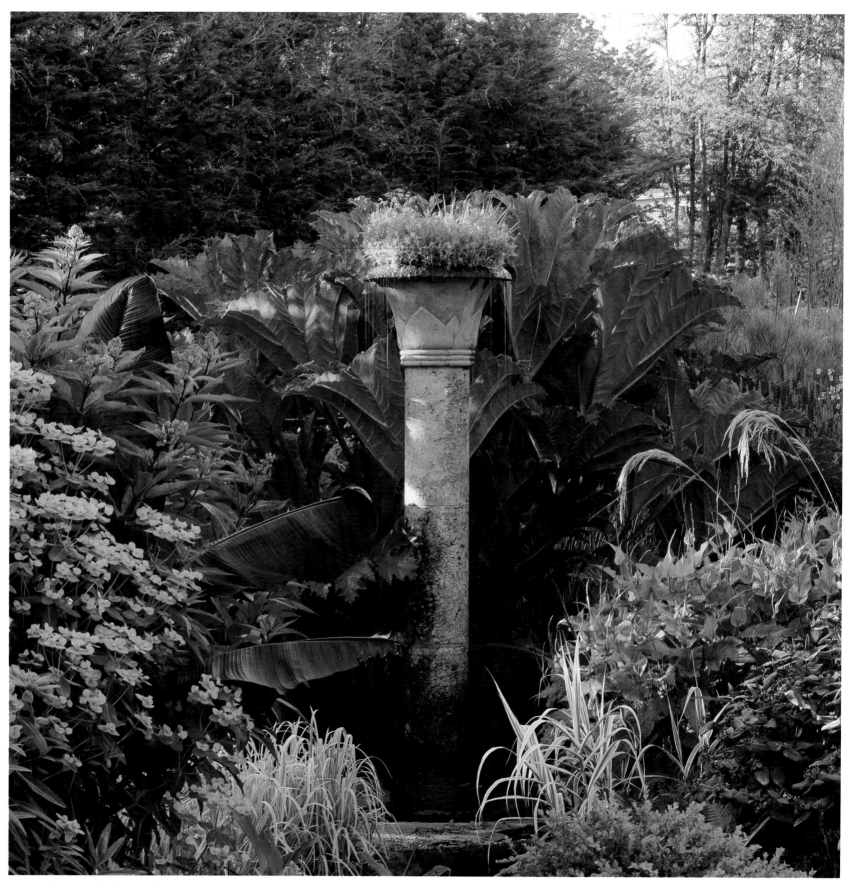

of fireworks draws crowds and cheers in large part because we know it is a burst of pleasure that will soon pass away. Stunning displays of plants should draw on the same emotions and take our breath away for an instant. Then, we move on, and another incident amazes us with the next wave of bloom or as we round the next corner.

A sudden garden vision or incident should spring up and delight us. Staging incidents is really the planting of 'spark plugs' that ignite our combustible sensory receptors and keep us amused, entertained and ready to laugh at ourselves.

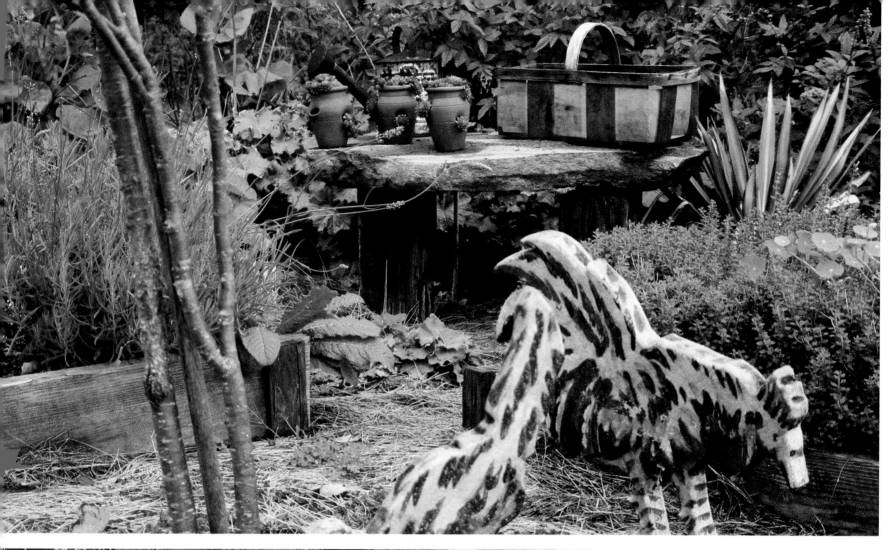

ABOVE Carved wooden chickens add humor to this vegetable garden. A few hens and chicks in tiny clay strawberry pots could be their babies – get it?

LEFT Clustering small pots of sempervivums and sedums around larger pots on my terrace creates a carefree grouping. Clustering pots into groupings creates a more anchored look.

RIGHT A set of antique carved limestone French garden dwarfs await visitors at the bottom of Lotusland, Gana Walska's amazing creation in Montecito, California. Perfectly placed, they appear to have magically emerged from the tree trunk they so closely resemble in texture and color.

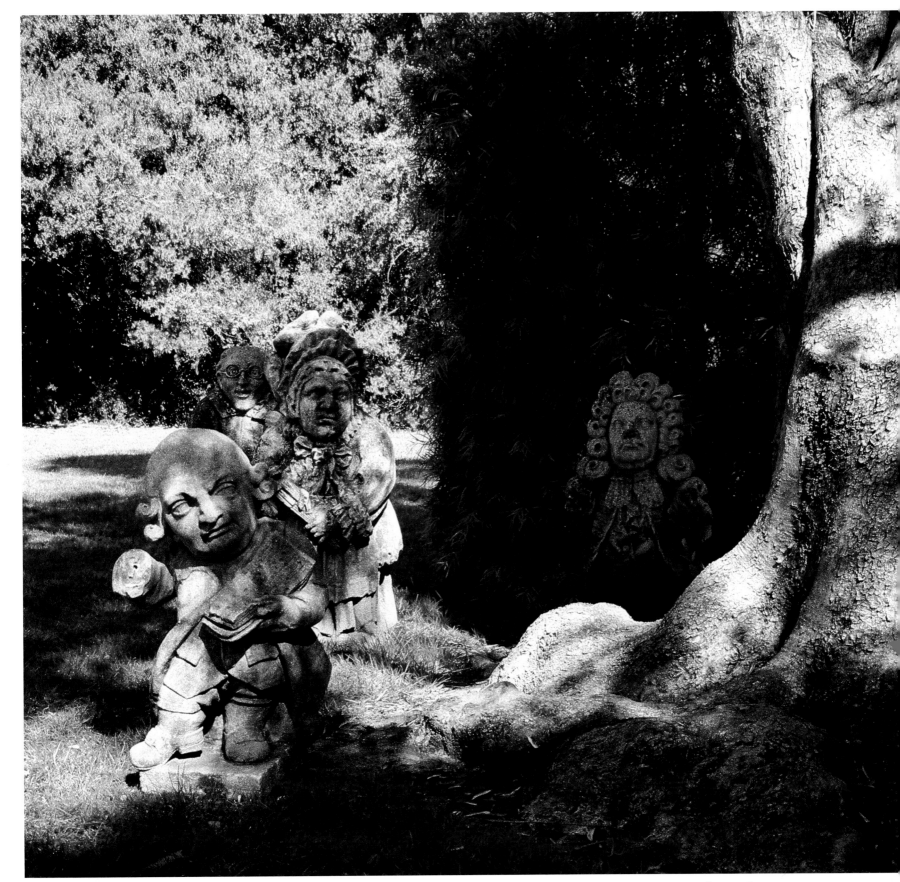

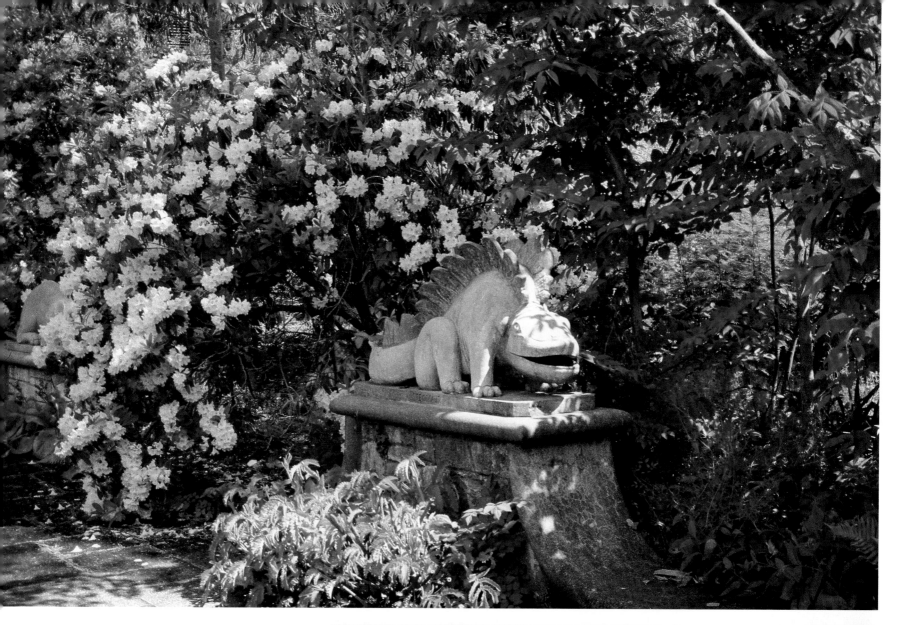

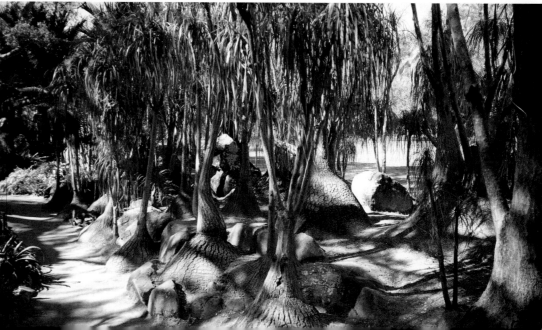

ABOVE Mount Stewart in Northern Ireland is full of incidents. When the *Melianthus major* planted below is in full growth, this prehistoric beast will look right at home amongst its jagged, saw-tooth foliage.

RIGHT At Lotusland, a mass grouping of Pony Tail Palms, *Nolina recurvata*, makes a startling and unique garden sculpture. Carefully chosen boulders mimic the swollen trunks, creating a wonderful, offbeat garden vision.

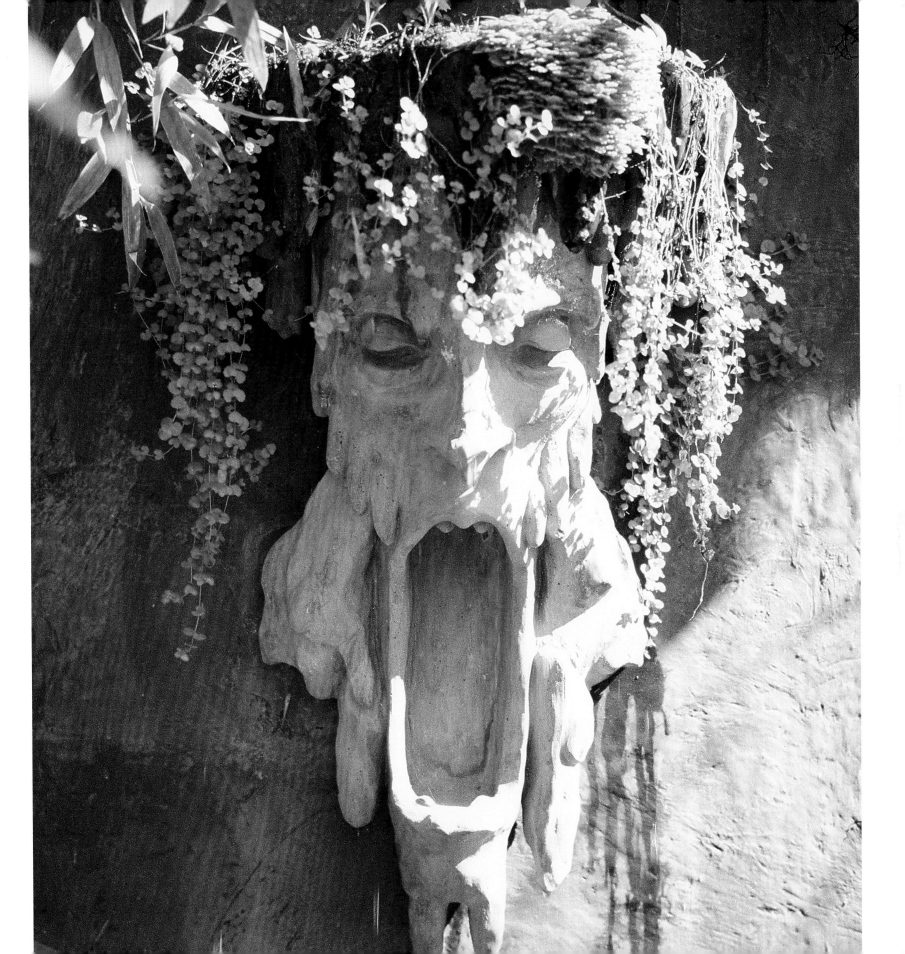

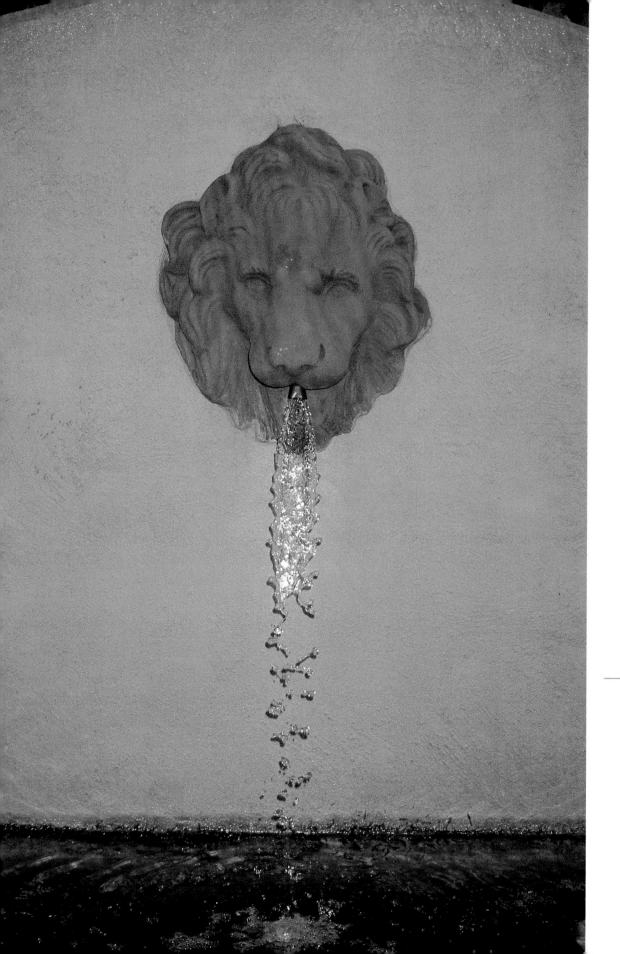

Lack of
confidence and
staging incidents
are opposites that
do not attract.

PREVIOUS PAGE Visitors are startled by this Little
& Lewis dripping water feature. Visual impact is
often more memorable when it isn't 'pretty'.

LEFT Although I loved the sound of falling water
from this lion's mask in my own garden, I have
since replaced it with a decadent jacuzzi pool.

RIGHT Do you see what I see? A garden sculp-
ture entitled "The Last Gardener" emerges from
a small pond, showing that this gardener has a
sense of humor.

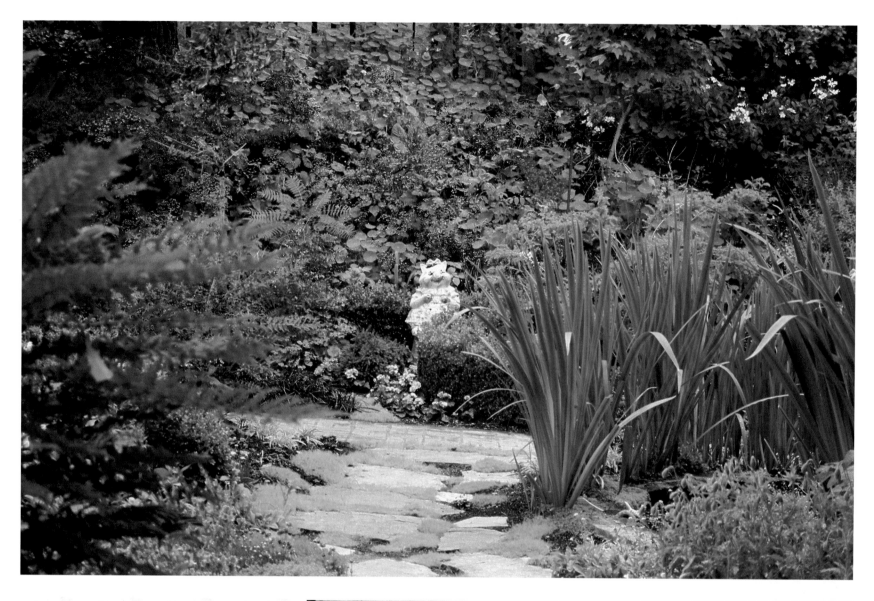

ABOVE I loved finding this Miss Piggy garden ornament in Bob Clark's very sophisticated California garden. The element of surprise is what is lacking in most gardens.

RIGHT A procession of topiary ivy quail lures visitors to investigate a garden stairway at Filoli, the outstanding gardens near San Francisco. Staging an incident such as this is often necessary to attract the eye, let alone a whole person into a new area of the garden.

ABOVE Probably more interesting than an actual fountain would have been, this sculpture in Roger Raiche's garden uses a broken column and a blue-leaved grass to create a unique watery effect.

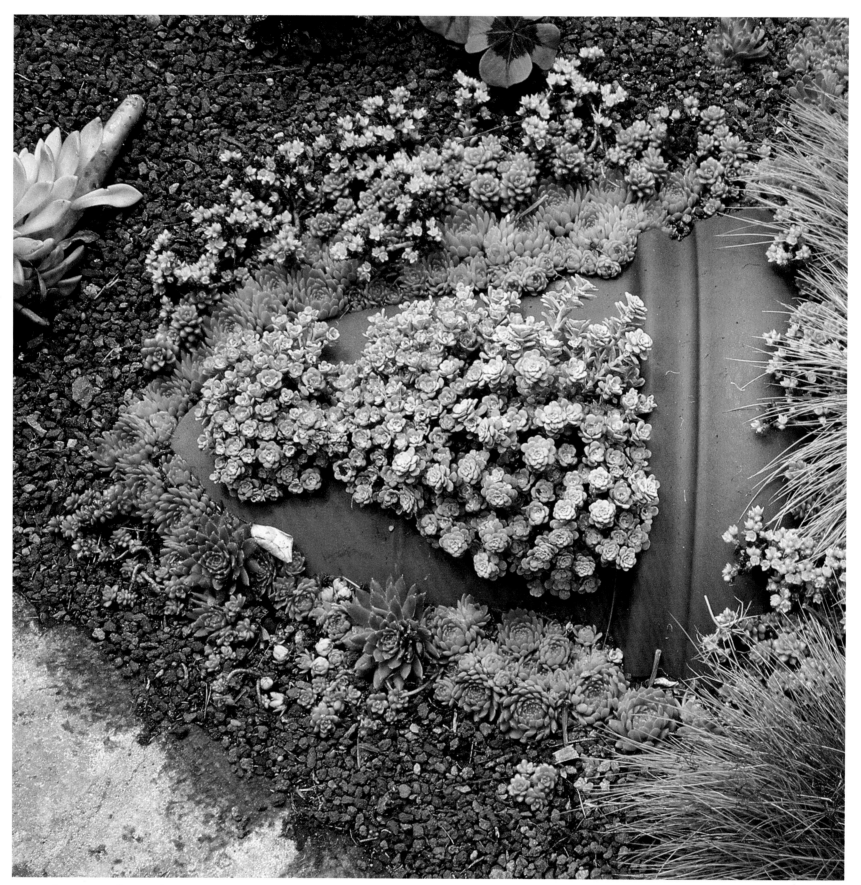

LEFT Mind games in Bob Clark's garden. A partially buried broken flower pot can still be 'planted'. Encountering such curiosities in a garden makes the experience memorable and inspirational.

ABOVE Mark Bullwinkle's iron sculptures put a smile on Bob Clark's garden gates. California leads the way, always.

RIGHT Again in California, Roger Raiche created a living sculpture by trapping an old lawn mower in a tangle of sedges and grasses. Far more interesting than something purpose-bought, this garden ornament shows real creativity.

ABOVE A spectacular explosion of *Molinia caerulea* 'Variegata' in an antique iron urn in my garden captures the evening sun. Sometimes one plant is all you need.

LEFT A rustic Mexican clay urn bearing a grape motif by my front door allows me to change my mind on its contents at will. Here a New Zealand flax (*Phormium tenax* 'Surfer') is dropped in for summer. I like its similarity of color and contrast in texture to the roughness of the clay.

portable drama

All good pottings are the result of inspiration, and mediocre ones are proof that there was none. I find that the container itself must inspire me. I have to love it. I have to want it, even empty. When you really like your containers, they will happily collect plants to fill them. If you are bored by your containers, or if they are just utilitarian vessels, they will never become dream-like visions of plantsmanship.

Placing pots is an art form. Try envisioning pots as pieces of jewellery used to decorate and enhance your garden. Understated elegance does not work all the time. Some garden situations call for knock-out punches delivered to spice up unre-markable areas, mark important features or remind us that we are awake. Group containers into clusters for more impact. Create related families of pots and contents for instant vignettes.

Color in your plant selections is a matter of preference. The choice is endless, but it is best to limit your palette in any one pot to a maximum of three colors, not including shades of green. Take a

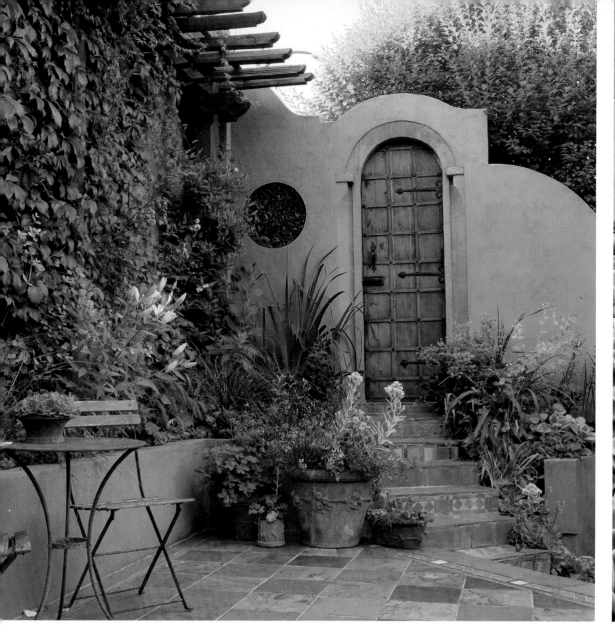

mental trip through the paintings you like and think of the colors. Soft lavender, minty green, light pink? Lovely Monet. Mustard yellow, burnt orange, black? Love those sunflowers! Transfer this artist's mentality to the colors of your plant selections and you will be staggered by the results.

Unusual plants in surprising places provide an even greater charge of excitement. A bold stand of *Colocasia esculenta* 'Black Magic' will never be forgotten, no matter where it is growing, but something always assumed so humble as Golden Baby Tears (*Soleirola soleirolii* 'Aurea') grown outdoors as a shade-tolerant, surprisingly hardy groundcover causes just as big a jolt

ABOVE Echeverias in low, wide clay saucers are clustered around my patio. By grouping these sculptural plants into pots I am better able to appreciate them up close rather than have them disappear in the general garden.

ABOVE RIGHT Echeverias are tucked in to every available space. Here they escape from the other side of the steps, creating a more natural effect.

to the brain because ît appears 'misfiled' — a common houseplant growing outdoors, and loving ît!

Part of gardening-as-shock-therapy is playing these mind games on ourselves, but especially on our garden visîtors. I remember being very impressed in mild, frost-free San Francisco seeing wall baskets planted entirely with the much-ignored houseplant *Streptocarpus*, happily frothing in gorgeous blooms in light shade. I just could not get over the 'houseplant only' mental picture of this plant as I had always known and grown ît.

By including unexpected plants in container plantings, the results can be striking.

envision pots
as pieces of
jewellery used to
decorate and
enhance your
garden.

LEFT Although they are not frost hardy, I rely heavily on echeverias for summer planting. All are lifted and stored in a frost-free greenhouse every winter.

Here are a few hints to ensure *successful* plantings in pots:

Plant with same-care, same-needs in mind. No matter how kooky you want to be, plants will die if their cultural requirements are forgotten or totally ignored.

Think about drainage. Pots quickly become coffins unless they drain well. Saucers that trap and hold excess water are also death-traps and should never be used outdoors.

Think about food for the plants. You must provide a good rich soil full of nutrition for your plants held hostage, trapped in a pot. No bagged soil is good enough the way it comes, and I suggest

RIGHT An Italian terra cotta garden stool simulating stacked cushions fills a niche. Sedums and echeverias bake in the sun in a very shallow planting pocket amongst my concrete paver patio slabs.

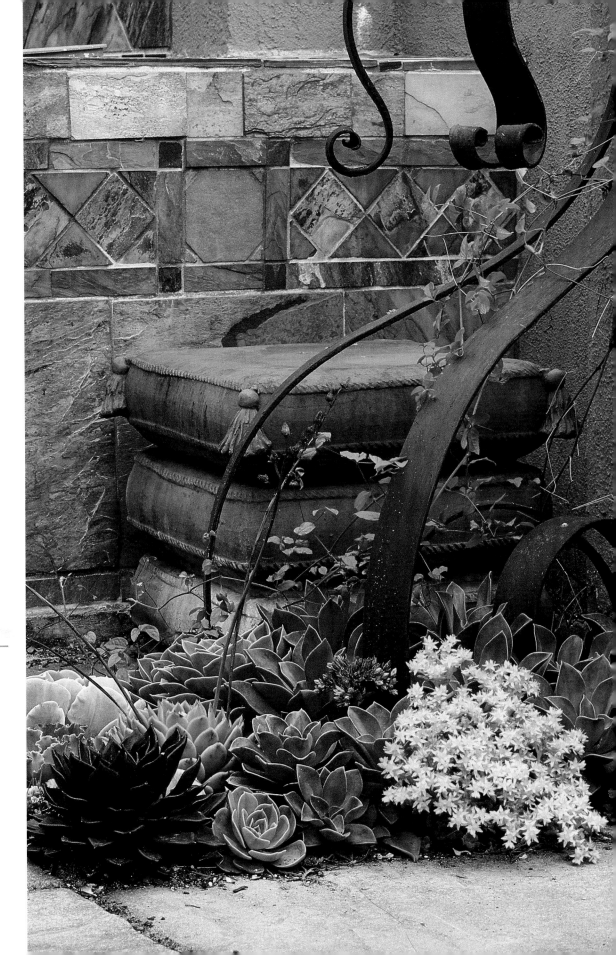

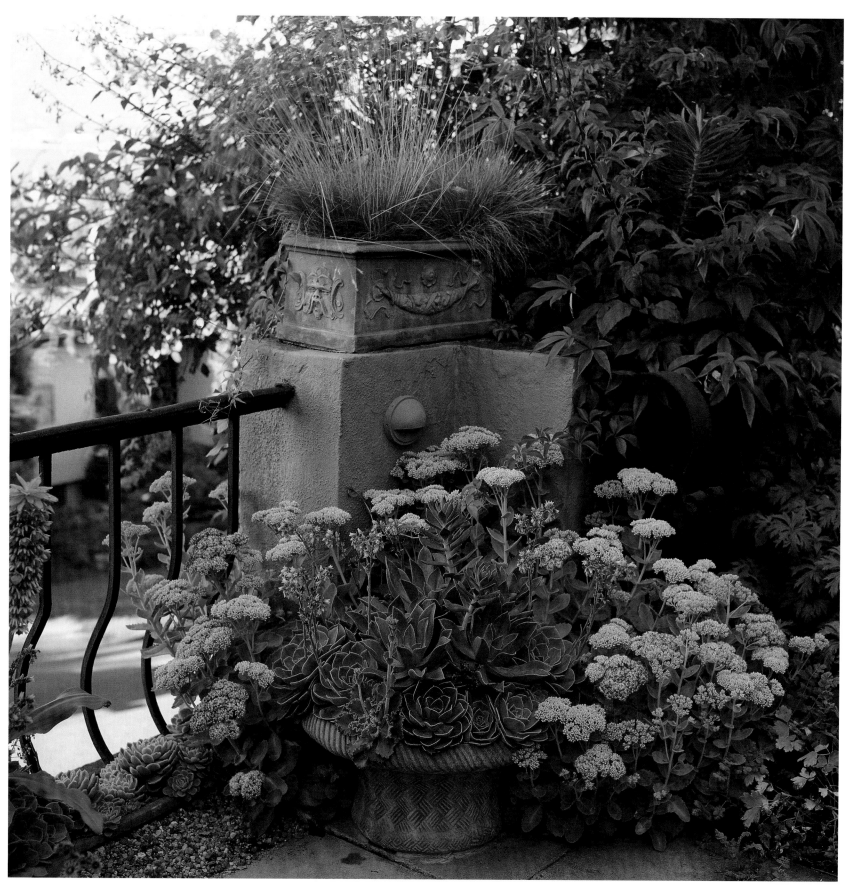

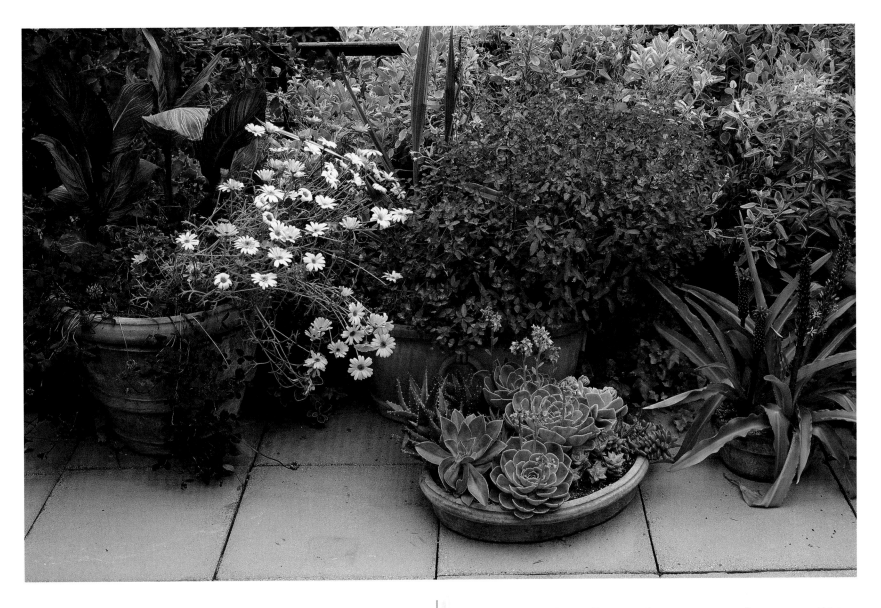

ABOVE A collection of pots forms a barrier against a low railing on my terrace. The rarely seen 'Peach Cheeks' marguerite steals the show. *Canna* 'Phaisson' and *Euphorbia dulcis* 'Chameleon' keep the colors masculine and interesting. The Pineapple Lily, *Eucomis bicolor*, is nearly hardy, but I grow them in pots just to be safe.

LEFT *Sedum* 'Autumn Joy' backs a basketweave Italian terra cotta pot bursting with echeverias on my terrace. An ornate, rectangular terra cotta pot is deliberately planted with simple, evergreen grasses. I want the pot to be noticed.

mixing in 50% well-rotted or composted manure. This will provide a good meal for potted plants for up to five years. Annuals love 20-20-20 fertilizer dissolved in water and applied liberally every two weeks. This produces lush, fast growth.

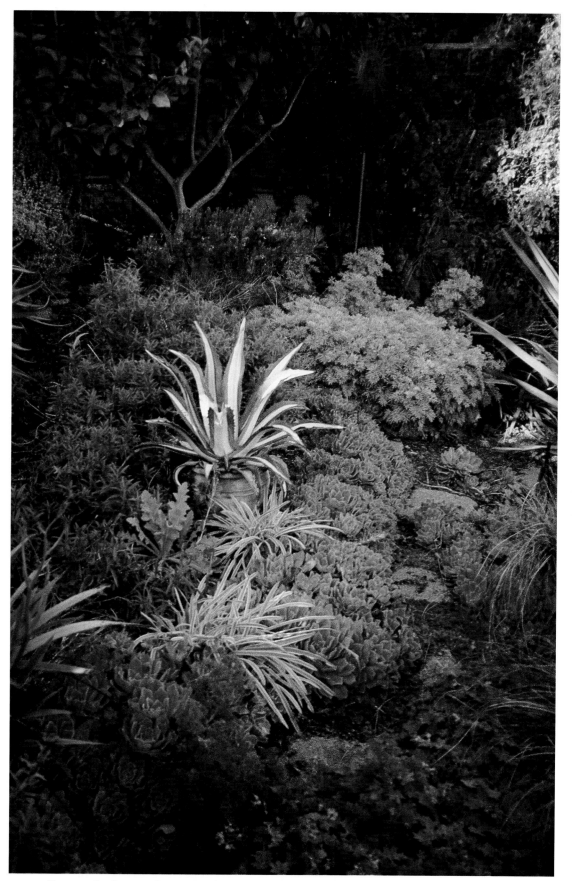

placing pots

is an

art form.

LEFT Dropping a potted agave into the picture adds instant punch to any setting. Here, the beautifully variegated *Agave americana* 'Medio-picta' creates a living focal point. In colder climates, these plants are just as happy indoors for the winter.

RIGHT At Heronswood Nursery in Kingston, Washington, Dan Hinkley uses potted Agaves and *Melianthus major* to define and beautify a seating area. Orange-flowered *Begonia suther-landii* obscures the huge pot in which it and the melianthus are growing by cascading profusely over the edge.

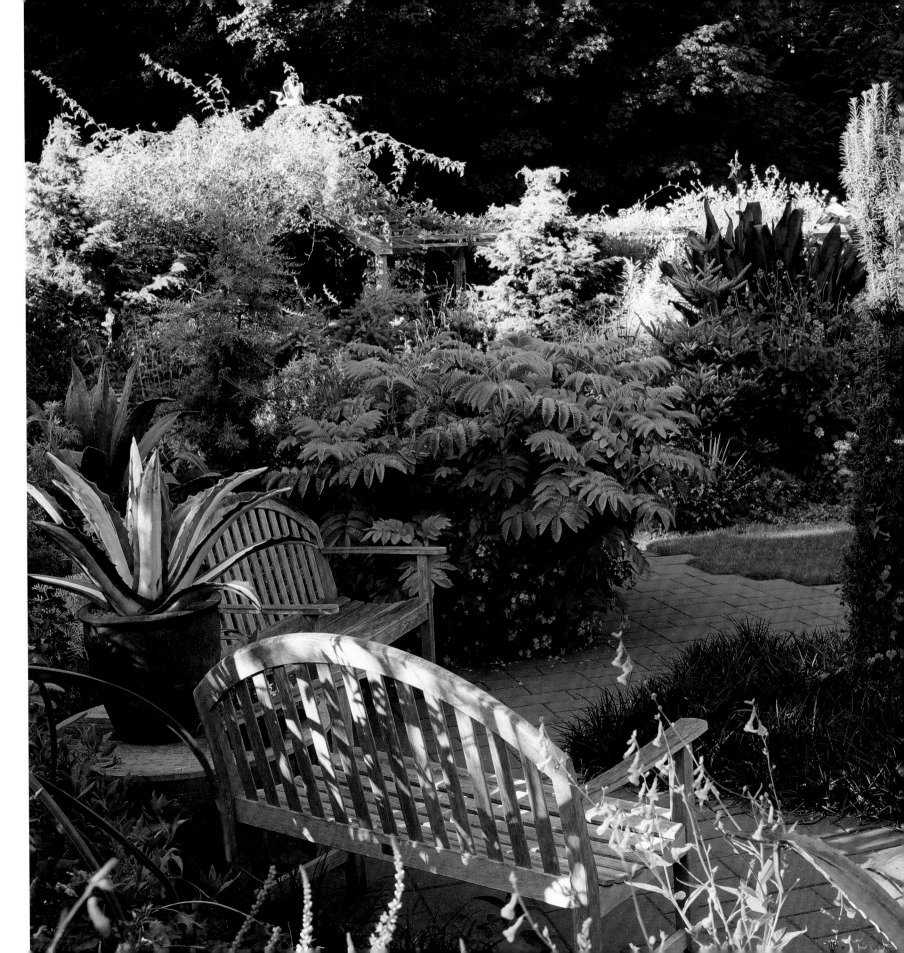

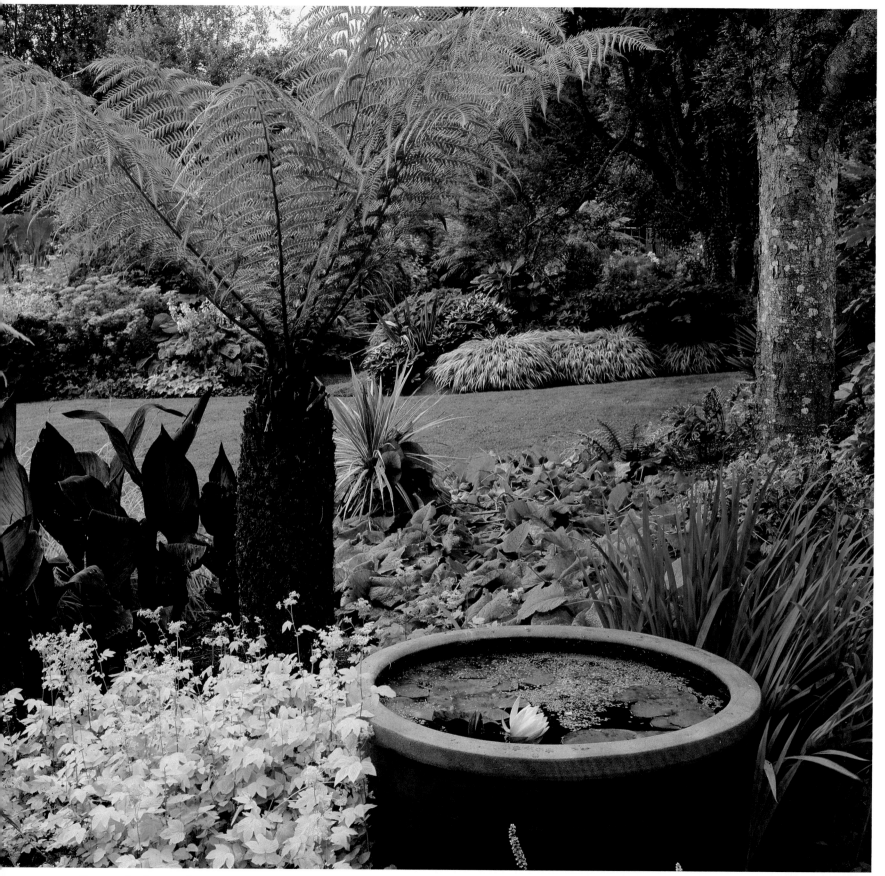

LEFT A simple pot of waterlilies under a *Dicksonia antarctica* tree fern in Linda Cochran's Seattle garden provides a Zen moment. The golden *Filipendula ulmaria* 'Aurea' matches the waterlily, of course.

ABOVE The exquisite simplicity of rose 'Sally Holmes' is a perfect match for this lovely glazed urn in Bob Clark's California garden. Remember that a container may also be left empty or filled with water. Sometimes actually planting a container should be the last choice.

RIGHT The startling acid yellow foliage of *Berberis thunbergii* 'Aurea' makes sure this urn of water is not overlooked in Bob Clark's garden. Frothy bronze fennel (*Foeniculum vulgare* 'Purpurascens') appears to be a water source billowing beside and visually anchoring the urn.

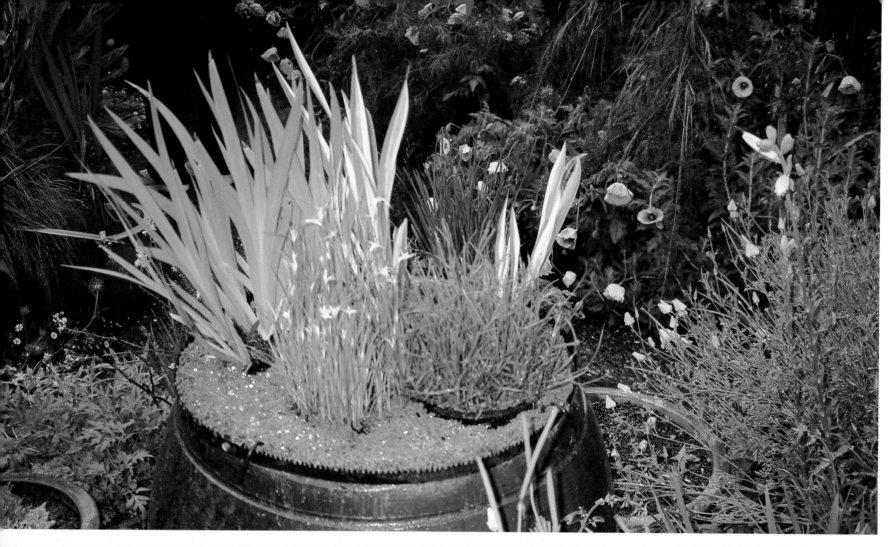

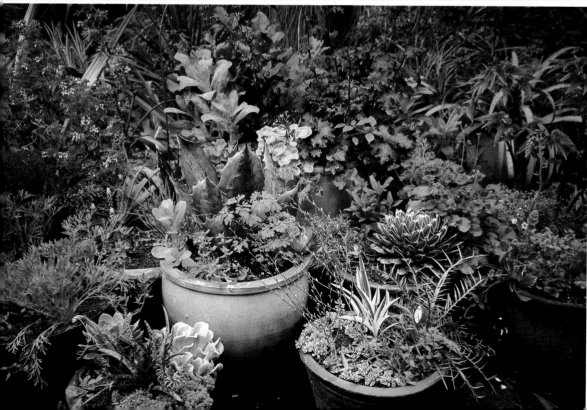

ABOVE Old saw blades installed around the rim of this container water garden act as an effective deterrent to marauding raccoons in Roger Raiche's California garden.

LEFT Roger Raiche clusters an amazing number of varied, interesting plants into his containers. Such plants can better be appreciated for their unique characteristics by contrasting them with other interesting foliages for a massive dose of beauty.

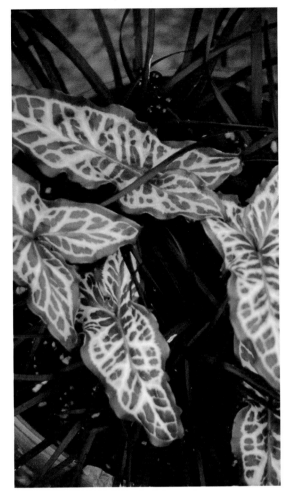

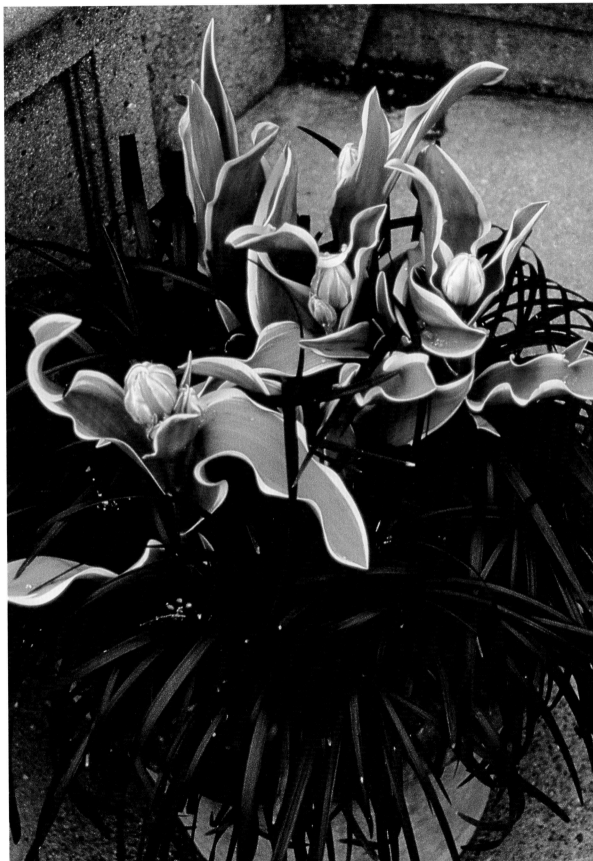

ABOVE Startling contrast in winter pots designed and planted by Charles Price and Glenn Withey. The beautifully veined and marbled foliage of *Arum italicum* 'White Winter' dazzles against the pure black foliage of *Ophiopogon planiscapus* 'Nigrescens'. Both plants enjoy cool winter weather and are unharmed by light frosts.

RIGHT Tulip 'Raoul Wallenberg' shows off its fabulous variegated foliage against the black *Ophiopogon planiscapus* 'Nigrescens' with which it shares a pot in this Withey–Price design. Particularly stunning plants cannot go unnoticed when brought to the viewer's attention by such dramatic planting.

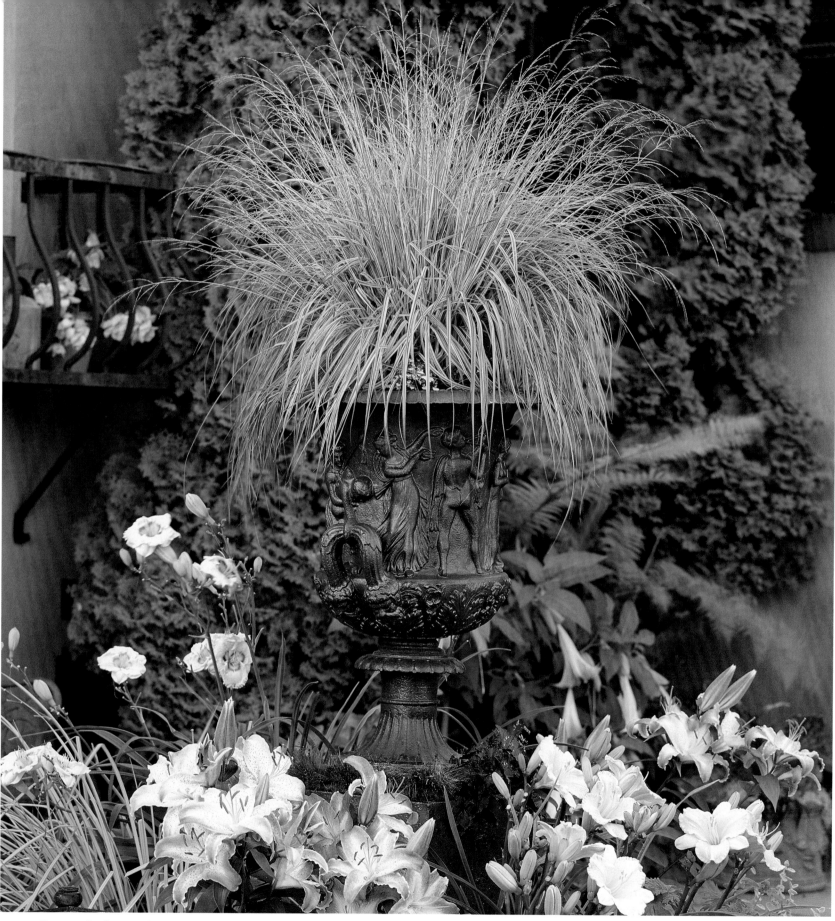

ABOVE *Rhodochiton astrosanguineum* decorates a balcony with its casual swags of two-toned flowers. Old watering cans are grouped nearby simply because I enjoy looking at them. Staging vignettes for your own satisfaction is what gardening is all about.

LEFT A planting of Oriental hybrid lilies and daylilies encircle a large iron urn in a summer spectacle on my terrace. *Molinia caerulea* 'Variegata' fills the urn with a fountain that needs no plumbing.

RIGHT Blackmore & Langdon tuberous begonias decorate an iron balcony overlooking my patio. I chose shades of apricot and soft ivory to go with my house's paint color. By elevating these beautiful begonias, I am better able to admire their flowers up close.

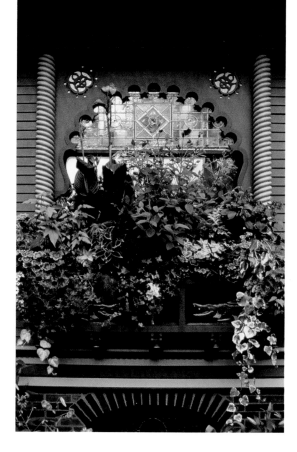

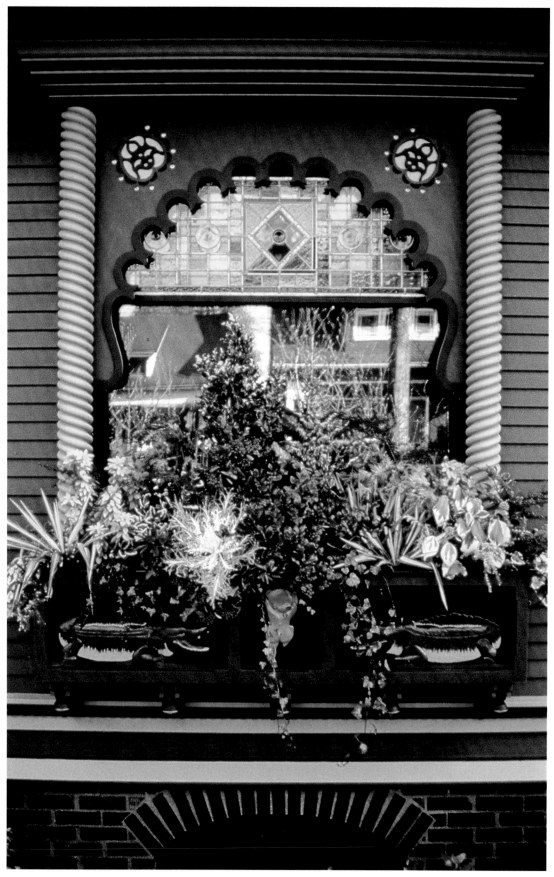

In Seattle, garden designers Charles Price and Glenn Withey orchestrate this magnificient tribute to the seasons in a client's spectactular, custom-made windowbox. Summer (above) and fall/winter (left) rely on diverse foliages. Spring (facing page) bursts with bloom in a spectacle matched only by the Victorian architecture of the house.

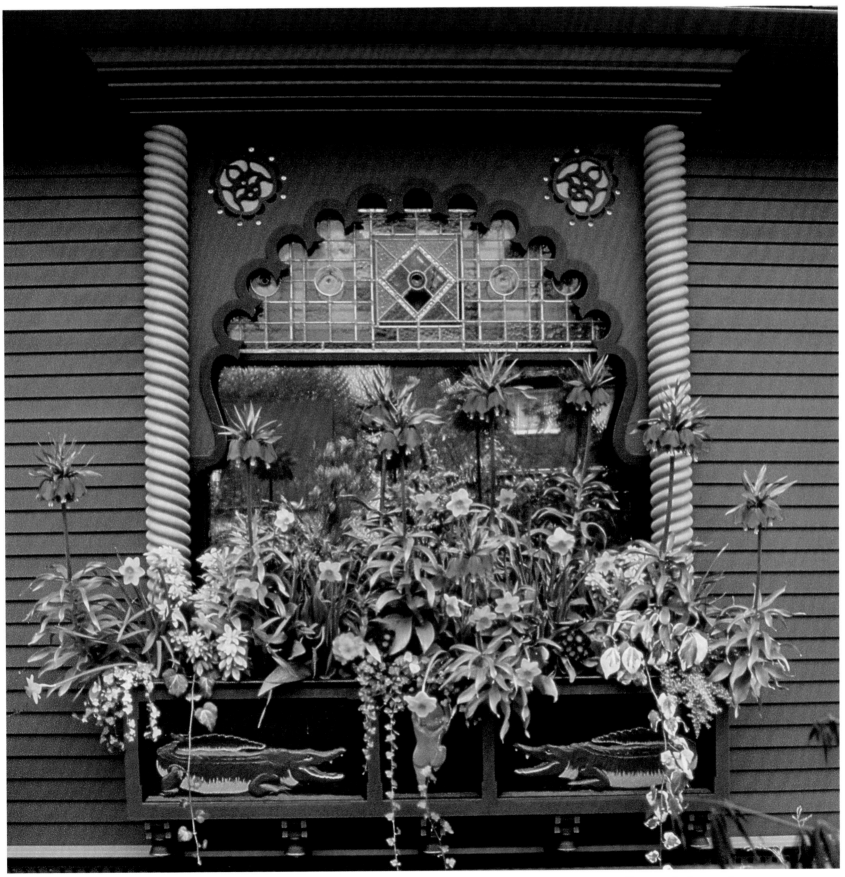

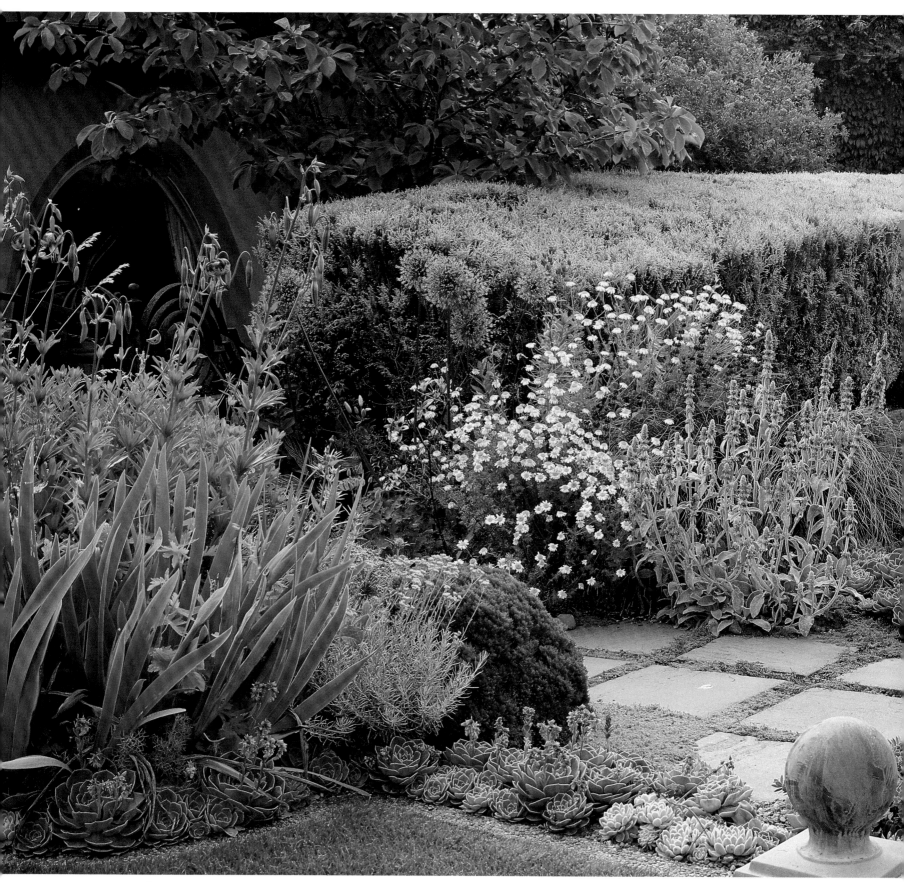

home

My own garden is the result of constant fresh input of more and more plants, endlessly replacing and augmenting already full plantings. I can always fit one more box of plants in, somewhere! Walking around with a plant in my hand, I try to envision what this plant and its combination effect will look like in five years, fifteen years — or even in fifteen minutes. If I like my vision into the future at each of those three intervals, I will quickly plant right there, right then. If I do not like the future vision, I walk around some more and squint my eyes, holding the plant into a perceived potential location and try again. It takes only one or two tries per plant to get the hang of it, and soon, very soon, all my planting is done. I never use a pen and paper, never a plan or drawing — ever. Experience has taught me that my own creativity is more spontaneous. There is nothing creative about paint-by-numbers planting.

The most dominating effect on a city garden is the house. It must be taken into consideration as it is generally too large and takes up too much of the lot to ignore. Most gardeners like their garden more than their house anyway, but the two should relate and complement each other. Architectural style of

LEFT The front walkway of tinted concrete pavers, cast to look like stone. Woolly thyme, *Thymus pseudolanuginosus*, fills between each paver and smells terrific underfoot. Ball finials define the entrance, and echeverias are bedded out each year to further enhance the hot, desert look. *Anthemis tinctoria* 'Sauce Hollandaise' is one yellow daisy I can stand, and combines softly with grey-leaved *Stachys byzantina* (Lamb's ears), and the wonderful dark biscuit brown of *Verbascum* 'Helen Johnson'.

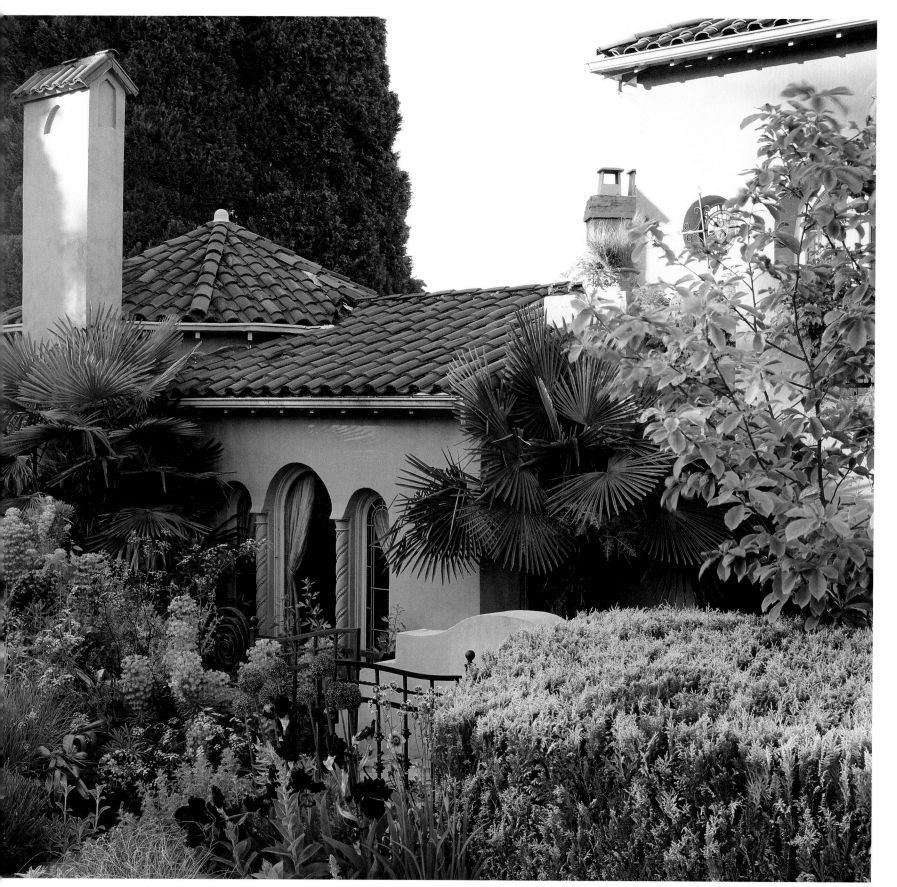

the house and garden should match. A sense of honesty should come through, not pretense or affectation.

My house is a 1930s Mission Revival-style oddity that inspired a garden quite unusual for my area. Most Pacific Northwest gardens rely heavily on rhododendrons and traditional mixed perennial borders. By taking into consideration my houses's architecture, I have surrounded it with a mixture of

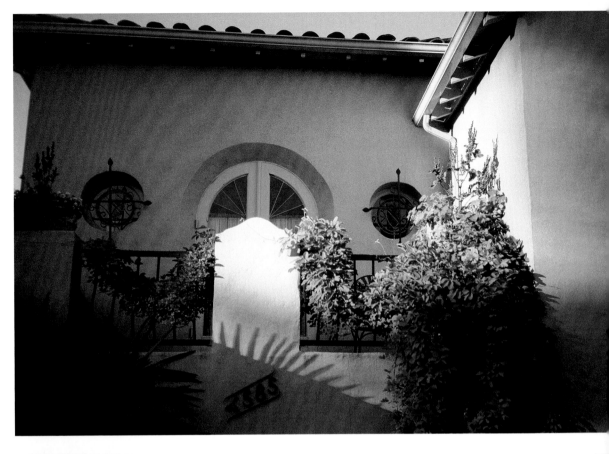

LEFT *Allium* 'Globemaster' and *Iris* 'Hello Darkness' add a splash of purple to my front entry walkway. The 1930s Mission Revival architecture of the house came to life when a glowing salmon paint job replaced fifty years of white ho-humness. Chartreuse *Euphorbia characias* ssp. *wulfenii* on the left balance an inherited golden cypress hedge on the right.

ABOVE RIGHT *Akebia quinata* 'Alba' maraudes its way to a second-floor balcony. Trained into a garland, its fragrant white blossoms make a superb, hardier jasmine substitute. A shadow of a palm leaf from *Trachycarpus fortunei* adds a tropical touch, as does night lighting installed to even more dramatic effect.

RIGHT What I call my 'burglar-proof border' sweeps across the front yard. White *Crambe maritima*, *Crambe cordifolia*, lime green *Euphorbia characias wulfenii* and purplish *Euphorbia dulcis* 'Chameleon' join verbascums, eryngiums, yuccas and other carefree heat-lovers in a no-bare-earth jungle.

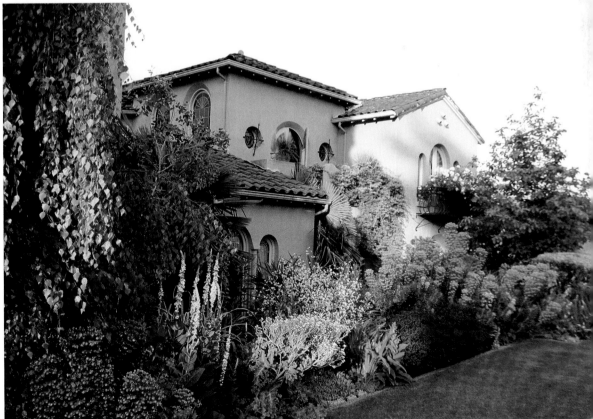

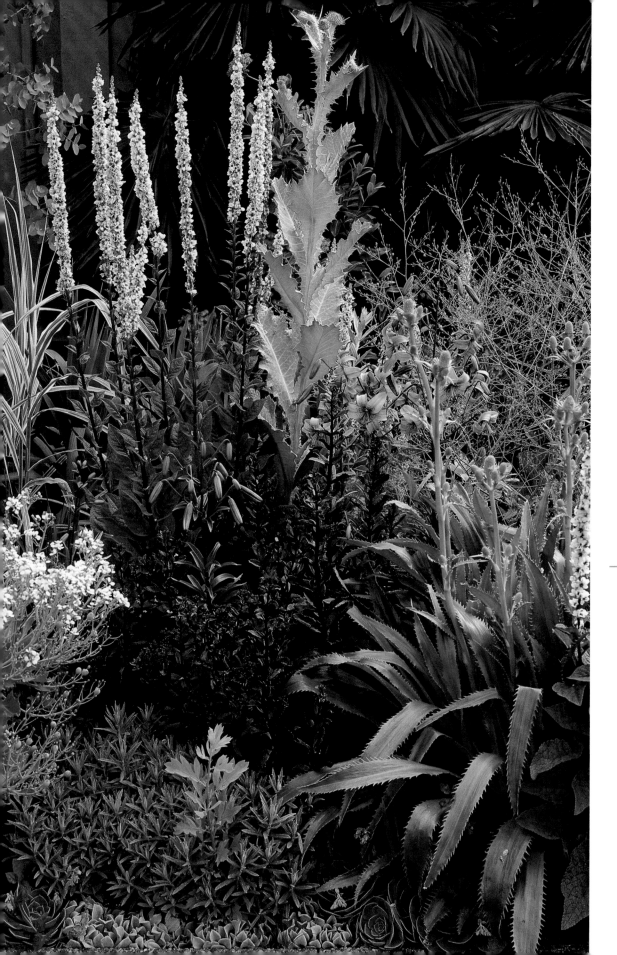

Mediterranean plants which have turned out to be surprisingly quite happy on the West Coast of Canada. By including as much spiky texture as possible, I have created a hot, desert-looking gardenscape that complements my home. I have eliminated most of the original planting and installed an exciting collection that makes of the garden and house one unified vision. This sense of appropriateness is the test of a successful outdoor space, whether it be a formal English garden or a Japanese koi pond complete with bamboo forest. Do not create the wrong gar-

LEFT A close-up of the front border. Vertical white mullein (*Verbascum chaixii* 'Album'), Giant Scottish Thistle (*Onopordum acanthium*), spear-like leaves of eryngium agavifolium and an unnamed hybrid lily create a textured cluster. The shiny, dark burgundy of *Sedum* 'Morchen' reinforces and brings attention to the dark stems of the white mullein.

RIGHT Both sides of my front walk have to energize me as I dash in and out every day. I like to limit the color palette to three colors in any one scene, but any number of plants is fine. On the left side, *Hebe cupressoides* 'Boughton Dome' forms a textural and colorful ball, nestling up to woolly thyme. *Lilium pardalinum* flashes hot orange, just strong enough to be noticed.

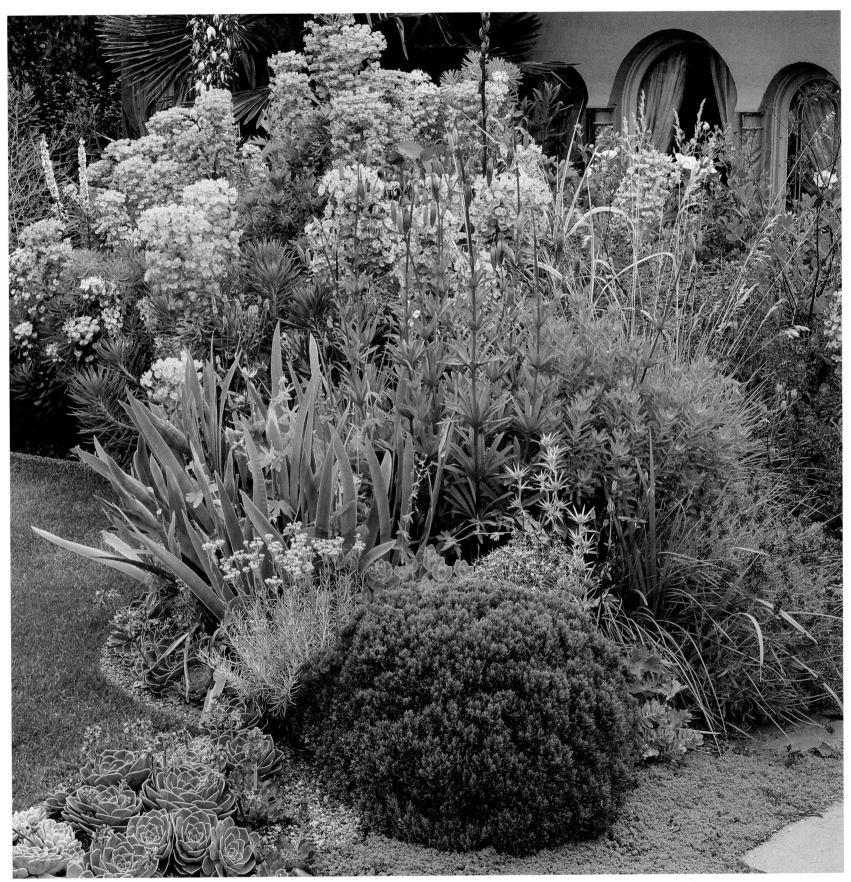

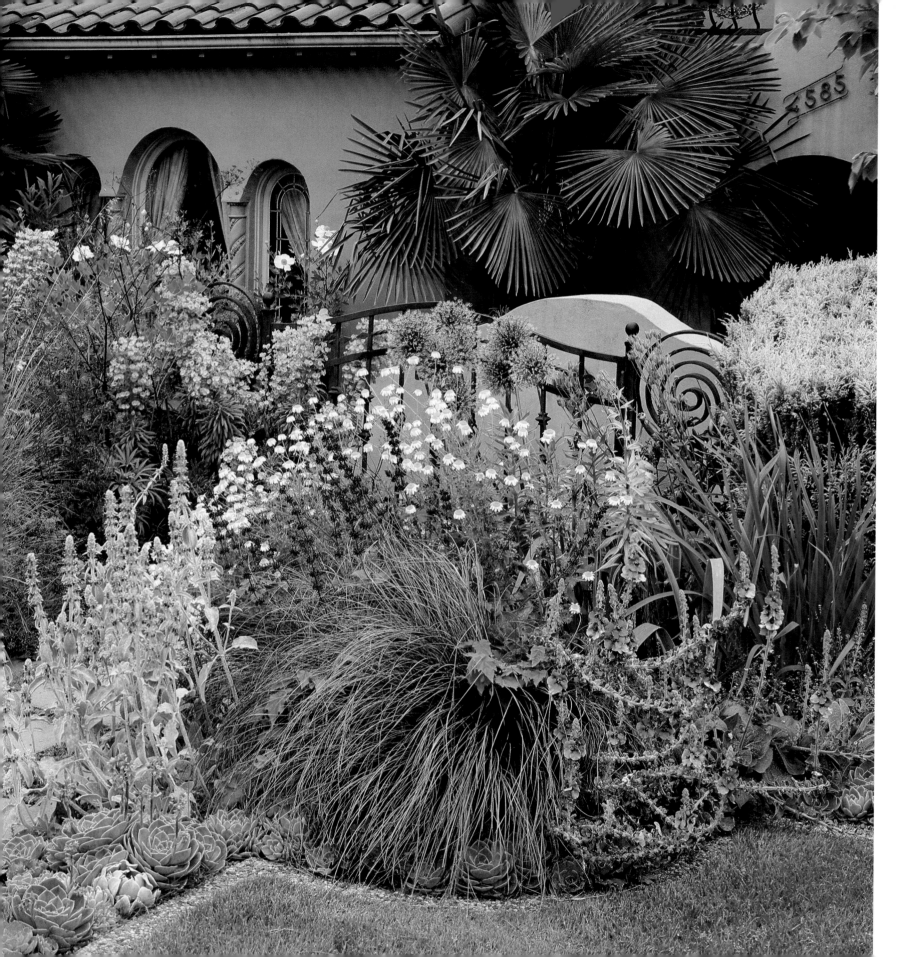

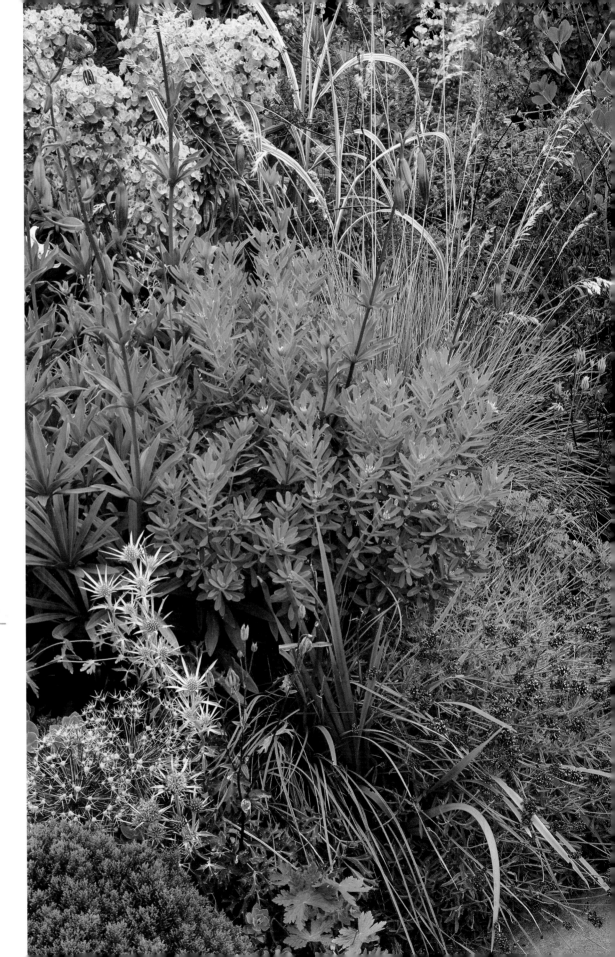

den for your house, no matter how fine the garden may seem in itself.

Color is a great stimulus: it can create and it can destroy. With the right backdrop to work against, I order plants to color co-ordinate. I know that shades of rust, peach and salmon will blend beautifully with my garden, and this makes selecting much easier. To my surprise I have found I also use lots of purple and mauve.

This limited color palette succeeds. I avoid yellow, red and pink. By slimming down the potential selection of plants by eliminating entire colors, the savings in time and unattractive results are huge. A tighter, more

RIGHT Lavandula 'Munstead' blooms in strong purple below *Geranium pratense* 'Victor Reiter'. Carefree grasses, *Eryngium bourgatii* and a small daphne mingle in happy abandon.

LEFT Biscuit colors tangle together at my front gate. *Verbascum* 'Helen Johnson' echoes the brown *Carex flagellifera* tuft. *Anthemis tinctoria* 'Sauce Hollandaise' is a soft yellow that keeps things mellow.

ABOVE *Clematis* 'Miss Bateman' echoes and softens the curve of a low wall, displaying herself to advantage.

cohesive overall garden 'look' comes out of this color-as-dictator missive.

It is important to have a navigable route around and through the garden. I use cement paving stones, cast to look like Yorkstone pavers in a neutral, soft mushroom beige tone. I can walk completely around my garden by means of these pavers and stay off the grass. A travel flow is essential and should be effortless. Steps and stairs are a bonus, as they add interest and give lots of interesting possibilities to place pots and create points of pause for drama. Make your favorite plants available for admiration by placing them close to the paths or in pots to be winked at as you pass by.

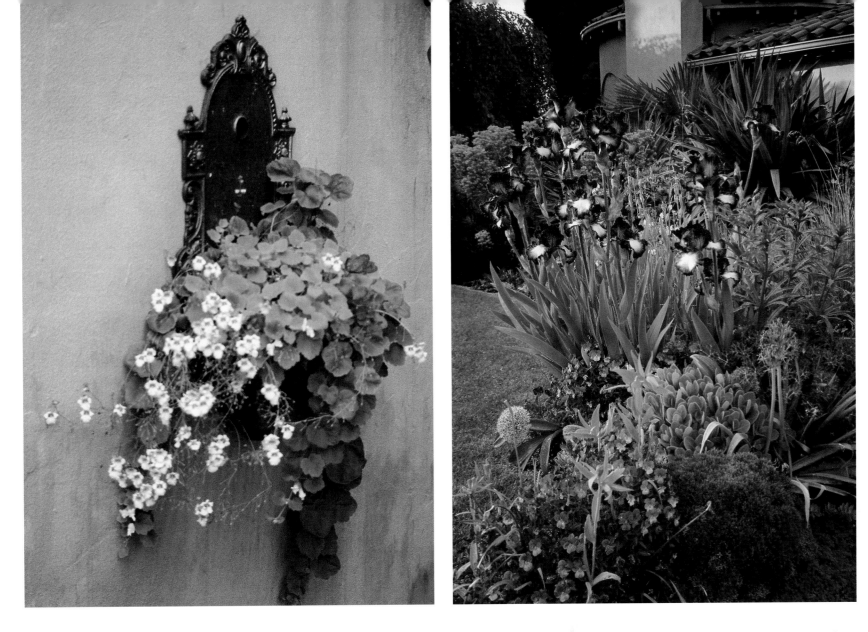

Privacy is what we crave most. It is essential. You must create it if it is not already there. Complete privacy may not be possible, but creating some area of refuge should be given top priority. The satisfaction we derive from a garden is multiplied manifold by how much of it we can experience in private, or with people we know and like. The whole reason we garden is because we enjoy it, and to take pleasure from our creation fully means we must communicate with it on a deeper level. This is when you want to be alone in the garden, and at such moments privacy protects you.

I am lucky. My garden is quite private, and by installing a few gates, an arbor and some strategically placed shrubs I have made it moreso. Look for

ABOVE LEFT *Diascia* 'Blackthorn Apricot' and *Asarina procumbens* cascade from an antique metal lavabo, providing a needed bit of color on an otherwise blank wall.

ABOVE RIGHT In spring, a happy clump of *Iris* 'Jesse's Song' and annual violas reinforce my love for purple against my house's color. I realized this unlikely combination of colors was my favorite when I first saw the hybrid pansy 'Jolly Joker'.

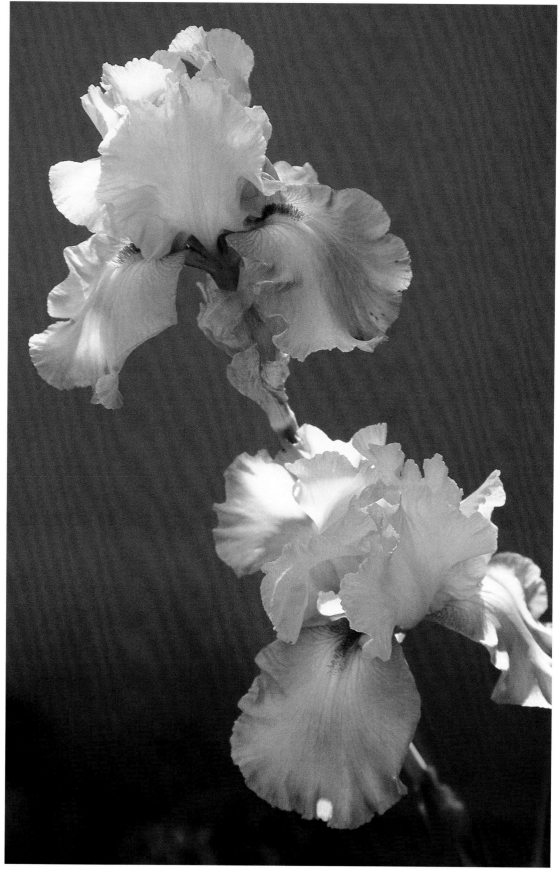

leaks in your privacy. Sometimes the addition of a broadleaf evergreen shrub will solve the problem, but it may take more. A scrim of vines or a columnar tree placed just right can block a view and add interest from your side of the fence.

Although I do love plants, I have become ruthless. Poor performers or overrated new introductions which take up valuable space I think nothing of ripping out in full bloom. This constant evaluating is the only way I have of making good use of my limited amount of space.

Once, a visiting, knowledgeable gardener, who seemed to be enjoy-

LEFT Bearded iris is one of my favorite flowers, and if I had more room I would grow many more. This variety is aptly named 'Goodbye Heart'. I often plant specific varieties of plants to go with my house's color.

ing herself, rounded a corner and pronounced, "This area is a disaster!" Instantly, I realized she was right, so I actually paved over that area of my garden. I had been unsuccessful in pulling together a triangular, sunny slope in the corner of my yard, but my failure only really hit me when someone else pointed it out. Knowing how many futile attempts I had made to garden there, I decided to create a raised concrete-and-slate terrace. It turned out to be a real asset to the overall design, and it truly anchors the south end of my property. I now have a stage on which I can display more potted collections and a private, sun-trap seating area.

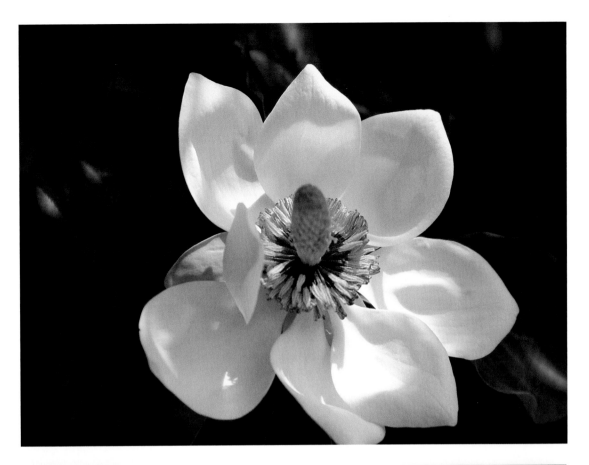

ABOVE *Magnolia* x *wiesneri* is a natural hybrid between *M. sieboldii* and *M. hypoleuca* from Japan. I always know when it is in bloom by the incredible scent of bubblegum wafting through the garden and the house.

RIGHT Even in death, *Magnolia* x *wiesneri* is completely stunning.

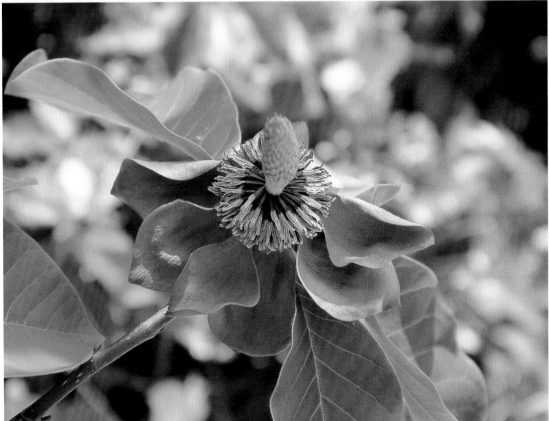

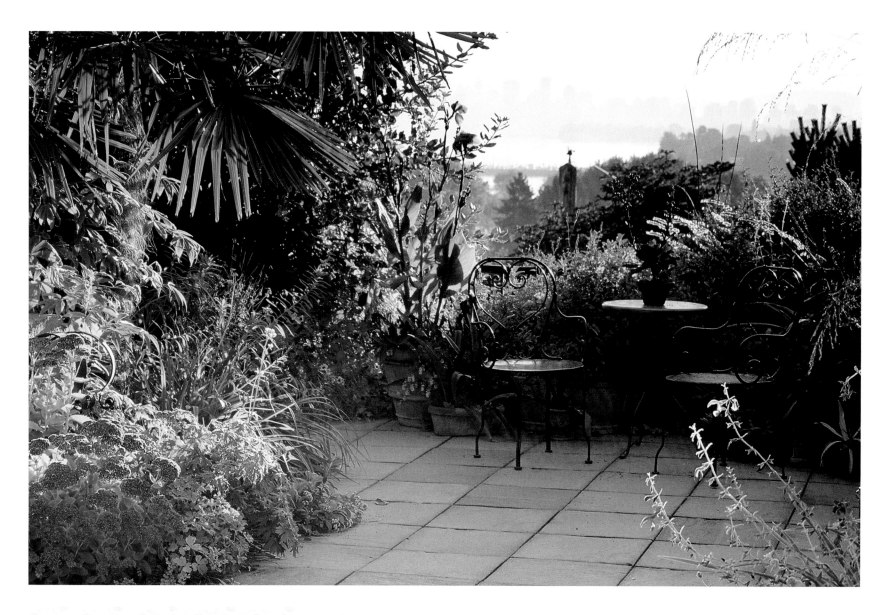

ABOVE My rear terrace is a broad sweep of the same concrete cast stone pavers as the front walk. Italian terra cotta pots hold summer favorites like *Canna* 'Phaisson', while the skyline of Vancouver draws the eye across English Bay.

RIGHT Detail of above

By planting chock-a-block full in all my beds, I have less maintenance and fewer weeds. Keeping a no-bare-earth garden happy requires more food for so many plants, so every two years I mulch all garden areas in late winter with a mulch of well-rotted mushroom manure. Spreading it by hand to a depth of two inches, I liberate trapped foliage and avoid plant crowns. Because I live in a rainy part of the world, the nutrition in the mulch is soon washed down, into the earth where the plants readily find it. The garden surfaces look immaculately tended with this lovely mulch, and the beds slowly become a bit raised, which I like the look of. By ensuring a good food supply this way, I can count on happy plants for next summer's display.

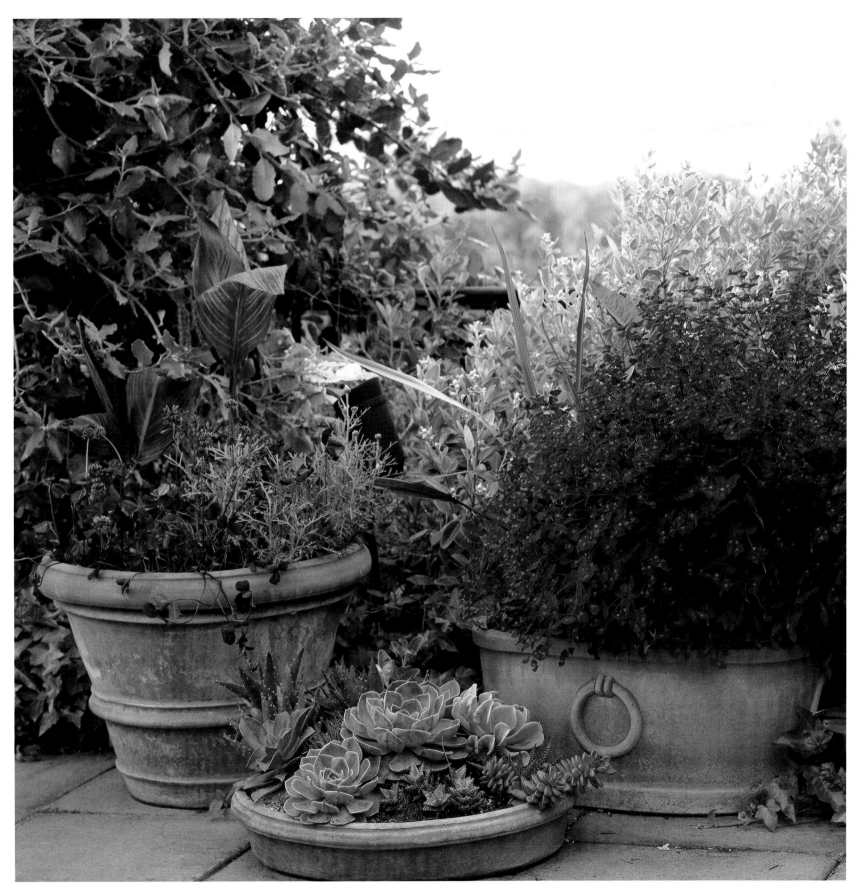

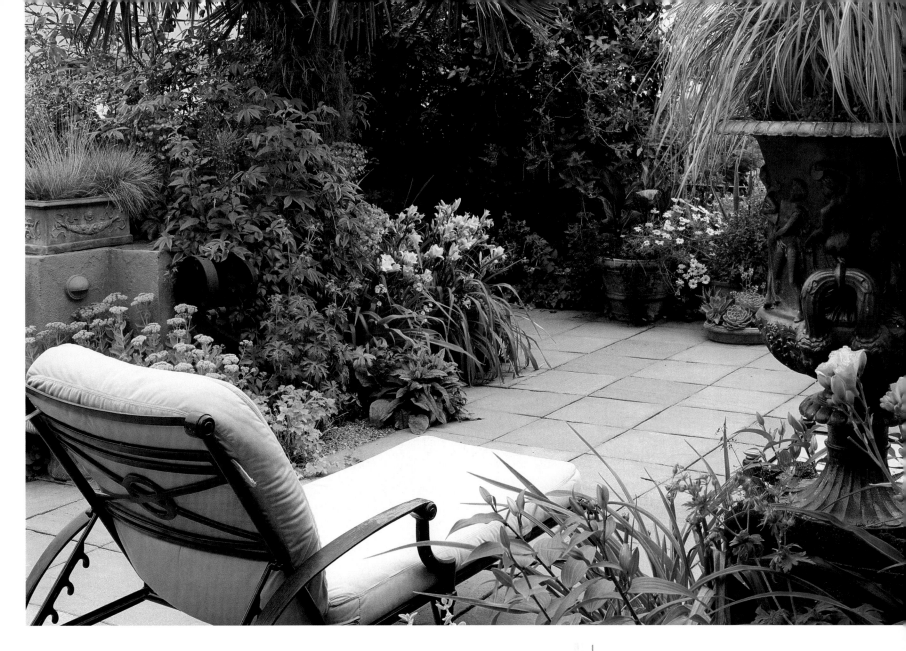

I rely on a lot of outdoor pots in the garden. I must have at least fifty. I never change the soil in them. I know I used good stuff to begin with, so I rely on that, and to ensure a good show in each pot or potted combination I sprinkle a hefty dose of slow-release 14-14-14 fertilizer pellets on top, once in the springtime. This feeding is all that is required, and because the fertilizer pellets are time-released and activated by temperature, the warmer it gets the more food the plants will receive. I hand water all my pots according to what is in them, and the results have been great.

ABOVE I think high quality, comfortable patio furniture is important. There is nothing tackier than white plastic: it says too much about your priorities. Here a comfy chaise waits amongst my patio plantings. The weeping copper beeches and large windmill palm, *Trachycarpus,* block a hideous power pole from view.

LEFT A slate and tiled plunge pool completes the 'away from it all' fantasy of my terrace. I consider this indulgence to be the best thing I've ever done, period.

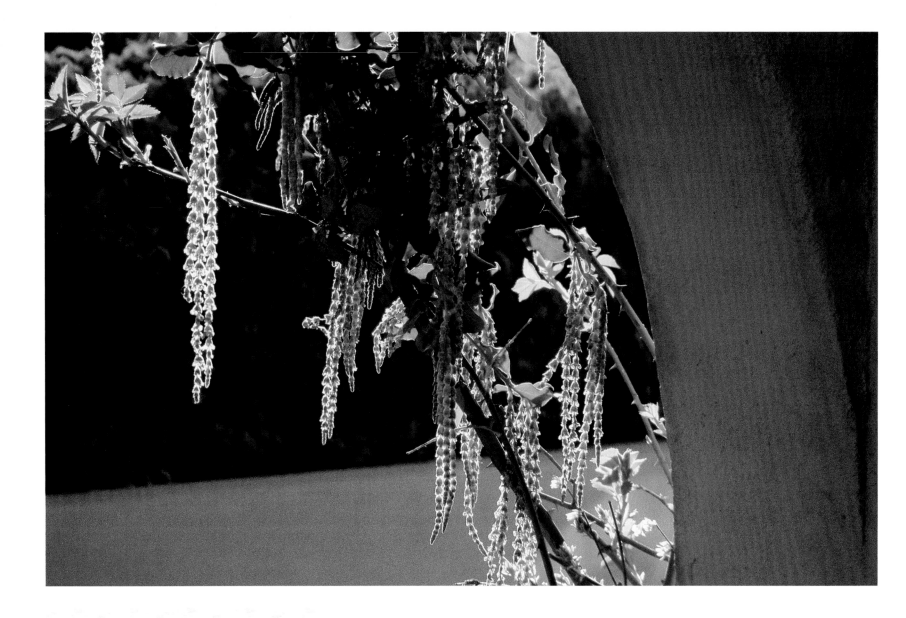

ABOVE The foot-long catkins of *Garrya elliptica* form a curtain outside an arched doorway to the patio. In late winter, they begin elongating and are fun to inspect close up. Participatory plants need to be handy.

RIGHT Every winter proves I cannot fool myself all year long. Who was it who said "A killing frost devastates the heart as well as the garden?" But there is always next year...

By combining gardening in containers with gardening in the open soil, I find I am better able to experiment and grow a wider range of plants at home. I use my own garden as a laboratory, constantly trying out new combinations of plants, hoping to score. Favorites come and go. Right now, I am mad about hardy abutilons, kniphofias and ferns, whereas three years ago I would not have given them a second glance.

The world is so full of exciting plants, I know I have not yet even scratched the surface. I wait and wonder when my next garden rampage will hit . . .

visions

Being overwhelmed by what you see is an experience that does not happen very often. When it hits me, I try to drink in the moment, standing absolutely still and practicing 'freeze frame' with my eyes and mind. My hope is for recall of these treasured visions at a later date, even forever. Appreciating what we see is magnified and made more enjoyable when we experience it alone, or at least with as few other people as possible.

LEFT Golden Italian cypresses (*Cupressus sempervirens* 'Swaine's Golden'), rare in this part of the world, rise in supreme contrast to the horizontally tiered steps of Peter Newton's dramatic pool at Newton Vineyards in Napa, California. Balance, contrast and scale come together to create a breathtaking spectacle.

Do not expect to feel transcendent in a mob scene. When you find yourself in what you realize is a special place, chances are only special people will be there, too.

The appreciative lover of beauty gets so much more out of life. We also give more back through our gardening efforts. Beauty helps us to get by. It is a terrific pain killer. Beauty can fill the void left by a lost love, sad childhood or bad investment. A walk in the park always cheers you up. I think the human spirit needs plants: we use them to access our true self. Never be afraid to receive from Nature what Nature wants to give back to you — your sense of wonder.

RIGHT Few plants could hold their own when competing with this magnificent garden staircase at Winterthur. *Picea breweriana* has been artfully pruned to effectively soften the passage and subliminally descend. It is hard to say which is more beautiful in this pairing: Nature's or Man's handiwork.

LEFT Locally known as Eden Rock, the gardens of Pamela Kramlich's Napa Valley garden perfectly take gardening into the New Millennium. Visionary in design and content, this garden uses sculptural forms as top priority.

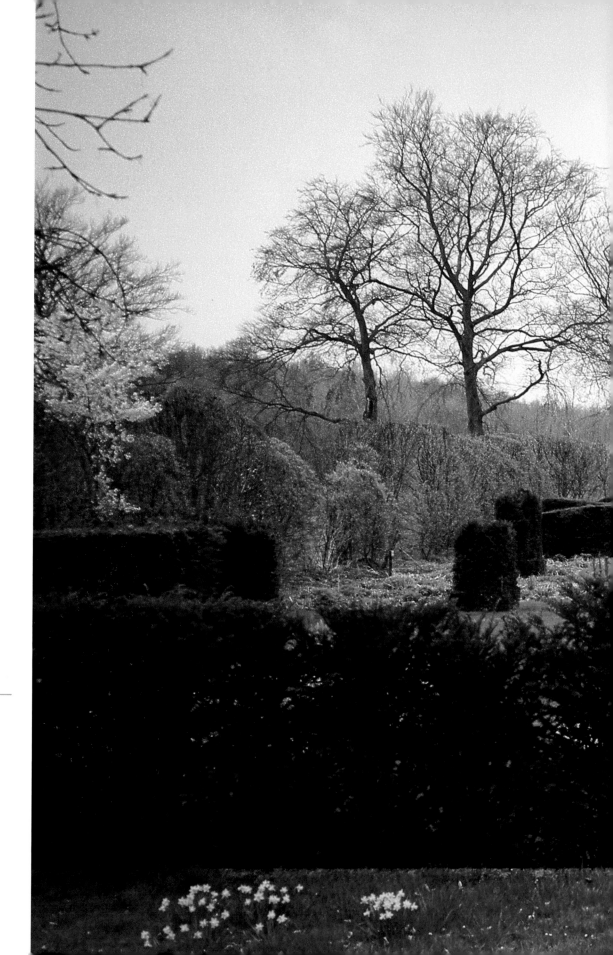

RIGHT In The Netherlands, nurseryman and garden designer Piet Ouldoff's hedges create a sculpture garden. More like an art installation, this unique concept will continue to grow and change over time as a living work of art and a monument to his talent.

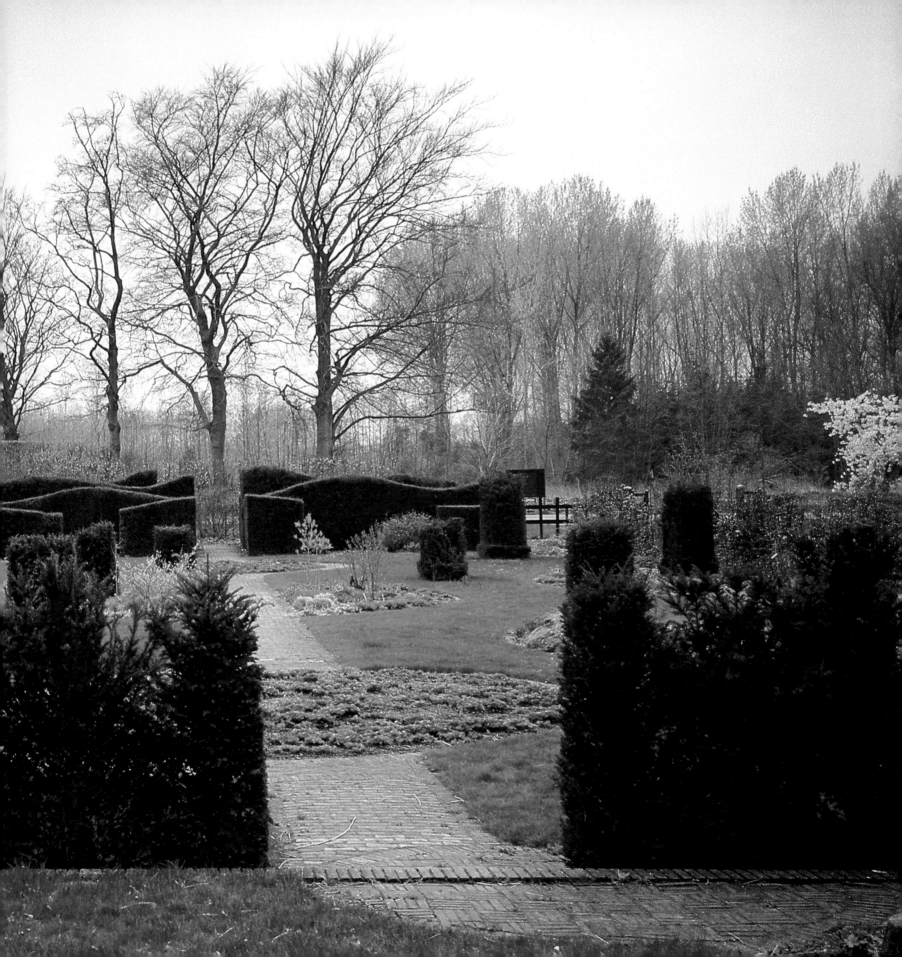

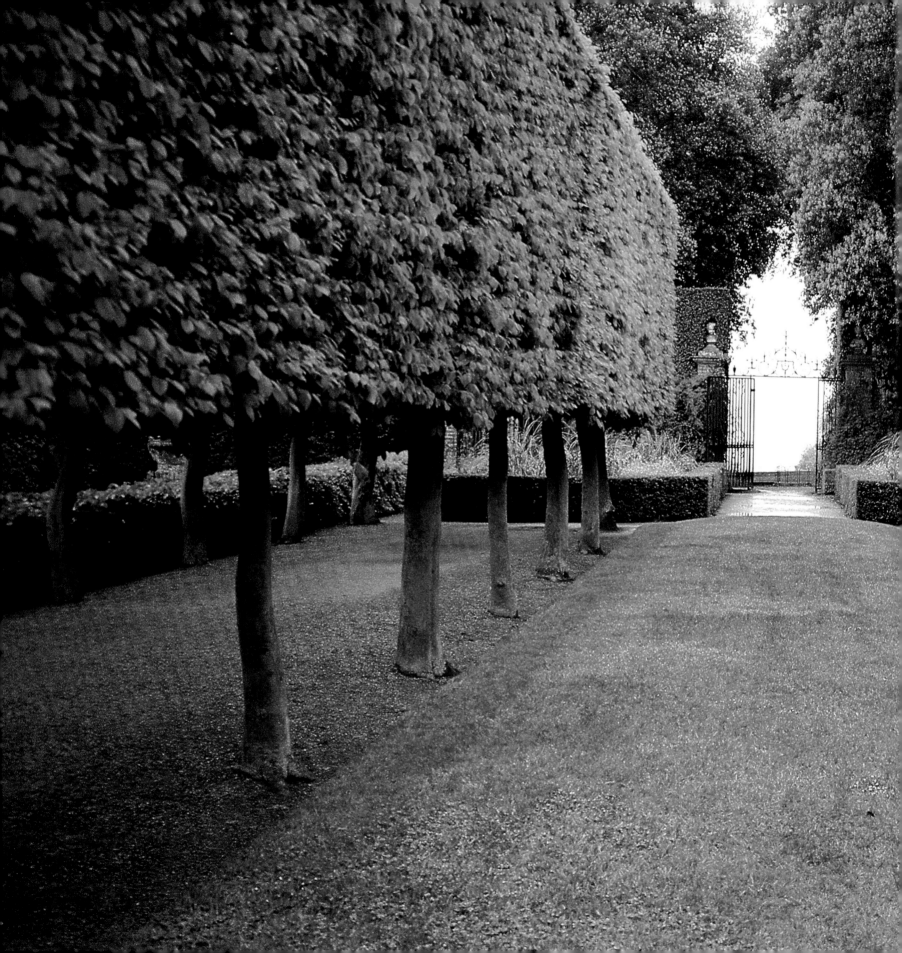

LEFT I think Lawrence Johnson created this allée at Hidcote specifically to send astral-travelling garden visitors right over the edge. Why else is the gate open?

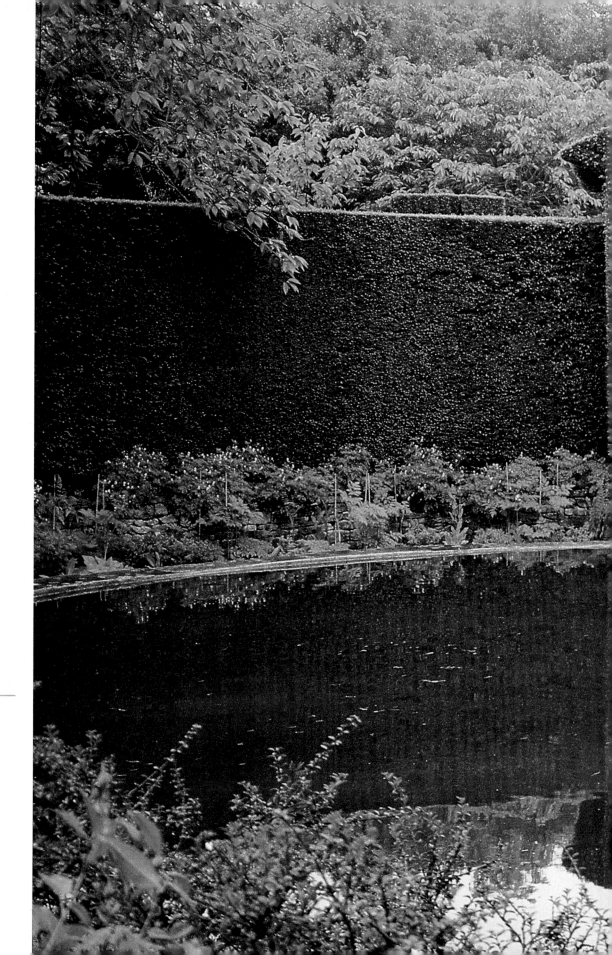

RIGHT This is a beauty overdose. At Hidcote, the lyrics Stevie Nicks of Fleetwood Mac sang, "When the rain washes you clean, you'll know," finally made sense to me when I stood right here…

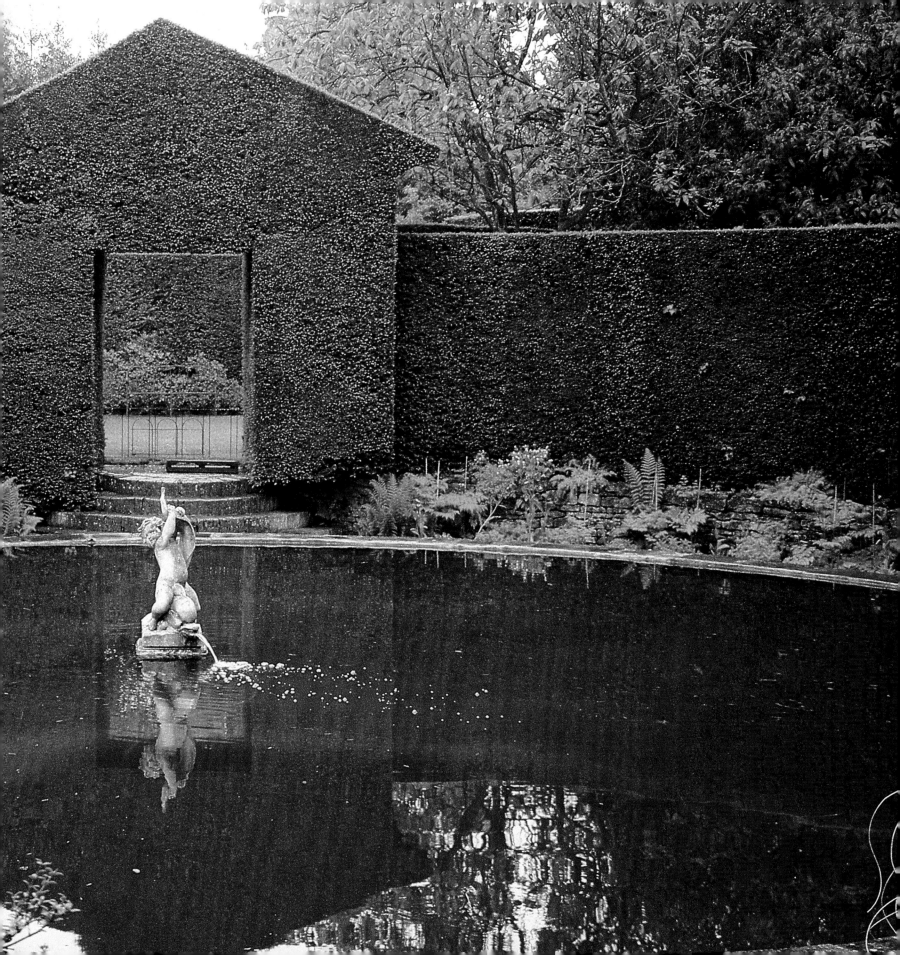

Plants Illustrated in This Book

Photographic Credits

Jerry Harpur, 24(l), 33(r), 105, 134 •
David McDonald, 17, 18, 20, 34, 41, 55, 64(l), 80, 81, 82, 84, 91, 92, 104, 106, 107, 108, 109, 110, 113, 114, 118, 119(r), 124, 135 •
Allan Mandell, 37, 40, 43, 46, 47, 48, 51, 52, 53, 54, 57, 59, 62, 65, 111, 122, 126, 127, 128, 129, 136, 137 •
Charles Price, 9, 19(r), 21, 44, 45(a), 49, 50(l), 56, 60, 63, 64(fl), 66, 74(ar), 117, 120, 121 •
All other photography by Thomas Hobbs •